Black is Bea

MW00344603

Foundations of the Philosophy of the Arts

Series Editor: Philip Alperson, Temple University

The Foundations of the Philosophy of the Arts series is designed to provide a comprehensive but flexible series of concise texts addressing fundamental general questions about art as well as questions about the several arts (literature, film, music, painting, etc.) and the various kinds and dimensions of artistic practice.

A consistent approach across the series provides a crisp, contemporary introduction to the main topics in each area of the arts, written in a clear and accessible style that provides a responsible, comprehensive, and informative account of the relevant issues, reflecting classic and recent work in the field. Books in the series are written by a truly distinguished roster of philosophers with international renown.

Black is Beautiful

A Philosophy of Black Aesthetics

Paul C. Taylor

WILEY Blackwell

This edition first published 2016
© 2016 Paul C. Taylor

Registered Office
John Wiley & Sons, Ltd, The Atrium, Southern Gate, Chichester, West Sussex, PO19 8SQ, UK

Editorial Offices
350 Main Street, Malden, MA 02148–5020, USA
9600 Garsington Road, Oxford, OX4 2DQ, UK
The Atrium, Southern Gate, Chichester, West Sussex, PO19 8SQ, UK

For details of our global editorial offices, for customer services, and for information about how to apply for permission to reuse the copyright material in this book please see our website at www.wiley.com/wiley-blackwell.

The right of Paul C. Taylor to be identified as the author of this work has been asserted in accordance with the UK Copyright, Designs and Patents Act 1988.

Library of Congress Cataloging-in-Publication Data

Names: Taylor, Paul C. (Paul Christopher), 1967– author.
Title: Black is beautiful : a philosophy of black aesthetics / Paul C. Taylor.
Description: Hoboken : Wiley, 2016. | Series: Foundations of the philosophy of the arts | Includes index.
Identifiers: LCCN 2016002850 (print) | LCCN 2016005797 (ebook) |
 ISBN 9781405150620 (cloth) | ISBN 9781405150637 (pbk.) |
 ISBN 9781118328675 (pdf) | ISBN 9781118328699 (epub)
Subjects: LCSH: Aesthetics, Black. | African American aesthetics.
Classification: LCC BH301.B53 T39 2016 (print) | LCC BH301.B53 (ebook) |
 DDC 111/.8508996073–dc23
LC record available at http://lccn.loc.gov/2016002850

A catalogue record for this book is available from the British Library.

Cover image: Seydou Keita, Untitled, 1952/1955. Gelatin silver print, printed later. Courtesy CAAC – The Pigozzi Collection, © Keïta/SKPEAC

Set in 11.5/13pt Perpetua by SPi Global, Pondicherry, India
Printed and bound in Malaysia by Vivar Printing Sdn Bhd

1 2016

Contents

Preface and Acknowledgments

Between Baraka and Brandom

"I don't know where to begin (or, it turns out, to end) because nothing has been written here. Once the first book comes, then we'll know where to begin."

<div style="text-align: right">

Barbara Smith, "Toward a Black Feminist Criticism"[1]

</div>

I went into philosophy because I thought it would help me help others think more productively about black expressive culture. This seemed like an important thing to do during the early days of the US post-civil rights era, in those days after world events had undermined the idea that, as Du Bois might say, the walls of race were clear and straight, but before it had seriously occurred to anyone to toy with thoughts of post-racialism. At that moment, black expressive culture – the aesthetic objects, performances, and traditions that defined blackness for many people as surely and as imperfectly as skin color or hair texture do – still seemed important in the ways that the US Black Arts Movement had insisted it was. But the old reasons for assigning it this importance had lost some of their purchase, and the old contexts for creating, experiencing, and understanding black expression were undergoing rapid and radical transformation.

The old reasons for focusing on black literature, film, music, and the rest were artifacts of earlier regimes of racial formation. Prior to the (qualified) successes of the twentieth-century black freedom struggles, black expressive culture mattered to blacks because culture work allowed them to escape, to some degree, more than aspirants to success in business or politics could, the yoke of white supremacist exclusion, and to achieve at a level commensurate with their talents. So blacks could look to entertainers and artists as emblems or defenders of their human possibilities. Black culture workers could show self-doubting blacks as well as negrophobes of other

races the true potential of unfettered black strivings, and they could defend the race against the racist images and narratives that dominated western culture. At the same time, black expressive culture also mattered to people of other races, even anti-black racists of other races, and also for a handful of reasons. For some, primitive blacks had their fingers on the pulse of some quintessentially human impulses that over-civilized people of other races had forgotten. For others, blackness could be a symbolic field for working out their own identities and impulses, consciously or unconsciously. For still others, and most simply, blackness was associated with dimensions of human experience that are always of wide interest – it was exotic, titillating, dangerous, and sensual.

This dialectical struggle of colonial and anticolonial approaches to blackness began to lose its relevance after African countries became self-governing, and after black subject populations in settler colonial states began to assert and win something like their full citizenship rights. Put simply: Once Oprah becomes a global media icon, and Toni Morrison wins the Nobel Prize for literature, and Mandela becomes the president of South Africa, and Obama becomes the president of the United States – perhaps better: now that Tim Story can direct summer blockbuster films like *The Fantastic Four* (for good or ill), and Halle Berry can win an Oscar (more on this later) *and* headline her own tentpole superhero film (*Catwoman*), and Okwui Enwezor can curate Documenta and the Venice Biennale, and Michael Jordan and Jay-Z can, like Oprah, become global icons for their skills as performers *and* as businesspeople – once all of this happens, the old approaches to black expressive culture seem much less pertinent. Why ask culture workers to uplift and defend the race, in the minds of black folks or others, when the work of vindication, in aesthetics and in ethics, has already been done?

Many of the particular developments that I cite above were still some distance in the future when I decided philosophy was relevant to black aesthetics. But the general drift was clearly discernible, as was a widespread incapacity to think intelligently about the cultural dynamics that our new racial orders had unleashed. We were starting to see the import of questions like these: How should African Americans orient themselves to icons of African identity, like kente cloth, especially since those icons had specific meanings to participants in specific African communities, and these meanings were often invisible to people looking through the lenses of US racial politics? Does it make sense to demand that black artists produce "positive" images of black life, now that there is less need to defend ourselves against assaults like *Birth of a Nation*? Does the widespread adoration of figures like Michael Jordan and Michael Jackson, or, now, of Will Smith and Beyoncé Knowles, mean that racism is over? What does it mean that the most lavishly

compensated participants in black practices are often white people? How can we even make sense of the idea of "black practices" after the collapse of classical racialism? Worse, how can we make sense of this idea after explicit racial domination gives way, thereby removing the impetus to close ranks and ignore both the differences between the many distinctive ways of being black and the centrality of interracial exchanges to even the most iconic "black" achievements? And what do we make of the strange ambivalence with which black bodies are still widely regarded, which leaves them both invisible and hyper-visible, desired and despised?

Those questions are only more pressing now, in the world after Quentin Tarantino, Joss Stone, and Justin Beiber, a world populated by symposia on Black Europe and Body Politics[2] and by Japanese reggae artists who trek to Brooklyn and Kingston in search of authenticity.[3] They are pressing in part because they represent a kind of changing same, though not the one Baraka invites us to contemplate. None of the phenomena I've gestured at are new, exactly, which means that we have to account for their persistence. But they are still interestingly distinct from the precedents that we might cite for them, which means that we have to explain the difference between, say, Tarantino and Norman Mailer, Beiber and Elvis Presley, Sidney Poitier and Denzel Washington.

Anyway, as I keep saying, I dimly perceived that these were things worth thinking harder about, in ways that seemed, in my experience, either of little interest to or beyond the capacities of most people. I knew that there was a long tradition of serious reflection on black aesthetics, though that description of the enterprise had become available only recently. And I knew that the tradition had even more recently made its way into the academy, into English departments and programs in cultural studies and other places, carried there by people benefiting from the same political victories that now made it necessary to interrogate the shifts in black culture. My hope was to extend the tradition and join the ongoing conversations, and to do so by bringing the tools of professional academic philosophy to bear on our shared problems.

What I did not adequately understand was the degree to which professional philosophy – the part of the profession into which I had been socialized, anyway – had purposely walled itself off from the places and people with whom I wanted to be in conversation. This turned my desire to join the conversation into an attempt to bridge discursive communities – more precisely, to build a bridge from a particular network of discursive communities, the ones that raised me, to the mainland of inquiry into black aesthetics. And that subtle but profound shift in the project has led to the book that you now hold.

I want to be clear about this background because it bears directly on the structure of the project as it stands. I have recently found myself calling this

an exercise in "retroactive self-provisioning," which means that I have tried to write the book that I'd wanted to read, back when the size of the gap between the work I was prepared to do and the work I wanted to do began to become apparent. So the shape of the project, its proximity to contemporary Anglophone philosophy and its distance from – though not refusal of – the veins traditionally mined by other approaches to black expressive culture, is a function of autobiographical contingencies and vocational choices. I undertook this project in part to fill a void in the expressive and theoretical resources of the intellectual traditions that inform my work, and to dissolve the dilemma that I once thought I faced: study philosophy, or study black expressive culture?

The void that I mention is doubly overdetermined. On the one hand, I was trained by analytic philosophers, and found while in their tutelage that I was interested in classical US thinkers like Emerson, William James, and John Dewey, and in the uses that people like Rorty and Putnam found for their ideas. I found further that following out the latter tradition in the right directions could lead me into productive encounters at the more accessible edges of "foreign" traditions, as represented by the likes of Foucault, Butler, Bordo, and Cavell. This sort of training, which was more ecumenical than it might have been, tends not to inspire curiosity about the likes of Amiri Baraka. On the other hand, I had long nurtured an interest in black critical thought. This began during my time at an HBCU (historically black college and university) in the 1980s, and has deepened in recent years as I've worked in greater proximity to scholars in African American Studies. This sort of training, for its part, tends not to inspire curiosity about the likes of Robert Brandom.

There is a small area of overlap between the traditions that claim Brandom and Baraka, an area occupied in increasing numbers by students and scholars of Africana philosophy and newer modes of political theory. But the bit of that work that attempts a rapprochement from the side of the philosopher tends not to fill the void I have in mind, for three broad reasons. First, much of it reproduces mainstream philosophy's indifference to aesthetics, and focuses, albeit quite reasonably, on questions from other precincts of philosophy. Think here, for example, of the composition of the important companion volumes to African American and African philosophy, as those documents stand as of this writing. They are massive texts, and vanishingly little of their huge page counts are occupied with work in aesthetics.

Second, the work that does take up aesthetic questions tends to set aside the aspiration to explore black aesthetics as a whole – call this the conjunctural aspiration, for reasons I'll come to in Chapter 1 – and focuses instead on particular idioms, periods, or thinkers. Think here of the fine work that people like Tommy Lott and Nkiru Nzegwu have done on particular

expressive idioms and media, or of the brilliant new work in political theory that treats Baldwin and Du Bois as thinkers whose approaches to the aesthetic and the political are inseparable. This is important work, but there is a need for more studies of the sort undertaken by people like Cornel West, Sylvia Wynter, and Fred Moten, work that aspires to think philosophically about the black aesthetic as such.

And third, the work that accepts the conjunctural aspiration tends to remain at a somewhat greater distance than I would like from the philosophical resources that I value. I am thinking here of philosophers who have left the profession to become, as Cornel West puts it, men and women of letters, not beholden to any narrowly specialized and professionalized approach to the life of the mind. These are people like West himself, of course, but also like Angela Davis and Adrian Piper, all of whom are card-carrying philosophers but whose interests – interests in, among other things, the issues that I will soon assign to the study of black aesthetics – have led them away from professional academic philosophy and into spaces that are in some ways (ways I don't have time to explore) more open.

I am also thinking, though, of figures who have not put aside academic philosophy but who have instead worked in or near it using vocabularies that are to some degree incompatible with my own. I think here of Moten and Wynter, and of others who have drunk deeply from the wells of post-structuralist thought. But I think also of Alain Locke, who did his work before the mid-twentieth-century ferments – in philosophy and in black cultural criticism – that shaped my vision of our shared interests. For this reason, Locke's arguments are for me nearly as distant and in need of translation as Royce's, or Hegel's, or Moten's. I accept that this need for translation is a shortcoming of my training, or of what I've made of myself in the wake of that training. It is surely the case that Locke's work (like Royce's, and Hegel's, and Moten's) should be less alien to me than it is. Still, one must on occasion cast down the buckets where one stands, which is to say that this project is an experiment in mining the resources that my upbringing, whatever its limitations, has prepared me to use.

All of that to say: My hope in this book is to use resources in and near the dominant traditions in Anglophone philosophy – which is what I will usually mean when I refer to "philosophy" here – to reconcile the black aesthetic with the contemporary race-theoretic consensus. If I do this properly, I will have written the book that I wanted, and could not find in graduate school, when I began to read Du Bois and Morrison through Danto and Dewey. And I will have given people who share my intellectual upbringing an accessible way into the study of black aesthetics.

Thinking, done properly, is about incurring debts. We end up beholden to our interlocutors and teachers, living and dead, to our correspondents and

collaborators, and to the people who have sustained us on our journeys through, and to and from, the worlds of our ideas. It is not clear whether I've thought properly here, but I have incurred the debts.

First, there are a number of audiences and commentators to thank, many of whom heroically masked their puzzlement as I tried to locate the questions and claims that make up this book. I am particularly indebted to the philosophy faculty and students at Rhodes University in South Africa, who have heard me work through the ideas here over several years of visits to Grahamstown. Ward Jones, Pedro Tabensky, and Samantha Vice have been gracious hosts, good friends, and generous conversation partners, and I am glad to have them as colleagues and comrades. Lectures at the University of Michigan, the University of San Francisco, the University of Cape Town, the University of the Eastern Cape, Middle Tennessee State University, Otterbein University, and Skidmore University have been similarly fruitful, thanks in large part to the comments and thoughtfulness of Robin Zheng, Ron Sundstrom, Elisa Galgut, Antjie Krog, Mary Magada-Ward, Stephanie Patridge, and Catherine McKeen. The philosophers at Bucknell University, led by Sheila Lintott, were especially kind as I worked toward the slowly dawning questions that now inform the chapter on funk. It has been particularly enlightening to share these ideas with faculty and students at historically black colleges and universities, both here and abroad. For these opportunities I have to thank Anika Simpson and Marcos Bisticas-Cocoves at Morgan State, Barry Hallen at Morehouse, and Abraham Olivier at the University of Fort Hare.

Audiences and commentators at various professional gatherings have also been quite helpful, beginning with the International Society for African Philosophy and Studies, where this project got its first public airing. Since then the good people of the Alain Locke Society, under the leadership of Leonard Harris and Jacoby Carter, and of the American Philosophies Forum, led by John Stuhr, invited me to give presentations that proved especially fruitful for this work. Similarly, opportunities to speak at meetings of the American Philosophical Association and the American Society for Aesthetics led to useful comments from Devonya Havis and Luvell Anderson, and from generous and attentive audiences.

I have also benefited from the edifying conversations put on by various college and university institutes and centers. I particularly appreciate the generosity of the University of Connecticut's Institute for African American Studies, led at the time by Jeff Ogbar and then by Olu Oguibe; of Florida Atlantic University's Center for Body, Mind, and Culture, under the direction of Richard Shusterman; of the University of Kentucky's African American & Africana Studies Program, led by Frank X. Walker; and of the Frederick Douglass Institute at East Stroudsburg State University, represented in its dealings with me by Storm Heter.

This work would of course not have been possible without the financial support of various institutions, and without the sustained encouragement and criticism of a number of individuals. I received generous research support from my employers at Temple and Penn State – much more generous support than I could reasonably have expected. And I enjoyed rich and vibrant intellectual communities in both places. At Temple, my colleagues Lewis Gordon, Miriam Solomon, Espen Hammer, and Kristin Gjesdal, along with students Danielle LaSusa, Joan Grassbaugh-Forry, Robert Main, and Avram Gurland-Blaker, helped me frame the project that became this book. Lewis was particularly helpful, not least in providing a model for moving between, and sometimes refusing, disciplinary boundaries. At Penn State, my colleagues Kathryn Gines, Vincent Colapietro, Shannon Sullivan, and Robert Bernasconi have been an invaluable support system, with Vincent in particular helping me to keep alive the hope that philosophy can be made safe for Ralph Ellison and Regina Carter. The Penn State students have been an inspiration, with their determination to avoid the kind of either-or choices that lead me in middle age to write the book that I needed in grad school. I am particularly grateful in this regard for the conversations I've had, in seminar rooms, sports bars, and chain breakfast restaurants, with Lindsey Stewart, Alphonso Grant, and Jamelia Shorter.

A number of individuals outside my workplaces have made the deepest impact on this work. Jeff Dean green-lit the project during his time at Wiley and then waited, with patience beyond measure, for it to come to fruition. I am grateful to Jeff and to Nicole Benevenia and Tiffany Mok for their serenity in the face of interminable delays. Cornel West and Susan Bordo, by argument, instruction, and example, helped me think it might be possible to build the intellectual bridges that I wanted to build, to take black expression seriously as an occasion for and record of deep thought and profound achievement, and to put philosophy productively into conversation with cultural criticism. Eddie Glaude was and long has been an invaluable conversation partner, inspiration, brother, and friend, and has shown me, in a number of ways over a number of years, how one might bring the exact intellectual and cultural resources that interest me into a fruitful and fascinating combination. Charles McKinney, Mark Jefferson, and Charles Peterson reminded me that the life of the mind includes – no, *requires* – laughter, and that the bonds of brotherhood remain intact across borders and in virtual conversation. To Eddie, Chuck, Mark, and Pete, I say: Ankh, Tchau, Seneb.

Anne Eaton gave me hope for philosophical aesthetics, and, sometimes, for philosophy, and pushed me to think harder and more carefully about every aspect of this project, and about much else besides. This book would not exist without her, though it would surely be better if I had listened to her

more often. Siobhan Carter-David reminded me, in word and deed, of the exciting work that people in other fields are doing in this area, and helped me keep keeping on when my interest and energies were flagging. Eduardo Mendieta, Anika Simpson, Kelly Ellis, and Nikky Finney offered just the right encouraging words, I suspect more encouraging than any of them knows, at just the right moment. And Philip Alperson endorsed the idea of this project early on, and gave me the opportunity to pursue it with Wiley.

My brother Mark inspired me with his commitment to the working artist's life, and to cultivating the craft that makes the life possible. If I have become one-tenth the writer that he is a musician, and if I've studied expressive culture with one-tenth the care that he devotes to producing it, then I will have achieved something.

My teachers Peter Kivy and Howard McGary have left indelible marks on this project, though in different ways. Peter showed me that one can attend to the quality of one's writing and of one's thinking at the same time, and modeled a way of putting both arts in service of productive reflection on the philosophy of music. I found myself rehearsing his arguments much more frequently in these pages than I had anticipated. I hope this pleases him as much as it pleases me. Howard's mark on the book is less direct, but no less substantial. I hope to have learned from him how to engage carefully and charitably with all comers, how to work patiently through an idea until it yields whatever it has to offer, and how to do all of this in conversation with the best of the black intellectual tradition, taking Audre Lorde as seriously as John Locke.

Finally, my wife, Wilna Julmiste Taylor, showed me every day what it is to walk and live and love in beauty. She has supported me through this project, and through all the detours that the book and our lives have taken, to a degree that I do not deserve. Her reminders about the business of culture work pull me back from the land of austere academic reflection, and enrich my reflections with real-world detail. And her joyfulness, spirituality, and passion remind me that experience both has and should aspire to have, as Dewey rightly but inelegantly put it, aesthetic quality. Like the dewdrops love the morning leaves, honey.

Notes

1　Barbara Smith, "Toward a Black Feminist Criticism," *The Radical Teacher* 7 (March 1978), 20–27; reprinted in Winston Napier, ed., *African American Literary Theory* (New York: NYU Press, 2000), 132–146, 132.

2　"Black Europe and Body Politics," *Africa is a Country* (blog), posted July 8, 2014, http://africasacountry.com/2014/07/projects-black-europe-and-body-politics/ (accessed November 30, 2015). "For those not familiar with this

groundbreaking project, BE.BOP is a curatorial project, in co-production with *Ballhaus Naunynstrasse*, that includes exhibitions, presentations, screenings and roundtables by artists (among others) from the Black European Diaspora. This project seeks to fill a gap when it comes to deconstructing the coloniality of western art and aesthetics in Europe" (par. 1).

3　Josh Chamberlain, "How to Be a Japanese Reggaephile," *villagevoice.com*, posted July 28, 2009, http://www.villagevoice.com/2009-07-28/music/how-to-be-a-japanese-reggaephile/ (accessed July 3, 2013).

1

Assembly, Not Birth

It is 1790, and you are at a seaport in South America. The port is part of the Dutch colony that has since become the country of Suriname, and it is a vital part, if the amount of traffic you see is any indication. One of the many ships here has just docked, and the crew is busy hustling its cargo above deck. The cargo is, in point of fact, hustling itself above deck. The ship, it turns out, is a slave vessel, just arrived from the Dutch Gold Coast, in what is now Ghana.

The forty or so people who make their way up from the cargo hold appear much the way you would have expected, had you expected them. They are dark-skinned and slender, and some give the appearance of being quite ill. They are solemn, apparently resigned to their new fates in their new world. Some have difficulty standing, and most are blinking in the sunlight.

These new African Americans surprise you in only one respect. They have stars in their hair.

Not real stars, of course. The new arrivals have had their heads shaved, leaving patches of hair shaped like stars and half-moons. Just as you begin to wonder how the ship's crew settled on this way of torturing their captives or entertaining themselves, you receive a second surprise. Not far from where you are standing, a man who seems to be the ship's captain is speaking with a man who seems to have some financial interest in the ship's cargo. The capitalist asks the captain why he cut the niggers' hair like that, and the captain disclaims all responsibility. "They did it themselves," he says, "the one to the other, by the help of a broken bottle and without soap."

1 Introduction

The story of slaves with stars in their hair comes from a groundbreaking anthropological study called *The Birth of African American Culture*.[1] The authors of the study, Sidney Mintz and Richard Price, report an eyewitness account

Black is Beautiful: A Philosophy of Black Aesthetics, First Edition. Paul C. Taylor.
© 2016 Paul C. Taylor. Published 2016 by John Wiley & Sons, Ltd.

of something like the events described above, and use it to support one of their key arguments. They mean to reject and correct certain received ideas about the pace at which Africans became Americans. They hold that distinctly African American cultures emerged quite early on, as enslaved Africans built wholly new practices and life-worlds out of the various old worlds – from different parts of Africa, as well as from Europe and the Americas – that collided in modern slave-holding societies. In the case of the new Americans in this story, the process of cultural blending began before they even reached shore, with an act of "irrepressible cultural vitality" that bridged their different ethnic backgrounds, and that transcended their presumably divergent ideas about adorning the body.

Mintz and Price might have made a slightly different and in some ways broader point, a point not about the birth of African American culture but about the birth of black aesthetics. The uprooted Africans in the story were positioned to become African Americans because they had first been seen and treated as blacks. They put stars in their hair in response to this forced insertion into the crucible of racialization. Having been stripped as much as was possible of their preexisting cultural armament, they had to replace it with something, to put some stylized barrier between themselves and the new social forces with which they would be forced to contend. Instead of entering the new world in the manner of the animals they were thought to be, unadorned, unmarked by the self-conscious creation of meaning, they found common cause in the essentially human act of aesthetic self-fashioning.

This sort of activity, I will want to say, is at the heart of the enterprise that has come to be known by the name "black aesthetics." Insisting on agency, beauty, and meaning in the face of oppression, despair, and death is obviously central to a tradition, if it is that, that counts people like Toni Morrison, Aaron Douglas, and Zora Neale Hurston among its participants. And reflecting on this activity is central, I will also want to say, to the philosophical study of black aesthetics.

We might start toward the philosophy of black aesthetics by rethinking the metaphor that organizes the Mintz–Price study. They speak of birth, a notion that could lead careless readers to overlook the amount of artifice and improvisation that people put into making a shared life. But think of what you saw at that South American port. A group of uprooted Africans engaged in an act of *bricolage*: they used what was at hand, both culturally and materially, to cobble together the beginnings of an African American culture. It appears that these cultures are not so much born as assembled.

The philosophical study of black aesthetics also involves a kind of assembly, in a sense that I will soon explain. I stress the philosophic nature of this enterprise because black aesthetics has been developed in many different ways, but

none, as far as I know, involve a sustained examination from the standpoint of post-analytic philosophy. This book will, I hope, correct for this oversight.

My aim in this introduction is to answer some preliminary questions concerning the project, and to gesture at what the other chapters will bring. The preliminary questions I have in mind emerge rather directly from the basic framing that I've given the project so far. First, to paraphrase cultural theorist and sociologist Stuart Hall: what is the "black" in "black aesthetics"? Second, in the same spirit: what is the "aesthetic" in "black aesthetics"? Third: what good is a philosophy of black aesthetics? And fourth: why discuss any of this in terms of assembly?

2 Inquiry and Assembly

In an essay on the Black Arts Movement in 1980s Britain, Stuart Hall introduces the sense of "assembly" that I'll use here. He writes:

> This paper tries to frame a provisional answer to the question, How might we begin to 'assemble' [our subject] as an object of critical knowledge? It does not aspire to a definitive interpretation.... What I try to do ... is 'map' the black arts ... as part of a wider cultural/political moment, tracking some of the impulses that went into their making and suggesting some interconnections between them. I 'assemble' these elements, not as a unity, but in all their contradictory dispersion. In adopting this genealogical approach, the artwork itself appears, not in its fullness as an aesthetic object, but as a constitutive element in the fabric of the wider world of ideas, movements, and events.[2]

On this approach, assembly refuses the quest for a "definitive interpretation" – think here of necessary and sufficient conditions, or of static, trans-historical essences. It aspires instead to identify, gather together, and explore the linked contextual factors in virtue of which we might productively and provisionally comprehend various phenomena under a single heading. And it takes seriously the degree to which these contextual factors involve the historical, cultural, political, and, in the eighteenth-century sense of the term, *moral* dimensions of human social affairs.

The method of assembly makes it easier to credit the complexity of historically emergent social phenomena – what Italian Marxist Antonio Gramsci encourages Hall and others to call "conjunctures." A conjuncture is "a fusion of contradictory forces that nevertheless cohere enough to constitute a definite configuration."[3] Assembly is the mode of inquiry that allows us to see and account for the coherence of the configuration without glossing over the respects in which it remains, in a sense, incoherent.

Complexity and relative incoherence are important aspects of dealing with the historical dimensions of social phenomena. In dealing with movements or cultural epochs it is often tempting to fetishize temporal landmarks or origin points. But, Hall points out, "[t]he forces operative in a conjuncture have no single origin, time scale, or determination.... [They] are defined by their articulation, not their chronology."[4] That is, conjunctural moments come into view when otherwise independent factors converge in ways that it pays us to think of as constituting something new.[5] For example, the period that we know as The Sixties doesn't begin on January 1, 1960; it begins when the forces that make The Sixties matter come together enough to warrant our attention – which is why it begins at different moments for different people, and why historians sometimes talk about the late fifties part of the Sixties. So one consequence of adopting the method of assembly is that it reminds us to avoid "giving [the conjunctural subjects of our inquiries] a sequential form and imaginary unity they never possessed." Instead, we should define them the way we define generations: "not by simple chronology but by the fact that their members frame the same sorts of questions and try to work through them within the same ... horizon or ... problem-space."[6]

These lessons of the method of assembly are particularly useful for a study of black aesthetics. Like Hall's study of the Black Arts Movement in the UK, this book will need to assemble its subject as an object of knowledge, not least because variations in idiom and in regional and national practice have created "a series of overlapping, interlocking, but non-corresponding histories" that defeat any appeal to a single origin or time scale.[7] (As a pragmatist, I think we always assemble objects of knowledge; but I mean here to invoke the specifically Gramscian resonances of Hall's use of the idea, and to credit the distinctive challenges of trying to tell a single story about several centuries of transnational black expressive culture.) The only way to think responsibly and all at once about something called "black aesthetics" is, as Hall puts it, to comprehend under one concept, albeit provisionally, the "condensation of dissimilar currents" that just is the history of black expressive practice.[8]

This Gramscian approach has its limits, in just the places Hall suggests. There are of course the intrinsic dissatisfactions that come with the inability to index a social fact to definite temporal beginnings and endings. And the expressive objects and practices that give this book its subject matter will not appear here, as Hall says, in their fullness as aesthetic objects, due to the relative weight I'll have to place on considerations apart from the work of criticism. To the first point: the study of complex, unruly phenomena can also be intrinsically satisfying, not to mention that reality just is unruly, no matter what we'd prefer. And to the second point: a different sort of book

would spend more time on criticism – on accounting for and evaluating the experiences that expressive objects underwrite in terms of the relevant features of the objects – and less on theory – on elucidating some of the wider contexts that should inform the critic's work. But this is not a work of criticism, in part because one basic conceit of the book is that the most productive way to think of black aesthetics is not centrally concerned with finding a unitary system of norms for producing or evaluating artworks.

It should be clear, then, that I think of the limits on a conjunctural approach as parameters, not as failings. Instead of, say, providing a definitive catalogue of the aesthetic norms that have governed every black community since the fifteenth century, I aim to assemble the interest in such norms, and much else, into the subject for academic philosophy that similar inquiries have never managed, or cared, to create. I hope to flesh out the familiar thought that there are philosophic continuities linking Edwidge Danticat to W. E. B. Du Bois, The Last Poets to the Suriname barbers. I want to map the philosophic dimensions of black aesthetic practice, by connecting them explicitly to the wider problematic of racial formation under white supremacy.

The vision of a unified black aesthetic – the vision I am refusing – is not unfamiliar. Practically every account of black expressive practice either endorses or contends with some version of it. Until recently, though, most versions of the idea relied on the problematic assumptions of classical racialism, in both white supremacist and black vindicationist forms. And the work that has gotten past these difficulties has often given up the ambition of thinking black aesthetics all at once, and focuses instead on particular disciplines, time periods, locations, or figures. There is considerable value in this narrower, more specialized work. But there is also some value in taking a more expansive view, provided that we can find a theoretically respectable unifying principle.

To my mind, the best short statement of an acceptably expansive approach comes from art historian Richard Powell. In *Black Art: A Cultural History*, he explains that the concept of the black aesthetic does not pick out the "singular and unrealistically all-inclusive" cultural monolith that Shelby's cultural nationalists want to find;[9] instead it denotes "a collection of philosophical theories about the arts of the African diaspora."[10] Where Powell says "theories," I would say "arguments" or "registers of inquiry." Where he invokes "the African diaspora" I would instead invoke the collection of life-worlds created by and primarily identified with people racialized as black. And while he ultimately focuses on the essentially post-liberation and postcolonial standpoint of the Black Power era, I would cast the net somewhat wider and attempt to locate the poets and dramatists of Black Power on a wider field of thought and action, alongside Barbara Smith, the Suriname barbers, and many others.

These differences aside, though, Powell outlines the basic strategy of this book. I aim to save and develop the intuition that there is a single thing worth calling "black aesthetics." And I mean to do this by appealing not to the fictive unity of monolithic, supernaturally harmonious, racially distinct culture groups, but to the essentially philosophic preoccupations that routinely animate and surround the culture work of black peoples.

As I'll use the expression, then, based on the foregoing argument for epistemic assembly, to do "black aesthetics" is to use art, criticism, or analysis to explore the role that expressive objects and practices play in creating and maintaining black life-worlds. The appeal to exploration here is more expansive than it may appear. One can explore something by trying to give an account of it, in the manner of a scientist. But one can also explore something by poking around, in the manner of an explorer. In this sense artists explore the roles that expressive objects can play by trying to make them play one role or another, or by participating in and commenting on previous attempts to do this. (I think here of Glenn Ligon's appropriation of slave narrative frontispieces.)[11] The idea to refer to something as a black aesthetic comes down to us only from the 1960s, when some of the people formerly known as Negroes decided that self-identifying as black would help turn the page on the historic failures and ideological limitations of the past.[12] But the work itself began long before the name caught on. The work began whenever and wherever the creation, analysis, and criticism of expressive objects first became crucial to the racial formation processes that produce and sustain the social phenomena that we think of as black people.

3　On Blackness

The idea of assembling black aesthetics presupposes that there is a responsible way of appealing to racial blackness. So the next question to take up is perhaps the most obvious one: what is the black in black aesthetics? It is possible, I suppose, to remain unmoved by this question, or to think that the answer is obvious. There is however no shortage of "obvious" conceptions of blackness, and some of these pretty quickly reveal themselves to be problematic. For these reasons, it is important to be clear about how this book will use "blackness" and "race" and all their cognate terms.[13] On the way to settling the meanings of these terms, we will also have to clarify some other issues, including the role that the idea of modernity will play here.

The first thing to say is that the "black" in "black aesthetics" is obviously a racial category, and only slightly less obviously a category that picks out, as W. E. B. Du Bois once said, the people who would have had to ride Jim Crow in 1940s Georgia.[14] This may seem to put the matter rather too simply, in

light of all the ethical and conceptual difficulties that attend the practices of racial ascription and identification. But there are many different ways to commit oneself to understanding and using racial categories – a commitment that I will indicate with the term "racialism."[15] And some of these ways have been crafted precisely to avoid or respond to these difficulties. The classical race theory made famous by white supremacists, anti-Semites, and neo-Nazis is what worries most of the people who fear and avoid race-talk. But anti-racists, social theorists, and social justice advocates have developed forms of critical race theory that use race-talk to understand and grapple with the social, ethical, and psychocultural conditions that classical racialism helped bring into being.[16]

The distinction between critical and classical race theory is not fine-grained enough to capture all of the varieties of racialism, each with its distinctive ontological and ethical commitments. Deciding which of these commitments is or ought to be in play has historically been one of the tasks that frames the enterprise of black aesthetics. The key for current purposes is just that some version of racialism is in play for students and practitioners of black aesthetics, and that this racialism can be critical rather than a form of racism or invidious essentialism.

This open-ended appeal to critical racialism is consistent with a broad consensus that has recently emerged in philosophical race theory.[17] Most race theorists now understand race *critically*, as a human *artifact* that is interestingly linked to European *modernity*, importantly *political* in its conditions and consequences, unavoidably *social* in its reach and structure, and essentially *synecdotal* in its operations. Each element of this consensus requires some elaboration.

To approach race critically is to refuse classical racialism. This means to refuse a picture of hierarchically ranked, naturally distinct human populations, reliably defined by clusters of physical and non-physical traits. For the critical racialist, race, whatever it is, is not what Samuel George Morton and Thomas Jefferson – and, for that matter, Marcus Garvey – thought it was.

To approach race as an artifact is to accept that our race-talk refers to the products of human agency. To say this is *not* yet to say that there can be no biological or evolutionary component to raciogenesis. It is simply to cast one's lot with the sort of view one finds in standard formulations of racial formation theory: that racial phenomena are products and records of human activities rather than prefabricated features of the universe.

To insist on the political significance of race is to insist not just on the standard racial controversies. It is also, and more importantly, to highlight the robust relationship between race-thinking and the modern world's basic political structures, from the growth of capitalism to the development of liberal ideas of freedom and democracy. Race has been central to the

conceptions of citizenship, justice, individuality, and more that define the modern project, and it remains central to contemporary elaborations and emanations of this project.

To stress the modernity of the race concept is to accept that the world's most influential racial practices are importantly, but of course not totally, discontinuous from their antecedents in the pre-modern world. This is not an especially controversial point, though people quibble over where to draw the relevant temporal boundaries and over what counts as a modern race concept. But the basic point is clear: after the fifteenth century or so, ideas about the structure, character, and capacities of different human types came to shape human affairs on a scale never seen before. And this massive project of social engineering – involving imperial and colonial adventures, massive forced and voluntary migrations, the extermination of astounding numbers of people, and the making and unmaking of entire civilizations – called into being massive schemes of knowledge production that purported to refine our knowledge of human diversity. All of this led to the quintochromatic racial schema – involving black, brown, red, yellow, and white races (if it helps, see all of those color terms in scare quotes) – that has played so powerful a role in world affairs for so long. It led to other things too, like the racialization of internal national populations in places like Japan and Rwanda by appeal to other schemas. But the putative differences between the four or five modern races have, especially in places like South Africa and Brazil, played a much larger role in world affairs than any conception of race (or, I would say, proto-racialism) that we find in, say, ancient Greece or Egypt.

To focus on modernity in this way, though, is to invoke a picture of the human social life and history that requires some development, and some clarity about its relationship to another picture. I claimed above that race is central to the modern project, but the point should actually be stronger: modernity was, in significant ways, a racial project. What we think of as the modern world brought itself into being in part by crafting and acting out narratives about who and what counted as civilized, or human. This narrative was anchored in the conflation of certain European cultural practices with the idea of the human as such, and with a profound myopia about the actual depth, meaning, and interdependence of the various forms of human practice. And it resulted, at its worst, in a simplistic, self-aggrandizing vision of human social progress, according to which some peoples, mostly in (certain bits of) Europe, had figured out how to lift themselves above a barbaric world of uncivilized, non-western darkness. They had become, in a word, modern. And they were, in general, white.

In contrast with this ideological sense of modernity, a sense that still animates contemporary ideas about "modernizing" and "developing" societies, I will use "modern" and its cognate terms in a more critical, descriptive

way. My use of these terms should be recognizable, as it largely tracks the standard practice of denoting the social formation that emerged from the intertwining of (certain) European cultures with particular approaches to such things as markets, technology, reason, democracy, individuality, and social identity. But I'll join many other students of these issues in holding also that European or North Atlantic modernity is not the only modernity; that the line between modern and "pre-modern" is harder to draw than we typically think, and does not neatly separate human history into civilized and un-; that the history of European modernity is not hermetically sealed off from the histories of "non-western" cultures; and that this history is not the seamless upward march (until World War I, at least) that it is often thought to be.[18] As I'll use the term, "modernity" refers to a constellation of social conditions that *includes* the practices of white supremacy, and that made those practices possible and intelligible. It does *not* refer to the world of whitely racial mythology, somehow considered in isolation from and in opposition to the benighted Others of white supremacist self-justifications.

To insist on the social significance of race is to insist that an agent's prospects in racialized settings are shaped to some degree by racializing structures not of his or her individual making. Our prospects are shaped by much else, of course, and all of these factors intertwine to produce our particular paths through life. But – and this is the key point – race is one of these social factors: it cannot be reduced to personal whims or choices about individual identity.

Finally, to claim that race is synecdotal is to highlight the central, semantic-relational mechanism of racialization. There are stronger and weaker ways to make the relevant point here, but the main idea is the same on both approaches, and is evident in the strong version that we get from David Theo Goldberg. In *Racist Culture* Goldberg explains that the concept of race "is almost but not quite completely vacuous," and borrows whatever meaning it has from prevailing social dynamics.[19] Race-thinking, he says,

> classifies ... people in virtue of their sharing some purported and purport-edly significant characteristic(s). The prevailing form of the grouping in question ... assumes content influenced by established political, economic, legal, cultural, scientific and social scientific factors and relations, but is not reducible to them.[20]

That is to say: race-thinking is a way of assigning social meanings to human differences, and of assigning significance to the characteristics that enable us to mark people as different from each other. What "purportedly significant characteristics" distinguish races? It depends on what the society that invokes racial discourse cares about at the time, and on how that society structures

its reflections on issues like social stratification and human diversity. Goldberg suggests that, "it could be, or could have been, that exclusion of women was defined as racism, if women were ... defined as a race."[21]

Why is a concept this loose not completely vacuous? Because there is a kind of grammar or logic to invocations of the race concept:

> race serves to naturalize the groupings it identifies in its own name.... In this way, race gives to social relations the veneer of fixedness, of long duration, and invokes ... the tendency to characterize assent relations in the language of descent.[22]

This business of assigning meanings, and of borrowing the resources for this process from prevailing discursive, sociopolitical, and epistemic currents, is what I mean to signal by referring to race as synecdotal. The persistence of a kind of core logic or grammar seems to me to pull against the strong form of the view that Goldberg and others[23] have adopted – to show, in other words, that we have good reasons not to describe the exclusion of women as racism, *even if the perpetrators did so on the assumption that women and men constitute separate races*. But this is not the place to debate that point, not least synecdotalism in either form offers the same lesson to critical race theorists: that societies use racial discourse to assign social meanings to various aspects of human being, and that this process is importantly bound up with efforts to create and manage social and political differences.

This process of sociopolitical meaning-assignment takes familiar forms in relation to modernity's five color-coded races, though these forms change and diverge over time. Classical racialism assumed that the book of nature was written in, among other places, the superficial facts of human bodies and bloodlines, that this book would explain social, political, and cultural differences as well, and that the race theorist's job was to figure out how to decipher the script. Critical race theory, by contrast, recognizes that centuries of classical racialist practice in fact created the code that made bodies and bloodlines into symbols of social meaning and location, and it assigns race theory the job of properly explaining the roots, content, and implications of this code. Racialized bodies and bloodlines cease to function as symbols of natural capacity and value, and instead become signs of sedimented mechanisms for asymmetrically distributing the benefits and burdens of social cooperation.

This limited consensus in race theory has several implications that will be of particular concern to students of black aesthetics. First, accepting the sociopolitical significance of race positions us to understand the abiding interest in ethics and social amelioration that we find in the black aesthetic tradition. Black aesthetics has not, usually, been a matter of art for art's sake

(though, to be fair, Europe's aestheticism had deeply ethical underpinnings too, however its slogan has since been interpreted). It could not afford to be.

Second, accepting the synecdotal dimension of race, assigning social meaning to human differences, and noting the routine deployment of these racializing mechanisms in settings that insisted on differences in things like skin color and bodily morphology, forces us to attend to the uses of the human body, both as it is represented and as it lives and moves. This positions us to connect the familiar concerns of critical race theory – racial justice, racist terror, racial identity, and so on – to the concerns of cultural studies and performance theory, and to join scholars of those fields in attending with care to the somatic and the phenomenological.

Third, accepting the artifactual dimension of race, its rootedness in human processes of creative activity, forces us to attend to the historicity and dynamism of racial phenomena. This means accepting the contingency and constructedness of the categories and conditions that result from these dynamic struggles, and getting on with the hard work of inquiry. I mean here to address one of the most common stumbling blocks to the critical reappropriation of racial discourse. It is tempting to think that many racial practices presuppose indefensible accounts of human diversity, and to conclude from this that the content of the practices is immaterial – once we have pointed out that the practices are misguided, little more need be said. But this is surely too quick. Whatever one thinks of the advisability of taking race seriously, it is clear that many people have done so, and have as a result shaped human affairs in ways that are worth attending to. Some of these racial projects – like chattel slavery, or apartheid, or the Black Consciousness Movement, or Black prophetic thought – have received a fair bit of attention from philosophers. Others – like the ones related to invocations of "the black aesthetic" – have received less, and are due for more.

With this race-theoretic consensus and its implications in hand, we can return to the questions that motivate this section. Blackness is a racial condition, and we can predicate it of definite people and practices in just the ways that inform the best – least incoherent – versions of garden-variety racial discourse. So the "black" in black aesthetics has more or less the same extension as its counterpart in commonsense race-talk. It refers to people who have been racially positioned as black, and to the life-worlds that these people have constructed. This racial positioning occurs differently in different places. But in the modern world these local practices are informed by global currents of meaning. In most places blacks will be people who are descended in the right sorts of ways from an indigenous population in early modern sub-Saharan Africa. But in some places – in the UK, for example, or in Australia – that sort of African descent is not the entire story. In all these settings, though, certain mechanisms of social

stratification track what used to be called "complexional distinctions," and certain resources for subject formation and social mobilization invite "blacks" to orient themselves to certain expressive practices in ways that implicate an expansive conception of the black aesthetic.

4 On the Black Aesthetic Tradition

Now that we know what "black" means, we can turn to the two remaining questions. One of these asks why the student of black aesthetics should bother with what many of us have been encouraged to think of as proper philosophy – and, for that matter, why philosophers should care about black aesthetics. The other question asks about the meaning of the "aesthetic" in "black aesthetics." The answers to these questions are intertwined, with each other and with a rich and varied history of cultural practice. For that reason, it is important to take a step back and consider what the traditions of black aesthetics have been and done.

I've defined "black aesthetics" as the practice of using art, criticism, or analysis to explore the role that expressive objects and practices play in creating and maintaining black life-worlds. It is important to distinguish between first-order and second-order versions of the black aesthetic enterprise. The first-order version emerged as soon as black people did – as soon as Africans and others began to seek and create beauty and meaning from within the cauldron of racial formation. The second-order version emerged some time later, when artists, critics, and other thinkers started to approach their expressive practices specifically from the standpoint of modern race-thinking. First-order work has gone on as long as black people have reflected on and revised things that *we* can look back on and recognize as black practices. Second-order work, by contrast, began within the last hundred and fifty years or so, when people began to think systematically about their practices *from a racialist perspective* – which is also to say, from a transnational and trans-ethnic perspective. (Modern races, whatever else they are, are not local populations.)

The distinction between first- and second-order enterprises allows us to distinguish also between practices and traditions, and to say that despite the longevity of black aesthetics as a set of practices, it emerged as a proper *tradition* only quite recently. Traditions have institutional conditions, including shared criteria for achievement or success, and canons of recognized achievement on which to build. Nothing like this materialized on a wide scale in black aesthetics until the 1920s or so, when the "New Negro" and Negritude movements emerged. At this point Africans on the continent and in the diaspora began to create networks of cooperative inquiry and

exchange, to find reliable support for these networks, and promulgate their work in journals and books. Even prior to this moment, though, there were important developments that we can plot against a backdrop of evolving ambitions. It may go without saying that this plotting will be idealized, incomplete, and highly provisional.[24]

Pre-modernity

As an empirical matter, there are continuities between black African and diasporal expressive practices, both at the level of cultural practice and at the level of philosophic orientation to the tasks of expression. And these continuities may well reach into medieval and ancient African cultures. That said, the idea of race in play here is an essentially modern idea: the idea that something called blackness could interestingly distinguish some people from others in multiple dimensions made little sense before the fifteenth century or so. So to ask about the role of pre-modern Africa in black aesthetics is to invite a great number of detailed, empirical answers about aesthetic and philosophic commitments and their persistence across space and time, none of which tell us anything yet about how to translate African norms into specifically *black* life-worlds. The imperatives of this cultural translation provide the occasion for philosophizing about black aesthetics in the idiom of critical race theory, which properly locates questions about ancient African cultures in the modern settings that seek to put these cultures to use. That is: there are philosophical questions to ask about the role of *the idea* of pre-modern Africa, construed either as the birthplace of classical African civilizations or as a site for savagery and barbarism. But these are questions not about ancient polities but about the development of *modern* racist or cultural nationalist ideologies.

Creolization

The first phase in the development of the black aesthetic tradition as a modern phenomenon begins with creolization, or the emergence of new cultural forms from the collision of preexisting traditions. This process occurred wherever racial formation processes changed the conditions of African life, and required people to make meaning and order their lives in pan-ethnic settings. The most familiar version of this process is the one that grew out of the transatlantic slave trade and that shaped the African-descended cultures that we find throughout the Americas. But Africans elsewhere, including on the continent, managed similar processes of cultural change and blending – though members of formally colonized communities typically had to do less of this than peoples who were uprooted and resettled.[25] In all these

settings, "heterogeneous crowds" of uprooted Africans made themselves into less heterogeneous (but still of course not homogeneous) communities by creating shared practices and expressive cultures.[26] The results of this process in the Americas come down to us in such familiar forms as the religious rituals of Vodun and Santeria, musical forms like rara and reggae, and the multimodal performances of capoeira. Like all practices, these creolizations occasioned ongoing reflection about guiding norms and values. We can confidently assume that they also occasioned some broader reflection on the cultural blending that was taking place – on its nature, on the conditions that required it, and on its value in adjusting to and altering the conditions.

Civilizationism

The second key development in the black aesthetic tradition saw the themes of racial vindication and Eurocentric civilizationism[27] added to the primary goal of cultural self-fashioning. At this stage, stretching more or less from the late eighteenth century to the late nineteenth, African-descended people used performances and aesthetic objects in European styles and settings not just to make meaning, but also to demonstrate to a skeptical world their capacity for culture and, hence, for civilization. Following in the footsteps of figures like Alexander Crummell, many people in this period uncritically accepted European ideas about African savagery, and were convinced that the benighted dark masses had to be "improved" – that is, *civilized* – by the better, more cultured, more "Europeanized" (or modern, or Christianized) members of the group. This period includes the poetry of Phyllis Wheatley (1753–1784); the speeches and writings of Frederick Douglass (1817–1895); the emergence of the slave narrative (from about 1760); and the worldwide travels of the Fisk Jubilee Singers (beginning in 1871).

Counter-modernity

By the end of the next stage of development, trans-ethnic and transnational traditions of black cultural work were fully in development, and civilizationist ideas were beginning, slowly, to retreat. We can call this the "counter-modern" stage, for a handful of reasons. The developments and figures in question fall within the chronological window usually reserved for artistic modernism, from roughly 1890 to 1940,[28] and often enjoyed sustained, mutually beneficial encounters with the techniques and canonical figures of mainstream modernism. In addition, the aspirations of the best known figures during this period were vitally concerned with helping black folks achieve the condition of modernity – "with removing the ... black population from ... poverty, illiteracy, and degradation" by, among other things, cultivating an urban,

western-educated bourgeoisie to stand alongside, or guide, or replace, the black peasant and villager.[29] At the same time, this black modernity was to be modernity with a difference — a *counter*-modernity infused with the distinctive "gifts" of black people, uncorrupted, as yet, by the alienating forces of the Eurocentric civilization that had excluded them for so long. And the black modernist pursuit of modernity was itself often at odds with mainstream modernism, which often used an image of the primitive, uncorrupted black person as an inspiration for rejecting the bourgeois, industrial society that many blacks sought to repair and join.

The New Negro and Negritude movements are the most prominent and historically influential instances of this stage. In a process that crystallized in the 1920s and 1930s, figures like Aimé and Suzanne Césaire, W. E. B. Du Bois, Zora Neale Hurston, and Alain Locke used art and criticism to cultivate new approaches to black identity, politics, and culture. These artists, activists, critics, and theorists had a great deal in common. They faced similar conditions, including the increasing virulence and ambitions of anti-black racism and the social ferment of the increasingly multicultural colonial metropoles. And they used similar resources, including Pan-African ideas, western educations, and, more systematically than ever before, the work of their peers and predecessors — including Locke's path-breaking anthology, *The New Negro*, and Du Bois's pioneering text, *The Souls of Black Folk*.[30]

These counter-modern thinkers shared three basic goals. First, they accepted the old goal of racial vindication: they believed expressive practices could demonstrate the humanity, and human excellence, of African peoples. This conviction moved such strange bedfellows as Du Bois and Garvey, who agreed on little else, to stage lavish spectacles — historical pageants for the one, massive pomp-filled marches for the other — to reveal the depth and richness of African personhood. Second, they tempered their civilizationist impulses and undertook to develop Africa's distinctive cultural "gift" to the world (though they typically imagined this project in European terms). And third, they called for a reorientation of African consciousness, to be effected by recognizing the value, coherence, and uniqueness of "negro" expressive culture. This exercise in consciousness-raising involved what later thinkers would call "decolonizing" African minds: rooting out the white supremacist assumptions that led black people themselves to think of themselves as ugly and of black practices as unworthy of attention.

The aesthetic forms of black counter-modernity that we now associate with Harlem and Paris were the dominant forms, but of course not the only ones. In addition to the versions, sources, and counterparts of these movements in Cuba, Haiti, and elsewhere in the diaspora, it is important to mention a distinctively feminist black aesthetic that emerged in the United States and spread its influence through the new media of audio recording and

transmission. While the black bourgeois pursuit of counter-modernity was driven by a politics of respectability, seeking (among other things) to disprove assumptions about black lasciviousness by counseling sexual temperance and feminine domesticity, blues singers like Bessie Smith and Gertrude "Ma" Rainey openly asserted their independence and embraced the demands of sexual desire. In doing so, they subordinated bourgeois values to values drawn from poor and working-class communities; they broke with the patriarchal conventions that pushed female culture workers, like Jessie Fauset and Paulette Nardal, into the background, behind the more celebrated men, like Du Bois and Césaire, with whom they worked; and they provided a model of black feminist assertiveness, self-possession, and autonomy that was in some ways ahead of its time.[31]

Decolonization

The fourth stage in the development of black aesthetics explicitly took up the task of cultural and psychological decolonization, in three basic ways. Fourth-wave black aestheticians completely broke with civilizationism, they collapsed the externally oriented goal of racial vindication entirely into the inner-directed goal of consciousness-raising, and they turned the commitment to expressive authenticity into a full-fledged cultural nationalist project, fueled by the same political and cultural currents that drove mid-twentieth-century liberation and anticolonial movements worldwide. This project found expression in the work of artists and critics like Amiri Baraka, Sonia Sanchez, and Addison Gayle in the United States, and of heads of state like Léopold Senghor (a third-wave holdover) in Senegal and Kwame Nkrumah in Ghana.

This is the point at which the tradition of black aesthetics becomes fully self-conscious, and takes the name that I've been using for it. People like Addison Gayle and Larry Neal insisted on the self-conscious creation of non-European or non-white aesthetic principles, authentically black principles that were meant to be more consonant with black practices. Hence these lines from writer Etheridge Knight: "Unless the Black artist establishes a 'Black aesthetic' he will have no future at all. To accept the white aesthetic is to accept and validate a society that will not allow him to live."[32] Hence also the best known refrain from this era, revalorizing black bodies with the words, "Black is Beautiful." And just as texts and figures from the counter-modern moment circulated through the black world of the 1920s and 1930s, products and figures from this moment circulated through different sites of struggle against white supremacy. Figures in South Africa's Black Consciousness Movement took inspiration from the counter-modern figures as well as from later figures like Nikki Giovanni and The Last Poets.[33] At the same time,

popular musical performers like Bob Marley, Miriam Makeba, and James Brown undertook quite public shifts toward greater black or Pan-African consciousness.

There was a concrete, institutional counterpart to the psychocultural decolonization that the fourth wave of black aestheticians called for. Liberation movements actually achieved some of their goals, with the result that black artists, analysts, and critics began to receive the attention, the positions, and the rewards that had previously been reserved, in western societies, principally for white people. As a result, one consequence of the political and cultural shifts that included the black aesthetics, Black Power, and anticolonial movements was the opening of elite institutional spaces to writers like Toni Morrison and Wole Soyinka, both Nobel laureates; to scholars like Henry Louis Gates and Valerie Smith, both ensconced at elite US institutions; and to curators like Thelma Golden and Okwui Enwezor, both charged in recent years with guiding some of the western artworld's most prestigious institutions and biennial exhibitions.[34]

Engendering and queering

In modern expressive culture as in modern politics, the imperatives of decolonization can easily get bound up with the imperatives of masculine self-aggrandizement. The twentieth-century struggle for black emancipation, whether waged by reformists or revolutionaries, remained for too many a struggle for black heterosexual manhood, with emancipation imagined as both condition and consequence of the black man assuming his rightful place at the head of the black family and/or nation. This patriarchal and phallocentric stunting of black liberatory aspirations notwithstanding, decolonization is, in part, a matter of uprooting the structures of "objectification and dehumanization" that inform and sustain the colonial and neo-colonial projects.[35] To the extent that hegemonic conceptions of sex and gender are among these structures, the convergence of nationalism and patriarchy thus indicates the incompleteness of the decolonizing project.

The next stage of the black aesthetic tradition stepped into the gendered, sexualized gap between the aspirations and the achievements of the decolonization effort. Figures like Morrison, Alice Walker, Toni Cade Bambara, Michele Wallace, Audre Lorde, Ntozake Shange, Howardena Pindell, and Bettye Saar were central to this stage in the United States, and achieved worldwide influence (Morrison and Walker, especially). These women produced art, literature, scholarship, and criticism that reclaimed the legacy of 1920s blues feminism, with its embrace of sexuality. They moved beyond the nineteenth century's "double-bind" argument about the dual impact of racism and sexism, to develop intersectional analyses of the mutually constitutive

relationships between race, gender, class, and sexuality. And they escaped the margins of the white feminist and male-dominated black liberation movements, to create alternate spaces for cultural work by black women.[36]

Poet-writer-essayist(-lesbian-mother-warrior, she would add) Audre Lorde is a crucial figure here, not just because she "made a significant contribution to the development of feminist theory," but also because one key to that contribution was the way she "actively resisted categorization" and "consistently challenged all definitions of identity."[37] She was in this way a progenitor of black queer theory, which combines queer theory's thoroughgoing repudiation of stable, discrete identity categories – beginning, historically and theoretically, with sex and gender – with an emphasis on the issues that arise from the racialization of some people as black. Artists and critics have been pivotal figures in this phase of the tradition, from reclaimed historical figures like Billie Holiday and Countee Cullen, to prescient forebears like James Baldwin, to recent figures like filmmakers Isaac Julien and Marlon Riggs, writer Cheryl Clarke, and critic/scholar Kobena Mercer.

Post-blackness

We might think of the latest stage in the history of black aesthetics as the slightly sanitized translation of the black feminist and queer moment into the commodified sphere of popular and "high" culture. The post-black moment, as curator Thelma Golden has inspired many to call it, is marked by the widespread sense that racial conditions have taken on novel configurations, and that old conceptions of a stable black identity cannot countenance or illuminate this novelty.[38] The most prominent of the older approaches to blackness – civilizationist, counter-modern, and nationalist – differed substantially, but usually began with assumptions about a stable black personality, culture, or subject. At this last stage, though, blackness ceases to be a foundation and becomes a question, an object of scrutiny, a provisional resource at best, and, for some, a burden. Skepticism of and suspicion about blackness, even among cultural analysts and workers most committed to it, did not originate during this period: Alain Locke's pluralism and Ralph Ellison's cosmopolitanism make this clear. And the flowering of black feminism and queer theory in the 1970s and 1980s helped prepare the way for this last stage by insisting on intersectional analyses. But during this period the suspicion becomes widespread, as does the sense that racial conditions have shifted in ways that call the fact of racial identification into question.

Along with Golden, other important architects of this moment include philosophers Kwame Anthony Appiah and Lewis Gordon, artist Kara Walker, and writer Trey Ellis. In a 1989 essay, Ellis signifies on and repudiates the previous era's call for a black aesthetic by describing the emergence of "an

open-ended *New* Black Aesthetic ... that shamelessly borrows and reassembles across both race and class lines."[39] As Ellis's "shameless borrowing" suggests, the thinkers in this period chafe at the constraints of the Black Arts Movement's narrow nationalism, and seek an approach to expressive culture that reflects their experiences of a world in which racial boundaries are blurry, racial hierarchies have been (to some degree) subverted, and single-minded forms of racial politics seem to have run out of steam. For post-black thinkers, nationalist ideas about cultural self-determination and about a unique African personality have been supplanted by individualist and often apolitical aspirations, and by appeals to intra-racial diversity and interracial commonalities (that is to say, by appeals to the fact that races comprise people who differ with respect to the other axes of social differentiation, and that these people are as a consequence interestingly connected to members of other races). Instead of aiming to vindicate black humanity or to express African ideals authentically, post-black aesthetics treats blackness not as its source but as its subject.

5 Black Aesthetics as/and Philosophy

The previous section introduced the idea of a black aesthetic tradition by providing a quick survey of some relevant history. A striking feature of this history is that academic philosophy has played almost no role in it. Better put: the figures whose work informs the practice of academic philosophy have, as individuals, played almost no role, which is to say that they have not been personally engaged in the projects that drive this history. John Dewey's work indirectly underwrote a great deal of the cultural work of the interwar black radical tradition in the United States, and some of the Harlem Renaissance. In a similar way, work in the Marxian tradition underwrote much of the Black Arts Movement and the cultural dimensions of various revolutionary nationalisms. But this had little to do with the interests and activities of practicing professional philosophers. People have been doing black aesthetics, in one way or another, since black people came into being. But for the overwhelming bulk of this time, black aesthetics and traditional western philosophy have either been indifferent or hostile to each other, the lonely efforts of the small black philosophical professoriate before the late twentieth century notwithstanding.[40]

Pointing to the distance between the traditions of philosophy and of black aesthetics helps to clarify the stakes behind the remaining questions for my project. Why – apart from my own needs as a thinker – bother offering a *philosophy* of black aesthetics? And in what sense is the project about aesthetics at all?

Philosophy and the black aesthetic

In addition to its role in a project of retroactive self-provisioning, this study can provide some benefit to the traditions that it aspires to bring together. The benefits to black aesthetics may be more elusive than the benefits to philosophy, since that tradition – as evidenced in the work of people like Fred Moten, Michele Wallace, and Houston Baker – has had fewer qualms about entering into conversation with the western philosophical canon. One benefit might derive from contemporary philosophy's familiar posturing about clarity. As recent work on Frederick Douglass, Anna Julia Cooper, T. Thomas Fortune, Ida B. Wells, and others has shown, philosophy can help us make sense of what goes on, and what's at stake, in the misleadingly familiar arguments of canonical black thinkers. So if nothing else, perhaps this book can clear away some underbrush around key notions like "black" and "aesthetics," as well as around the notions that endeavor to knit those two together, like "identity," "appropriation," and "invisibility." And in doing this perhaps it can shrink the distance that seems to stretch between these two traditions, and help create new spaces for intellectual exchange and professional collaboration.

The benefits of this sort of intellectual bridgework for philosophy are somewhat clearer. One consideration is that philosophy is its context comprehended in thought, and that the philosophical contexts in which many of us find ourselves have yet to develop a vocabulary for the important and influential aspect of western culture that people like Baraka and Morrison represent. To put the point differently: academic philosophy has not yet fully come to terms with the diversity of the communities it seeks to serve and understand, though it is doing better. To put the point still differently, and more cynically than I mean it: as an academic discipline in the age of corporatization and declining state support for higher education, philosophers need all the constituents and allies we can get. Learning to talk responsibly about, say, Sun Ra and ring shouts can only help get us more, and more diverse, students, and better alliances across disciplines and units. (Something like this might also be a motivation for outreach by aestheticians in black studies, whose programs and departments are too often under attack or under-resourced.)

A more important consideration emerges from a moment's reflection on the way race works. As we saw above, race-thinking has to do with assigning meaning to human bodies and bloodlines – call this "racialization." In the mode of racialization most relevant to this book, to have dark skin, tightly curled hair, and full lips, or to be descended from people who look like that, or from a place full of people who look like that, is to have certain claims more likely to be true of you. Nineteenth-century westerners thought that

the relevant claims had to do with moral worth and capacity for civilization. Now we know that the widespread assent to nineteenth-century racialism instantiated the truth conditions for other kinds of racial claims, claims having to do with the vulnerability to state surveillance and police brutality, with relative stores of net financial assets, with proximity of domicile to environmental hazards, and so on.

The assignments of meaning that constitute racialization are often bound up with aesthetic phenomena, in a variety of ways involving both mediated and immediate experience. I call this "the race–aesthetics nexus," and take inspiration for the idea in this passage from Monique Roelofs:

> Racial formations are aesthetic phenomena and aesthetic practices are racialized structures. A theory of the nature of race and racism ... must address the place of the aesthetic in processes of racialization. Correlatively, a theory of the aesthetic as a philosophical category ... must account for the ways in which structures of aesthetic exchange channel racial passions and perceptions.[41]

To say that aesthetic practices in the modern West are racialized structures – to speak, as Roelofs does, of racialized aestheticization – is to highlight the role of race-thinking in shaping the boundaries and trajectories of these practices. This shaping occurs, very broadly speaking, on two levels. First, it shapes the exclusions and openings that define individual relationships to opportunity structures. In the grip of an idea like this, Du Bois worries about the color bar keeping African American sculptors in his time from undertaking formal study; the dancers in The Urban Bush Women point out that the training mechanisms of European classical dance, obsessed with hegemonic visions of white femininity, systematically weed out women with bodies like theirs; art historian Sidney Kasfir reveals that deeply ingrained ideas about "the Dark Continent" lead curators and collectors to prefer old, putatively anonymous "tribal" art to the work of contemporary African artists;[42] and director Robert Townsend launches his career with a caustically funny complaint about the limited roles available to blacks in Hollywood. (This has of course changed, to some degree, though more for men than for women. We will return to this.)

In addition, though, aesthetics gets racialized not just at the level of managing access to specific practices, but also at the level of imagining the structure, meaning, and content of the human endeavors that the practices constitute. The ideas of race and of the aesthetic came into being more or less together, along with modern ideas of humanity and civilization; and all of these ideas implicated each other in deep ways.[43] We see this at work in each component of "the modern system of the arts." The primitivism of modern painting, the orientalism of nineteenth-century opera, the uses of literature

and literacy in modern nation-building projects, and the conscription of Greek sculpture and of the burgeoning technologies of photography into the projects of white supremacist racial anthropometry all show the concepts of race, of art, and of modern civilization getting worked out together. Aesthetics as such, Roelofs wants to say (echoing Clyde Taylor[44] and others), is itself a kind of racial project.

In addition to claiming that aesthetic practices are racialized structures, Roelofs claims also that racial formations are aesthetic phenomena. In this spirit she introduces the idea of aesthetic racialization, in order to insist on the role of embodiment and aesthetic stylization in the processes of racial formation. We see one aspect of this aesthetic racialization in the ideological functioning of racial meaning-assignments. I invoke "ideology" here in the Althusserian sense, to say that race belongs to the manifold of social reality, and helps structure our experience, our immediate experience, of the world. Often enough, we directly perceive racial phenomena: we just see race, the way we see just see home runs and rude gestures. Because of this, the differential modes of treatment that mark the boundaries between racial populations can be reliably underwritten by aesthetic perceptions – by the affectively and symbolically loaded workings of immediate experience. Black people *look* dangerous, or unreliable, or like bad credit risks, which is why studies keep showing, for example, that similarly situated – identically situated – black and white job-seekers or apartment hunters (or loan applicants, or, or) will have rather different experiences in their respective markets. (Some would argue that this is also why an unarmed Amadou Diallo seemed dangerous enough to warrant forty-two bullets from the NYPD in 1999, and why, more recently, an unarmed Trayvon Martin seemed so out of place to his killer, and why, even more recently, Eric Garner and Michael Brown seemed to their killers, and to the citizens charged with reviewing the circumstances of their deaths, somehow impervious to, and therefore permissibly available for, the exercise of lethal violence.)

A second dimension of aesthetic racialization becomes evident in the work of Saidiya Hartman, who insists on the importance of performance and performativity.[45] To fashion and inhabit a racial identity is to undertake a kind of performance, and to create by dint of that performance an identity that would otherwise not exist. This effective enactment of blackness can unfold by appeal to certain self-consciously expressive styles, and can provide the kind of enjoyment that can attend any successful performance. Think here of the way in which people of all races, all over the world, link blackness to a particular hip-hop aesthetic. (I think in particular of Joe Wood's essay on Japanese blackfacers, from the late 1990s.)[46]

The race–aesthetics nexus, with its various manifestations and implications, points to the key reason for linking black aesthetics and philosophy. Race,

racism, and blackness have become thriving areas of philosophical inquiry, and the study of these fields is incomplete without an account of the robust links between aesthetic practice, aesthetic ideologies, and racial formation processes. A study of black aesthetics will not exhaust those inquiries, not least because racialization comes in modes other than the ones that eventuate in blackness. But it will provide a starting point, one that will benefit from the substantial inroads into philosophy made by Africana philosophy, and from the long experience with black expressive culture in other fields of inquiry.

What is the "aesthetic" in "black aesthetics"?

If professional philosophy has done its work at a sufficient distance from black aesthetics to require reassuring words at the outset of this project, the position of specifically philosophical aesthetics is even worse. The discussions of art and expressive culture that have unfolded in places like the *British Journal of Aesthetics* and the *Journal of Aesthetics and Art Criticism* since 1950 or so have focused on questions that are difficult even to motivate from the perspectives adopted by the central approaches to black aesthetics. Where philosophers tried to define "art" and domesticate its ontology, black aestheticians argued that the concept of art was an expression of western parochialism, and that African cultures tended not to lock creative expression away in museums, concert halls, and galleries, separated from the rest of life. Where philosophers interrogated the basic structures of aesthetic judgment and criticism, black aestheticians pointed out that appeals to generically human capacities for judgment are often in fact appeals to particularistic prejudices based on some specific and contingent set of cultural practices. People on both sides of this divide have of course explored many questions other than the very broad ones indicated here. But the basic point remains apt, and is simply a refinement of the broader point about philosophy that we saw above: black aestheticians and philosophical aestheticians have done their work, for the last several decades at least, at some remove from each other.

In light of this additional distance between philosophy and the relevant black intellectual traditions, it is important to be clear about how the idea of the aesthetic functions in this study. We might begin by borrowing a model from ethical theory and distinguishing descriptive, normative, and meta-theoretical approaches to aesthetics. Descriptive aesthetics is what anthropologists, art historians, and others do when they report that some particular set of norms regulates the production, reception, and evaluation of expressive objects. Normative aesthetics is what people like Henry Louis Gates and Samuel Floyd do when they *prescribe* sets of principles for understanding and evaluating expressive objects.[47] And aesthetic theory is what we do when we ask deeper questions about the status or meaning of the concepts employed in

aesthetic inquiry – questions like "What is art?" and "Are judgments of human beauty really about beauty, or are they about something else?"

The role of descriptive and normative work in black aesthetics should be clear. For an example of descriptive approaches we can look to contemporary students of African art, who work diligently to get very clear on the precise nature of the aesthetic practices in particular settings, and on the norms and conventions that govern those practices. This is a vital counterweight to generations of commentary that sees an undifferentiated racial spirit at work behind the art. For an example of normative inquiry, we can look to writers in the US Black Arts Movement, who argued vehemently for a Copernican revolution in normative aesthetics, and insisted that the work of black poets should not be evaluated by appeal to the norms of the New Critics.

The relationship between mainstream aesthetic theory and black aesthetics may be less clear, but two possibilities have recommended themselves to me. The first is a kind of comparative meta-aesthetics. The other is a kind of immediatist phenomenology of aesthetic experience. This study will rely here and there on views about descriptive and normative issues, but it will do the bulk of its work in the theoretical register.

The comparative approach takes its cues from the tradition that equates aesthetic inquiry with the philosophy of art. From this perspective, we can bring new resources to bear on the familiar questions of mainstream analytic aesthetics. One might ask about the ontology of art in light of the fact that many cultures in Africa and elsewhere decline to distinguish rigidly between what we think of as separate disciplines, like the performance of poetry, storytelling, or music-making.[48] Or one could give the old question "What is literature?" new life by subjecting the question itself to genealogical scrutiny in light of racialized assumptions about the relationship between literacy, literature, modernity, and civilization.[49] This study will adopt the comparative approach mainly by exploring the way familiar mainstream aesthetic concepts function in studies of black expressive culture. This will yield discussions of authenticity, beauty, and ethical criticism, among other things.

A second possibility for using philosophy to inform the "aesthetic" in "black aesthetics" builds on the appeal to immediate experience, introduced above in the discussion of the race–aesthetics nexus. Where the comparative approach considers the questions of mainstream analytic aesthetics in light of data gleaned from "black" contexts, the immediatist approach asks the kinds of questions we find in continental traditions of ideology critique and in continental and American naturalist traditions of phenomenological inquiry. Arthur Danto and John Dewey provide me with the starting points for this sort of inquiry in their germinal reflections, offered many decades apart, on new directions for aesthetic inquiry (drawing on old arguments that we can trace back to Baumgarten and Kant).[50]

Dewey famously argues that experience has what he calls "aesthetic quality." He means here to denote the felt sense of connection and wholeness that registers the fashioning of a proper experience out of the fugitive elements of our encounters with the world. Through pragmatic and interpretive processes of inquiry, agents assign meanings to the phenomena they encounter, and these interpretations order the world in a way that renders it intelligible and navigable. When an interpretation "fits," we feel a sense of its appropriateness and of the harmony of its elements – think of the "ah-ha" moment that one experiences upon finally seeing the solution to a mathematical problem. The point of all this for Dewey is to track aesthetic experience to its phenomenological roots, and to use this deeper vantage point to reframe – and, to some degree, to deflate – the study of art.

Arthur Danto echoes this turn to experience when he invites philosophers to accept that "aesthetics ... penetrates our experience of the world to such a degree ... that we cannot seriously address cognition without reference to it."[51] He has in mind the way that aesthetic considerations shape the way we see, represent, and understand the world, as exemplified, in Danto's piece, by the stylized and semantically rich images produced by early modern scientific illustrators. Danto provides a remarkable critical reading of illustrations by Leeuwenhoek and others, but he could as easily have chosen more mundane examples. Consider, for example, the studies suggesting that people systematically benefit from being attractive: handsome teachers get better evaluations, pretty lawyers make partner sooner, and so on. This happens not because the relevant authorities are trying to curry favor, but because they unconsciously respond to surface features that have no intrinsic bearing on the attributes that are putatively being assessed.[52] This phenomenon, sometimes called "sensory transference," is not limited to human encounters. It is in fact well known and widely relied upon by market researchers, who use focus groups to determine, for example, which stylized containers will "improve" the taste of their beverages. This cognitive overreaction to superficial traits is relevant to Danto's project because it dovetails with his broader agenda. Where Dewey wants to return the study of aesthetics to its roots in experience, Danto wants to link aesthetics to other ways of studying experience – to complement epistemology and the philosophy of mind by enriching their accounts of human cognition.

Dewey and Danto are interested, in slightly different ways, in the aesthetic dimensions of what is sometimes called "rapid cognition." It is a truism that concepts streamline our journeys through the world, helping to reduce the dynamic flux of experience. It is less commonly recognized that immediate judgments about which concepts to apply, and when to apply them, enable even further streamlining. This process has at least four

features that we routinely associate with more narrowly aesthetic judgments. First, rapid cognitions unfold swiftly and intuitively, without recourse to consciously managed processes of reflection. Second, the judging agent is often unable to account for the judgments that he or she makes, and has to work to find words for them. Third, the judgments register certain immediately recognized constellations of meaning, each of which can be as directly meaningful and affectively charged as a work of art, ritual artifact, cultural symbol, or other expressive object. And fourth, the constellations of meaning are sometimes informed by sedimented commitments to principles of aesthetic merit, as in the case of lookism.

The relevance of immediatist phenomenology – or *aesthesis* – to black aesthetics should be apparent. We saw above that race is an aesthetic phenomenon, which means in part that immediate and affectively loaded perceptions help racial formation processes do their work. Danto and Dewey remind us that interrogating these aesthetic experiences, that scrutinizing their conditions and consequences, might be part of the work of aesthetics. This interrogation is all the more valuable in racialized contexts. If the perception that a thing is superficially beautiful or ugly can prompt immediate, unexcavated judgments about that thing's deeper traits; if, in the case of humans, judgments about surface beauty have for several centuries been indexed to ideas about physiognomically distinct human types; if these racialized judgments of beauty feel immediately to "fit" in ways that immunize them from critical introspection; and, finally, if this fittingness holds the key to the distribution of social goods up to and including the ability to survive routine encounters with the state; if all of that is right, then understanding aesthetic racialization is an indispensable step toward understanding what Frantz Fanon calls "the fact of blackness."

6 Conclusion

The burden of this chapter has been to explain the basic parameters of this study, and to circumscribe the topic. I've explained that as I'll use the expression, following Hall, Powell, and Gramsci, to do "black aesthetics" is to use art, criticism, or analysis to explore the role that expressive objects and practices play in the creation and maintenance of black lifeworlds. The appeal to blackness in "black aesthetics" gets its content from the sorts of insights that racial formation theory marshals and mobilizes, and that Du Bois channels with his line about the Jim Crow car. The appeal to aesthetics gets cashed out by appeal to two forms of meta-theoretical inquiry, one extending more or less traditional questions in art theory

into untraditional domains, and the other using the insights of immediatist phenomenology to motivate deep interpretation and criticism of our habitual aesthetic judgments. And all of this is a fit subject for philosophy for several reasons, the most banal of which is that black aesthetics and philosophy are both social practices that are driven by their participants, and some of their participants, like me, are interested in ring shouts as well as in Twin-Earth arguments (though in one of these much more than in the other).

It should now be clear just how enormous a field of inquiry black aesthetics represents. There are many things one might do under this heading that I will not do. I will not examine any empirical claims about the precise degree to which some diasporic practice is indebted to its African sources. I will not provide a state of the art guide to any "black" practices, say, to explain which hip-hop artists are worth attending to now and which should be ignored for the good of the tradition or of our children. And I will not provide close critical readings of any particular aesthetic objects. This is an exercise in theory, not in criticism or curating, and its burden henceforth will be to identify the themes that organize some of the problem-spaces in the black aesthetic tradition. My organizing thought, borrowed from Hall and Powell, is that the recurring interrogation of these themes across time and space gives black aesthetics whatever unity it has, and all the unity it can responsibly aspire to have.

The chapters to come will consider the following themes, and examine the registers of inquiry, reflection, and argument that have grown up around them.

1. The relationship between visibility, invisibility, and recognition.
2. The burdens and limits of ethicopolitical criticism.
3. The seductions of authenticity and complications of mobility.
4. The complexities of somatic aesthetics in anti-black contexts.
5. The meaning of black music for the body and the soul.
6. The dialectic of aversion and attraction in contexts of interracial exchange.

These themes provide only a partial window onto the tradition of black aesthetics. They are a provisional point of entry, not an exhaustive list of philosophic problems. A different selection and arrangement of themes could do the work that I mean to do here, and could perhaps do it while teasing out issues that I leave underdeveloped. My hope is that this selection and arrangement successfully reveals to the reader the basic shape and most prominent elements of black aesthetics as a philosophic phenomenon. Once that's done, the rest is a matter for the detail work of more specialized study.

Notes

1 Sidney Mintz and Richard Price, *The Birth of African American Culture* (Boston: Beacon, 1976), citing John Gabriel Stedman, *The Journal of John Gabriel Stedman, 1744–1797, Soldier and Author, Including an Authentic Account of his Expedition to Surinam, in 1772*, ed. Stanbury Thompson (London: Mitre Press, 1962). "All the Slaves are led upon deck … their hair shaved in different figures of Stars. half-moons, &c. / which they generally do the one to the other (having no Razors) by the help of a broken bottle and without Soap" (48). The authors comment: "It is hard to imagine a more impressive example of irrepressible cultural vitality than this image of slaves decorating one another's hair in the midst of one of the most dehumanizing experiences in all of history" (48).

2 Stuart Hall, "Assembling the 80s – The Deluge and After," in David A. Bailey, Ian Baucom, and Sonia Boyce, eds., *Shades of Black* (Durham, NC: Duke University Press, 2005), 1.

3 Hall 4.

4 Hall 4.

5 As Hall uses it, "articulation" is a double-barreled term, denoting both a process of clarifying production – like articulating a statement – and a structure with linked but semi-independent elements – like an articulated bus. This is a Marxian version of an idea that we can find in many post-Enlightenment traditions, from romanticism to Hegelianism and pragmatism, though it registers in these other traditions under other descriptions.

6 Hall 4.

7 Hall 4.

8 Hall 4. He goes on to say that his subject – the 1980s – represents a conjunctural *shift*, a point at which the problematic that defined black art could be seen to "fracture decisively." Here I will part company with him, as I am less interested, for now, in the fractures than in coherence, and in depicting this coherence philosophically.

9 Tommie Shelby, *We Who Are Dark* (Cambridge, MA: Harvard University Press, 2005).

10 Richard J. Powell, *Black Art: A Cultural History*, 2nd ed. (New York: Thames and Hudson, 2003), 15.

11 Glenn Ligon, *Some Changes* (Toronto: The Power Plant, 2009).

12 See Addison Gayle, ed., *The Black Aesthetic* (New York: Anchor-Doubleday, 1971); Houston A. Baker, *Afro-American Poetics: Revisions of Harlem and the Black Aesthetic* (Madison: University of Wisconsin Press, 1988); James Smethurst, *The Black Arts Movement: Literary Nationalism in the 1960s and 1970s* (Chapel Hill: University of North Carolina Press, 2005).

13 To the extent that this book offers an argument in race theory, it draws heavily on an account that I work out in more detail elsewhere. See Paul C. Taylor, *Race: A Philosophical Introduction*, 2nd ed. (Cambridge: Polity, 2013), especially Chapters 1–3.

14 W. E. B. Du Bois, *Dusk of Dawn: Autobiography of a Race Concept* (1940; New York: Transaction, 1982), 153.

15 This is a slightly non-standard usage of "racialism," based on a principled objection to the standard approach championed by Appiah, Mallon, and others. For details on this objection see Paul C. Taylor, "Introduction," *The Philosophy of Race (Critical Concepts in Philosophy)* (New York: Routledge, 2011).

16 On this approach to the idea of racialism, and the distinction between its classical and critical forms, see Taylor, *Race* 11, 38, 72.

17 I discuss the emerging consensus in philosophical race theory in slightly more detail at Taylor, *Race* 87–88, drawing on Ron Mallon, "'Race': Normative, Not Metaphysical or Semantic," *Ethics* 116:3 (2006), 525–551; and Larry Blum, "Racialized Groups: The Socio-Historical Consensus," *Monist* 93:2 (2010), 298–320.

18 See Dilip Parameshwar Gaonkar, *Alternative Modernities* (Durham, NC: Duke University Press, 2001). The account here is heavily informed by Stuart Hall, David Held, Don Hubert, and Kenneth Thompson, eds., *Modernity: An Introduction to Modern Societies* (Cambridge, MA: Blackwell, 1997).

19 David Theo Goldberg, *Racist Culture: Philosophy and the Politics of Meaning* (Cambridge, MA: Blackwell, 1993), 81.

20 Goldberg 82.

21 Goldberg 82.

22 Goldberg 81.

23 See Quayshawn Spencer, "A Radical Solution to the Race Problem," *Philosophy of Science* 81:5 (2014), 1025–1038; Ron Mallon, "Passing, Traveling and Reality: Social Constructionism and the Metaphysics of Race," *Noûs* 38:4 (2004), 644–673.

24 The attempt to break history into periods requires idealization and, to some degree, distortion. Three forms of distortion are worth mentioning at the outset. First, I will say little about the years of reaction that the key moments below spawned, or about the numerous interracial connections that enabled and enriched much of this history. Second, the story I'll tell takes place against the backdrop of monumental political and economic changes, from imperial warfare through cold wars to terror wars, from mercantilist globalization through struggles over industrial democracy to post-industrial globalization. All of this must be kept in mind, but for now also kept in the background, for reasons of space. And third: agency and resistance are ever-present, though not omnipresent, features of the history to follow. Black peoples brought themselves into being, albeit under the pressures of white supremacy. They were not the passive creations of others, and their agency was at points in every stage devoted to the project of emancipatory struggle. Having thus registered the centrality of the fight for justice to this history, I will not insist on it in the text.

25 K. Anthony Appiah, *In My Father's House* (New York: Oxford University Press, 1993), 7–9.

26 Mintz and Price 18.

27 I have borrowed this term from Wilson Moses, who uses it to indicate a commitment to the idea that social progress requires development along a path "that replicates, or at least resembles, the history of Western Europe." Wilson Moses, *The Golden Age of Black Nationalism: 1850–1925* (New York: Oxford University Press, 1988), 229.

28 Raymond Williams, "When was Modernism?" *New Left Review* 175 (1989), 48–52, 48–49.

29 Baker 4.

30 On the transnational connections between the Paris intellectuals and the New Yorkers, see Eileen Julien, "Négritude," in Colin A. Palmer, ed., *Encyclopedia of African-American Culture and History*, vol. 4, 2nd ed. (Detroit: Macmillan Reference USA, 2006), 1633–1635; and T. Denean Sharpley-Whiting, *Negritude Women* (Minneapolis: University of Minnesota Press, 2002).

31 On the overlooked contributions of the "Negritude women," see Sharpley-Whiting. On the "blues feminism" of the 1920s singers, see Angela Davis, *Blues Legacies and Black Feminism* (New York: Knopf, Doubleday, 2011).

32 Elsa Honig Fine, "Mainstream, Blackstream and the Black Art Movement," *Art Journal* 30:4 (1971), 374–375, 374.

33 Mphutlane wa Bofelo, "The Influences and Representations of Biko and Black Consciousness in Poetry in Apartheid and Postapartheid South Africa / Azania," in Andile Mngxitama, Amanda Alexander, and Nigel C. Gibson, eds., *Biko Lives!* (New York: Palgrave Macmillan, 2008), 191–212, 193.

34 Enwezor curated Documenta 11 (2002) and Seville 2006, while Golden heads the Studio Museum of Harlem and was on the curatorial team for the 1993 Whitney Biennial.

35 M. Jacqui Alexander and Chandra Talpade Mohanty, "Introduction: Genealogies, Legacies, Movements," in M. Jacqui Alexander and Chandra Talpade Mohanty, eds., *Feminist Genealogies, Colonial Legacies, Democratic Futures* (New York: Routledge, 1997), xiii–xlii, xxviii.

36 Perhaps the best known emblem of this moment is Aretha Franklin's cover of Otis Redding's "Respect," which turned it into an anthem of female sexual assertiveness. At around the same time, Franklin would release an album of traditional black Christian music – with a picture of herself in African garb on the cover.

37 Cherise A. Pollard, "Lorde, Audre 1934–1992," in Fedwa Malti-Douglas, ed., *Encyclopedia of Sex and Gender*, vol. 3 (Detroit: Macmillan Reference USA, 2007), 907–909, 908–909. Gale Virtual Reference Library, Gale, Temple University, http://libproxy.temple.edu:2284/ps/start.do?p=GVRL&u=temple_main (accessed July 19, 2009).

38 Thelma Golden, "Introduction," in Christine Kim and Franklin Sirmans, eds., *Freestyle* (New York: Studio Museum of Harlem, 2001), 14–15, 14.

39 Trey Ellis, "The New Black Aesthetic," *Callaloo* 38 (1989), 233–243, 234.

40 There is a story to tell about the difficult relationship between philosophy and its "underrepresented populations." People like Lou Outlaw, Susan Bordo, Kathryn Gines, and John McClendon have told and are telling this story more effectively than I ever could.

41 Monique Roelofs, "Racialization as an Aesthetic Production," in GeorgeYancy, ed., *White on White / Black on Black* (Lanham, MD: Rowman and Littlefield, 2005), 83–124, 83.

42 Susan Bordo, *UnbearableWeight* (Berkeley: University of California Press, 2004); Janell Hobson, "The Batty Politic," *Hypatia* 18:4 (2003), 87–105; Sidney Kasfir, "African Art and Authenticity," in Olu Oguibe and Okwui Enwezor, eds., *Reading the Contemporary* (Cambridge, MA: MIT Press, 2000).

43 Roelofs 83.

44 Clyde R.Taylor, *The Mask of Art: Breaking the Aesthetic Contract* (Bloomington and Indianapolis: Indiana University Press, 1998).

45 Saidiya Hartman, *Scenes of Subjection:Terror, Slavery, and Self-Making in Nineteenth-Century America* (NewYork: Oxford University Press, 1997).

46 Joe Wood, "TheYellow Negro," *Transition* 73 (1997), 40–66.

47 Henry Louis Gates, *The Signifying Monkey: A Theory of Afro-American Literary Criticism* (New York: Oxford University Press, 1988); Samuel A. Floyd, *The Power of Black Music: Interpreting Its History from Africa to the United States* (New York: Oxford University Press, 1995).

48 Kofi Agawu, "Aesthetic Inquiry and the Music of Africa," in KwasiWiredu, ed., *A Companion to African Philosophy* (Cambridge, MA: Blackwell, 2005), 404–414.

49 Ngugi wa Thiong'o, *Decolonising the Mind: The Politics of Language in African Literature* (Nairobi, Kenya: Heinemann, 1986).

50 Think here of Baumgarten's identification of aesthetics with the study of sensuous cognition, and of what this becomes in Kant's hands. In the Transcendental Aesthetic section of the First Critique, Kant explores "the doctrine of sensibility," the point of which is to discover the forms of sensible intuition by means of which knowledge "is in immediate relation" to objects. *Immanuel Kant's Critique of Pure Reason*, trans. Norman Kemp Smith (New York: St. Martin's Press, Macmillan, 1929), 65–67, 65 (A21–22/B35–36).

51 Arthur Danto, "A Future for Aesthetics," *Journal of Aesthetics and Art Criticism* 51:2 (1993), 271–277, 275.

52 Gabriela Montell, "Do Good Looks Equal Good Evaluations?" *The Chronicle of Higher Education*, Wednesday, October 15, 2003, http://chronicle.com/jobs/2003/10/2003101501c.htm (accessed May 23, 2007); Kate Lorenz, "Do Pretty People Earn More?" Monday, July 11, 2005, http://www.cnn.com/2005/US/Careers/07/08/looks/ (accessed May 25, 2007).

2
No Negroes in Connecticut: Seers, Seen

HARTFORD, CONNECTICUT, 1957

EXT. WHITAKER HOUSE - DUSK

Music accompanies a slow and stately ascent upon
the Whitaker house, trimmed with cars and bursting
from inside with the exuberance of the annual
company party. We can even hear the distant clamor
of merriment and laughter churning from within.

INT. LIVING ROOM - DUSK

The house, impeccably decorated, is swarming with
[white] people in evening dress, drinking, smoking,
chatting, laughing. An overstuffed Christmas tree
glistens in the corner as an endless parade of hors
d'oeuvres are passed solemnly by the all-black,
formally uniformed, serving staff.

We see various faces from the Magnatech office,
including Marlene. Cathy [Whitaker] is listening
to a [white] middle-aged elderly woman.

 ELDERLY WOMAN
 ... Not to say that I'm against
 integration mind you. I do

Black is Beautiful: A Philosophy of Black Aesthetics, First Edition. Paul C. Taylor.
© 2016 Paul C. Taylor. Published 2016 by John Wiley & Sons, Ltd.

```
                believe it's the Christian thing
                to do. But I still say what
                happened in Little Rock could
                just as easily have happened
                here in Hartford.

A stout, red-faced man answers.

                     RED-FACED MAN
                Nonsense!

                     ELDERLY WOMAN
                And why is that?

                     RED-FACED MAN
                Well for one thing, there's no Governor
                Faubus in Connecticut. But the main
                reason - There're no Negroes!
                     (laughs)

Two of the serving staff close enough to have heard
his remark continue serving.¹
```

1 Introduction

An obvious place to begin a discussion of black aesthetics is with the problem of black invisibility. And an obvious way to approach that problem is through the writing of Ralph Ellison, whose work has inspired half of the title of this chapter. I'll come to Ellison soon enough, or perhaps not soon enough, given the enormity of his role in highlighting the problem of invisibility. I've started instead with an excerpt from Todd Haynes's award-winning film, *Far From Heaven*, for a couple of reasons. The first reason is that the film is more recent, and does not have to be recovered from the indifference and assumed familiarity that comes from decades of high school book reports. The second and more important reason has to do with the remarkable combination of eloquence and efficiency with which Haynes captures the paradoxes that attend the racialized drama of the seer and the seen.

The scene captures different aspects of invisibility in its written and cinematic forms. Both forms lay bare the willfulness of racialized misperception, the refusal to see what is manifestly and indispensably present. The film invites us to focus on what an "invisible" black man sees, as he is

not only within earshot, as the screenplay indicates, but is also looking directly at the red-faced man. The black man's visible disdain, and the red-faced man's indifference to it, deepens the film's engagement with the transactions of racialized sight. The screenplay, by contrast, undercuts its own profound awareness of racial dynamics, but in doing so reveals even more about the workings of invisibility. The text identifies the black characters by their race, while leaving the white characters racially unmarked. Whiteness becomes invisible, while blackness becomes hyper-visible, even as the complex personalities of individual black people disappear from view.

Far From Heaven is not a black film in any straightforward sense – a fact that we will return to in due course. But it does highlight the basic structure of the problem of black invisibility, as that problem figures in the black aesthetic tradition. That structure has to do with race-related disregard, and with attending to, or disavowing, the evidence of the senses. It has to do with organizing and acting on this evidence in ways that shape the prospects for individual experience, social transactions, and power relations. The "negroes" at the party enter the man's visual field, and he orients himself to them practically – to keep from running into them, for example, and to invite them to refresh his drinks. But he has no regard for them, and manifests this disregard by ignoring their presence and denying their very existence.

Understanding racial invisibility in this way – as a matter of multi-level racial disregard – points beyond the study of perceptual and visual experience, and of aesthetics, to broader issues in social theory and ethics. These issues have to do, for example, with theorizing and responding to racism, and with imagining and establishing social justice. But the phenomena that raise these broader issues are intimately tied to the social conditions and consequences of aesthetic experience. This is especially true of racial phenomena, which are tightly bound up with perception, visibility, and, as I will soon say, visuality. Black aestheticians have long been aware of the connections between ethics, sociality, perception, and aesthesis, and have explored them using many forms of expression, criticism, and analysis. They have been particularly keen to criticize anti-black modes of perception, to expose the archives of stock images and tropes that inform anti-black expression and perception, and to provide alternative archives and perceptual templates. This work has not only elaborated the themes that organize the problem-space of black invisibility; it has also made room for and modeled a mode of inquiry that pivots readily from phenomenological reflection to critical engagement.

The central aim of this chapter will be to show that the tradition of reflecting on black invisibility provides the resources for identifying and working through a particular kind of problem case. The cases I have in mind have to do with race-specific casting decisions in film and theatre, and will be exemplified here by the recent controversy over the casting of the Nina Simone biopic. On the way to assembling the resources for working through this case, the chapter will introduce some of the figures that have defined the problem-space of black invisibility, explore some of the approaches and artifacts these figures have produced, and tease out some of the philosophical issues they have explored.

2 Setting the Stage: Blacking Up Zoe

In the fall of 2012, fans of musician and civil rights activist Nina Simone received what many of them regarded as extremely unwelcome news. An actress named Zoe Saldana, best known for her roles in the rebooted *Star Trek* franchise and in shoot-em-ups like *Colombiana* and *The Losers*, and for lending her voice to the love interest in James Cameron's film *Avatar*, had been cast as the "High Priestess of Soul."[2] This was unwelcome news because, as one of the bloggers who stoked the fires of protest put it, casting Saldana seemed to involve "the erasure of Nina Simone's image."[3]

The thought that giving Ms. Saldana this role would lead to Ms. Simone's erasure derives from a particular sense of what Ms. Simone represented during her career. The best way to motivate this point may just be to go to the images themselves.

I came across the first image I'd like to discuss in an article from *Clutch Magazine Online*. The title tells the tale: "New Photos of Zoe Saldana as Nina Simone Emerge – We're Still Not Impressed."[4] The photos in this article show Ms. Saldana on the set of the Simone biopic, with her skin artificially darkened and her features artificially altered so that she looks more like the woman she's meant to portray.[5] Unfortunately, she looks more like something from a sci-fi movie set – think one of the patrons at the intergalactically diverse cantina in *Star Wars*. Also unfortunately, I'm limited to describing this image instead of showing it because it appears to have been pulled from the social media rotation, which I take as evidence of how embarrassing it is. The film should have come out (after several years of delays) by the time this book gets published. So the evidence will be there for all to see.

We'll come soon enough to the issue of why Ms. Saldana appearing, effectively, in blackface is a problem. Here's why it's necessary: Nina Simone is on your left, and Ms. Saldana is on the right.

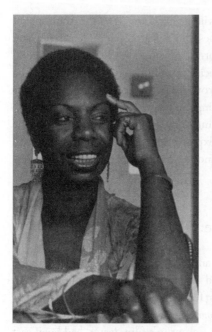

Figure 2.1 Composite image comparing Nina Simone and Zoe Saldana.

Here's a thought one might have on seeing these pictures together. *Surely the filmmakers have to do something to make one of these things more like the other. So* (this first thought continues) *what's wrong with altering Ms. Saldana's appearance to make her more closely resemble Ms. Simone? If Robert De Niro can transform himself for* Raging Bull, *then how is this any different?*

Properly locating the difference between De Niro becoming Jake LaMotta and Saldana becoming Nina Simone requires attending to a variety of issues. We will come to some of these in a later chapter, in a discussion of the links between race-thinking and judgments of human bodily beauty. For now the key issue has to do with the frequency and regularity with which particular bodies, along with the bearers of those bodies and the histories that make the bodies meaningful, become invisible in western-led expressive culture. It will pay us to work through the various levels or registers of this erasure.

3 Theorizing the (In)visible

The mid-twentieth-century Afro-US writer Ralph Ellison may have done more than anyone else to establish the idea of invisibility as a way of thinking about a recurring feature of black life. He was not, however, the first or the only thinker to use the idea in this way. His work signals the mainstreaming

of a tradition of thought that rather famously stretches back farther in time, and that continues, productively, to this day. Five key themes emerge from this tradition to frame the discussion of this chapter. Each has a prominent spokesperson whose work underwrites the argument I'll soon develop.

Ellison: Mutuality and the inner eye

We have to begin with Ralph Ellison, whose remarkable book of essays, *Shadow and Act*, has provided me with the title for this chapter. The work that cements Ellison's place in the lineage of invisibility theorists is of course the celebrated novel *Invisible Man*, which begins with a famous passage that is worth quoting at length:

> I am an invisible man. No, I am not a spook like those who haunted Edgar Allan Poe; nor am I one of your Hollywood-movie ectoplasms. I am a man of substance, of flesh and bone, fiber and liquids.... I am invisible, understand, simply because people refuse to see me. Like the bodiless heads you see sometimes in circus sideshows, it is as though I have been surrounded by mirrors of hard, distorting glass. When they approach me they see only my surroundings, themselves, or figments of their imagination – indeed, everything and anything except me.... The invisibility to which I refer occurs because of a peculiar disposition of the eyes of those with whom I come into contact. A matter of the construction of their *inner* eyes, those eyes with which they look through their physical eyes upon reality.[6]

The passage is valuable because it thematizes at least two crucial aspects of the philosophic problem of racial invisibility. First, the narrator's invisibility results from the construction of the viewer's "inner eye," which frames the exercise of the physiological capacity for sight. More precisely, his invisibility results from the construction of the inner eye out of resources provided by white supremacy and anti-black racism. There are many philosophic routes to the idea that some condition of the seer explains what gets seen. We started down one of these paths in Chapter 1, in the discussion of rapid cognition. We might have also followed the lead of recent work in psychology and behavior science, which focuses on ideas like implicit bias (the version of this work that has been most influential in philosophy), cognitive heuristics, and bounded rationality.[7] For now we'll refer to it as a problem of ideology and subject formation.

The second contribution of this passage is that it reminds us of the problem of the red-faced man in *Far From Heaven*. The construction of the inner eye overrules, in a way, the evidence of the senses, which results in people who *refuse* to see. This refusal is so complete, he says, that the object of vision may as well have been "surrounded by mirrors of hard, distorting glass." This

language points us in two directions. The idea of people refusing to see suggests the psychological blockages that call forth talk of the unconscious or of sedimented habit. And the idea that this refusal mediates and obstructs a relationship between persons points us to the dialectics of intersubjective recognition, the dynamic unfolding and interplay of the interpersonal "forms of mutuality that contribute to self-esteem and identity."[8] Ellison is telling us what a failure of recognition looks like, and reminding us of the role that psychological factors play in bringing these failures into being.

Du Bois and second sight

Invisible Man made Ellison the first black winner of the National Book Award in 1953, and secured his place in the history of American letters. It swiftly became a fixture of college and secondary school reading lists, and provided many of its readers with their first serious glimpse of what many insisted on calling "the black experience." This is a testament not just to Ellison's achievement, though it does testify to that, but also to the thoroughgoing segregation of US thought and culture that Ellison explored so eloquently in his fiction, essays, and criticism. Most United-Staters knew very little of black life under white supremacy, and knew even less of the expressive traditions that had emerged from black communities and thinkers to constitute and explore this life. Ellison may have made racial invisibility a mainstream topic, but his forerunners in the black aesthetic tradition had explored it with great care and insight many years before.

W. E. B. Du Bois, for example, clearly prepared the way for Ellison's formulation of the problem of invisibility. In what may be the most famous passage in African American letters, in one of the most influential books in the entire history of African diasporic thought and expression, Du Bois offers the following description of the African American condition:

> BETWEEN me and the other world there is ever an unasked question: unasked by some through feelings of delicacy; by others through the difficulty of rightly framing it. All, nevertheless, flutter round it. They approach me in a half-hesitant sort of way, eye me curiously or compassionately, and then, instead of saying directly, How does it feel to be a problem? they say, I know an excellent colored man in my town....

> [T]he Negro is a sort of seventh son, born with a veil, and gifted with second-sight in this American world, – a world which yields him no true self-consciousness, but only lets him see himself through the revelation of the other world. It is a peculiar sensation, this double-consciousness, this sense of always looking at one's self through the eyes of others, of measuring one's soul by the tape of a world that looks on in amused

contempt and pity. One ever feels his two-ness, – an American, a Negro; two souls, two thoughts, two unreconciled strivings; two warring ideals in one dark body, whose dogged strength alone keeps it from being torn asunder.[9]

With his insistence here on metaphors of visuality, Du Bois provides the template for many later invocations of invisibility. The Negro, he says, is gifted with second-*sight*: African Americans are burdened by the peculiar "sense of always looking at one's self through the eyes of others," and are enjoined by white supremacist culture to limit themselves to this way of seeing. They have taken liberties when and where they could, formulating what we will soon call "hidden transcripts" for ordering their lives and esteeming themselves. This is one way to credit the idea of second sight, and the idea that this sight might be a gift, a way of seeing more, rather than simply of seeing poorly. But the two ways of seeing are in tension; the seer is burdened by double-consciousness, and by the sense of "two-ness" that comes from being both American and Negro.

There is much more going on in Du Bois's account, in ways we'll return to in the pages and chapters to come. For one thing, he is working out a cultural nationalist, masculinist, and bourgeois approach to black politics: this is why he tells us about *the* Negro, and why he describes the Negro as a seventh *son*, and why he'll go on to flesh out the problem of being a problem in the manner of racial uplift theorists, worrying about the moral degeneracy of the black poor. For now, though, the point is that he explicitly uses visual metaphors to discuss the problems of recognition and of subject formation in racialized contexts. Invisibility is what happens when the seer fails to credit the two-ness of "the Negro" – when we see black life *only* through the eyes of others, without attending to the counterhegemonic impulses and practices that might make black life more than a problem. And double-consciousness is what happens when black people struggle against the socially cultivated habit of refusing to see the specificity of their own experiences and conditions.

Look, a Negro! Fanon's spotlight

In *Black Skin, White Masks*, one of the foundational texts for postcolonial theory and Africana thought, Frantz Fanon transposes Du Bois's talk of double-consciousness into arguments about a third-person perspective. He has many of the same ideas in mind, concerning problems of recognition and the mechanisms of subject formation. But he brings these concerns more directly into connection with the phenomenology of embodiment and of everyday experience.

In one of the many trenchant passages from the book that bear on our subject, Fanon explains what happens to the black person's sense of embodiment, or "animate form,"[10] in an anti-black world. He relies heavily here on the notions of the body image and body schema. There are different ways to cash out these ideas, but for our purposes it is enough to say that the schema is "a system of motor functions that operates below the level of self-referential intentionality … [involving] a set of tacit performances, preconscious, subpersonal processes." The elements of this system inform and are informed by the organism's perception of the body, or body image, and together these "play a dynamic role in governing posture and movement" and, we should add, in framing the organism's career in the world and sense of itself.[11] As Fanon points out, this complex phenomenon of lived embodiment becomes a problem in an anti-black world.

> In the white world, the [person] of color encounters difficulties in elaborating his body schema. The image of one's body is solely negating. It's an image in the third person…. Beneath the body schema I had created a historical-racial schema. The data I used were provided not by 'remnants of feelings and notions of the tactile, vestibular, kinesthetic, or visual nature' but by the Other, the white man, who had woven me out of a thousand details, anecdotes, and stories…. As a result, the body schema … collapsed, giving way to an epidermal racial schema…. I was unable to discover the feverish coordinates of the world. I existed in triple.[12]

Not only do black people become invisible to "the Other," like Ellison's narrator; not only do they have to struggle against becoming invisible to themselves as persons, as Du Bois points out; they also have to struggle against losing sight of themselves, against losing the capacity to envision and construct themselves, as embodied points of contact between (what we learn to distinguish as) self and world. Fanon develops this point further by invoking a popular contemporaneous advertisement, typically featuring a dark-skinned, grinning, African man. (The ad is the French equivalent, in a way, of Uncle Ben in the United States – if Uncle Ben had been a World War I infantryman.) "I cast an objective gaze over myself, discovered my blackness, my ethnic features … and above all, yes, above all, the grinning *Y a bon Banania*."[13]

The "objective" gaze is the whitely gaze, inviting the speaker in Fanon's essay to see himself, as Du Bois puts it, through the eyes of others. But it is also the source of a third layer of complexity, on which, to paraphrase Lacan, the speaker (i) sees the Other (ii) seeing him, and (iii) *sees himself* doing this, and becomes undone as a result. This is the psychoanalytic and phenomenological complement to Claude Steele's influential discussions of stereotype threat, or "spotlight anxiety": the frequently disabling "fear of doing

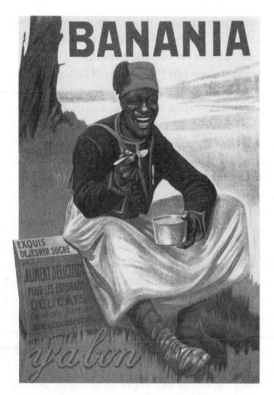

Figure 2.2 Banania advertisement.[14]

something that would inadvertently confirm [a negative] stereotype."[15] Not only does the stereotype obscure the reality of black personhood and obscures the self from itself; it also obscures the self's orientation to itself as animate form, and to the world that this form discloses.[16]

Morrison's eye for beauty

Nobel laureate Toni Morrison contributes to the study of the racialized "inner eye" by insisting on the gendered specificity and phenomenological depth of the dynamics of invisibility. Her first novel, *The Bluest Eye*, provides a richly intersectional account of the way particular bodies in particular settings register the problems of recognition, subject formation, and phenomenological disclosure.[17] In the process, it corrects for certain oversights and silences in the tradition, and highlights the importance of factors like desire and love.

At the heart of Morrison's novel is a little black girl who is completely overwhelmed by the pressures of invisibility. Pecola Breedlove internalizes the imperative of seeing herself through the eyes of others. And she signifies

and manifests her commitment to this imperative with a desperate yearning for blue eyes – the eyes that have so often (but of course, not always) been the conduit for the "inner eye" of white supremacy.

While Pecola's story restages the drama of black subject formation under white supremacy, there is more to the story than this. There are, for example, the features that make it count as a story rather than as an abstract treatise. There are also, of course, the features that make it into just this story, beginning with Morrison's inimitable style, even in this early work. More to the point, though, there is the specific contribution that this work makes to the tradition whose contours I am trying to sketch, over and above the issues of mutuality, ideology, embodiment, and recognition that we've canvassed so far.

The distinctive contribution of *The Bluest Eye* begins with its depiction of a particular version of the racialized struggle for recognition, the version that invites individuals to esteem themselves by appeal to societal standards of beauty. Pecola wants, among other things, to be beautiful. On the terms of the anti-black racism that she has so thoroughly internalized, this longing easily translates into a desire to escape blackness, and to see black bodies, including one's own, as objectionable and shameful. Morrison's novel emphasizes the way issues of embodiment, desire, and self-love converge with questions of love, gender, and sexuality. Pecola wants to be loved and valued, and desires beauty as one route to this end. But these desires are particularly vexed for black girls and women in a world given shape by white supremacy, male supremacy, and compulsory heterosexuality. The novel insists, with unstinting clarity and great sensitivity, on these complex specifications of the racial problematic of black invisibility.

Wallace: visuality blues

Cultural critic and essayist Michele Wallace extends the tradition still further. In the essays that make up (tellingly entitled) books like *Invisibility Blues* and *Dark Designs and Visual Culture*, Wallace uses, among other things, the metaphor of invisibility to discuss all of the issues raised above.[18] Particularly in *Dark Designs*, she examines the challenges of mutuality and recognition, desire and embodiment, neurosis and self-consciousness; she explores the connections between these challenges and the mechanisms of external coercion and internalized discipline; and she considers the way these mechanisms function in support of intertwined systems of racialized, gendered, sexual, national, and economic power.

Broadly speaking, Wallace extends this tradition by restoring the connections between metaphors of invisibility, the literal experience of visual perception, and the production and management of those experiences by

regimes of cultural practice. She does this in part by moving seamlessly between criticism of contemporary popular culture and of the specifically visual arts of painting and cinema, using skills honed during a long stint as a regular contributor to the *VillageVoice*. More importantly, though, she extends the Ellisonian tradition by employing and developing recent theoretical innovations.

The theoretical innovations that Wallace brings to the study of racial misperception figure prominently in the interdisciplinary field of inquiry known to some as visual culture studies. Translating the Ellisonian study of invisibility into this theoretical idiom, Wallace writes, "vision, visuality, and visibility are part of a [broader] problematic in African American discourse." She refers to this problematic as "the problem of black visuality," and points out that it "takes many forms." Then, as if to bear out this claim, though more likely in deference to the expository requirements of a regular journalistic assignment, she discusses a bewildering variety of these forms.[19]

The problem of black visuality continues to unfurl in Wallace's hands, as she broadens the Ellisonian problematic to encompass questions related to sexuality, postmodern theory, and the political economy of the world of visual "high art." This conceptual expansion heightens the need for the sort of conceptual map or schematic that should by now seem eminently necessary. The next two sections will provide this, first with a quick pass at the theoretical resources of visual culture studies, and then with an anatomy of the varieties of black invisibility.

4 Theorizing Visuality

The importance of using notions like "visuality" to explore the problem of black invisibility goes beyond finding a fashionable or state of the art vocabulary. The vocabulary is useful because it signals the invocation of certain modes of analysis. To invoke visual culture and visuality in this way is to point all at once to the conditioning of visual experience by discursive, sociohistorical, and material factors, in the context of fairly specific social formations.

Visual culture and visuality

Sometimes "visual culture" means just what it seems to, and simply denotes the aspects of a total way of life that are interestingly or primarily related to visual experience. But in the practice of visual culture studies (hereafter VCS) the expression often picks out a particular, historically specific cultural formation, one that has elevated sight above the other senses and organized itself in quite

distinctive and thoroughgoing ways around the proliferation and management of visual experience. One name for this cultural formation is "modernity," and one name for the modern (and postmodern) obsession with vision and imagery is, as intellectual historian Martin Jay puts it, "ocularcentrism."[20]

If the assiduous management of visual experience is the key to visual culture, then the idea of visuality is one key to understanding this process of management. According to visual culture scholar Nicholas Mirzoeff, Thomas Carlyle introduces the term "visuality" into the English lexicon to signify a kind of "pictorial vision" that gives history structure and meaning.[21] VCS takes from Carlyle the distinction between structured, meaningful observation and chaotic, meaningless sight, but reframes it in terms of contemporary discourse theory.

Ernesto Laclau explains what it means to commit to a discursive approach to observation, vision, or sight: "The basic hypothesis of a discursive approach is that the very possibility of perception, thought, and action depends on the structuration of a certain meaningful field which pre-exists any factual immediacy."[22] That is: preexisting fields of meaning create the conditions under which an act of perception can sort the flux of sensation and events into particular things. (The discursive approach is, in a way, what's left of Kant's categories and pure forms of intuition after Hegel gets done with them, and after people like Marx, Heidegger, Althusser, and Dewey get done with Hegel.) Dewey once wrote that an object is just an event with a meaning. Discourses are the already-structured fields of possible meaning that allow us to make objects out of the events we encounter. And "visuality" is a name for the state of affairs in virtue of which already-structured fields of possible perceptions underwrite and inform our specifically *visual* experience.

Art historian and visual studies scholar Norman Bryson clarifies this notion of visuality when he writes the following: "Between retina and world is inserted a *screen* of signs.... [W]hen I see, *what* I see is formed by paths or networks laid down in advance of my seeing."[23] To speak of visuality is to point to the cultural "screen" that shapes perception, the field of preexisting meanings that makes some states of affairs visible to us as things while others remain beneath our notice.

An example may begin to make this more concrete. I might look at a building in Spain and see nothing but a strange and interesting anomaly. In the wake of this unstructured observation, I might experience nothing but puzzlement at the difference between this building and buildings I've seen elsewhere in Europe. By contrast, someone more knowledgeable about Spanish history and architecture might have the conceptual resources to structure her observations into things. She might see a relic (of Muslim rule or influence), or a complex palimpsest of cultural influence and contestation (a mosque that was long ago converted into a cathedral).

While this humble example illustrates what one scholar refers to as "the primary axiom of visual communication – the more we know the more we see,"[24] the discursive approach to visual experience goes deeper than this. The impetus for studying visual culture, remember, comes from the claim that modernity is ocularcentric, placing a *distinctive* emphasis on sight and vision. There are different ways to understand this claim, or different levels of significance to assign to it.

Three levels of ocularcentrism: metaphor, materiality, and interiority

On one level, the claim about ocularcentrism is just that one of the defining conditions of modernity – along with, among many other things, the emergence of familiar forms of capitalism, liberalism, and racialism – is the enthronement of vision as a master metaphor for other domains of practice and experience. On one way of cashing out this point, experiments with perspective in Renaissance painting signified a break with older ideas of visual experience, and embodied an orientation to the world that eventually came to shape modern understandings of selfhood, knowledge, inquiry, and reality. The paradigm case of this, for everyone from Martin Jay (as a commentator on the debates) to Heidegger, Dewey, and Richard Rorty (as partisans in the debates), is the western epistemological tradition from Descartes to Hume. For these thinkers, the knowing subject approached reality as a disembodied spectator, surveying an essentially static reality from the outside. On this account, the mind is, as Rorty puts it, a mirror to nature; it is, as Jonathan Crary has it, a camera obscura, veridically reflecting a scene in which it is not involved, and to which it contributes nothing. This "Cartesian perspectivalism" results from translating an essentially visual orientation into epistemological terms. This visual orientation is what Martin Jay, borrowing language from film theorist Christian Metz, calls a "scopic regime": it offers a particular conception of vision as a way of understanding much broader forms of human engagement with the world.

Another level to the claim about modern ocularcentrism emerges with the realization that Cartesian perspectivalism was not the only modern scopic regime. If Jay is right, there were contemporaneous competitors, though none were quite as influential. More importantly, though, the passage of time brought new and different expressions of the commitment to organizing human experience around the power of sight. In the most significant development along these lines since the Renaissance, an alternate scopic regime emerged in the late modern period and paved the way to the world we now know. Crary locates this break in the 1820s and 1830s, while others locate a simpler version of it somewhat later, with such developments as cinema and post-impressionist painting. Whenever the break happened, the

world found itself launched on a new phase in the development of modern visuality. This phase – call it the modernist phase – broke with the fantasy of perception as unmediated, spectatorial reflection, and restored the embodied human subject to the process of visual experience. This led to a new set of possibilities for visual experience, and for the mediation of experience by visual imagery.

Moving from Cartesianism to visual modernism deepens the claim about ocularcentrism by forcing us to focus on social and material conditions. The nineteenth century restructured the possibilities and meanings for visual experience in ways that were bound up with profound forms of social-structural reorganization. To borrow the language of some VCS theorists, we might think here of the "industrialization of the visible" – of the way new technologies and practices, like photography and cinema, enabled the mass production and commodification of images. Or we might think of the "saturation of social space by visual technology," as mass-produced images – in, for example, advertising, newspapers, political campaigns, and photographic studies of deviant physiognomies – begin to insinuate themselves into every nook and cranny of civil society, political society, and the marketplace. By the twentieth century, this process becomes so advanced that social critics and theorists begin to worry about the culture industry and the society of the spectacle, in which images come to mediate all social relations, and citizens become passive, isolated, alienated spectators to what should be their own lives.[25]

These worries about the material and social-structural dimensions of modern visuality open onto a third level of meaning for the claim about ocularcentrism. Just as the late modern orientation to visuality reorganized social structures from the political party to the economy, it also reorganized the psychic, phenomenological, and epistemological structures of experience and identity. For adherents to this view, the organization of visual experience becomes one of the keys to the formation of individual subjectivities and identities. At the same time, the capacity to organize visual experience becomes one of the key resources for both the coercive and non-coercive exercise of power. Put differently, modernist visual culture is a framework for the operation of what Hacking calls "dynamic nominalism":[26] it creates subjects who construct their personalities and imagine their prospects as particular *kinds* of people in accordance with the demands of cultural imagery. In the process, it creates the conditions under which institutions can use these images to guide and shape individual and social action, whether with advertisements or with campaign videos.

Here, at the intersection of visuality and interiority or subjectivity, the discursive approach to vision comes to fruition. The most prominent approaches to discourse analysis derive from poststructuralist accounts of

the sign and from Foucauldian accounts of disciplinary regimes. Both accounts explain the ethical and political dimensions of contests over cultural meanings – one by way of notions like hegemony, the other by way of notions like genealogy and governmentality. On both approaches, politics is crucially a matter of mobilizing *meaning*, to frame the way moral agents understand themselves and their prospects. This contest over meaning does not pit all-powerful rulers against duped subjects. Rather, rulers and ruled occupy the same terrain (though the rulers of course have significant advantages), and struggle against each other in part by marking out and taking up different semantic positions. As Laclau puts it, "struggles about the ways of fixing the meaning of a signifier like 'democracy' ... are central to explain the political semantics of our contemporary ... world."[27] Howard Winant makes a similar point for critical race theorists, when he argues that racial practices develop historically in two registers at once, as struggles to distribute social goods are bound up with struggles over meanings and symbols, including terms like "merit," "equality," and "opportunity."[28] VCS theorists would add to these statements that struggles over meaning are always also waged on the terrain of visuality, by way of visual images and signs.

Racializing visuality

The previous several paragraphs present a highly idealized and simplified sketch of a diverse field of study, a field in which many participants take many different views. I think some version of the discursive approach to visual culture is surely and obviously right, but I don't mean to endorse or defend any particular VCS accounts, or any of the narratives of cultural, intellectual, or art history that inform them. Nor do I propose to go much deeper into the details of any particular story, despite having brought the survey up short of perhaps the most provocative set of arguments. (I am thinking here of arguments about the society of the spectacle, and about the subjects of late capitalist visual culture not just seeing the world through cultural images, but also navigating the world as if selfhood were just a conduit for the reception and transmission of images.)

My aim has not been to offer a novel interpretation of the arguments about visuality, but to clarify the aspects of those arguments that can shed some light on the phenomenon of black invisibility. If it is right to say that modernity is distinctively ocularcentric, if ocularcentrism is in fact constitutive of the modern, then this will surely have some bearing on the distinctively modern phenomenon of racialization. To speak of ocularcentrism is to indicate the emergence and ascendancy of certain metaphors, technologies, and social practices, all of which have profound import for modern modes of social organization and self-conception. It is, more precisely, to speak of these things

as markers of a particular span of time and family of places – times and places that also spawned and were shaped by racialist ideas and practices.

One might say much more in this vein, but the sort of thing I have in mind should by now be apparent. If, as Bryson says, a "screen of signs" separates retina and world, and if modern societies have devoted themselves in unprecedented ways to shaping and supporting this screen, *and* if this devotion to cultural screens came into being precisely when ideologies of racial difference were taking shape and shaping social life, then, to paraphrase Fredric Jameson, visuality must be essentially racialized. Modern visual experience is constituted in part by the possibilities for seeing, and for not seeing, the members of the different races. Race-thinking is an integral part of modernity's screen of signs, and discovering what this screen screens *out* is the key to understanding black invisibility.

5 Two Varieties of Black Invisibility: Presence and Personhood

The stakes of invoking ideas like invisibility and visuality should now be clear. If the VCS theorists are right, modern visual experience is beholden to the states of affairs that modern subjects are prepared to see. This preparation is a matter of conceptual endowment and psychological habituation, both of which, in the modern era, are profoundly racialized. Ellison's "inner eye" is a sociohistorical artifact, with historically specific blind spots and conditions of employment.

Turning to these historically specific conditions, we can provisionally divide the problematic of black visuality into four distinct categories. These comprise problems of presence, personhood, perspectives, and plurality. Each of these manifests a form of denial or disregard, and each carries with it distinct implications for the worlds of art and expressive culture.

These forms of invisibility tend to hang together, in life as in the works of art, criticism, and theory that examine them. But I will in what follows focus on the way certain studies of invisibility are particularly revealing windows onto one or another of these forms of racial misperception. As it happens, misperceiving blacks is a danger for both whitely and anti-whitely forms of expressive culture. "Whitely" refers here to the ways of interpreting, navigating, and inhabiting the world that are consistent with or that follow from white supremacist ideology. In this spirit, we can say that expressive objects and practices manifest whiteliness when they accept, rely on, follow from, or advance white supremacist prejudices, and that anti-whitely objects and practices will resist or challenge these prejudices. Interestingly, opposition to whiteliness does not guarantee a commitment to black visibility.

Presence

In speaking of the disdain for black presence, I use "presence" more or less lit-
erally, and not in any of the technical senses that emerge from the likes of
Heidegger or Derrida. I mean, to paraphrase William James, just plain, honest,
English "presence," in the sense that there are certain contexts from which
black people and practices are or have historically been excluded or removed.
There are many obvious examples of this in and near the domain of expressive
culture. Michele Wallace, for example, argues that a kind of "restraint of trade"
limits opportunities for black visual artists, and that the causes of this exclusion
lead also to a kind of repression, which distorts or erases the contributions
that black artists have made to western expressive culture.

Apart from Wallace's determination to trace this restraint and repression to
a deep, psychocultural suspicion of black capacities for visual experience, this
argument should be uncontroversial. One of the main elements and instru-
ments of white supremacist modes of social organization has been the distor-
tion of opportunity structures and exclusion from social institutions, including
the institutions of the artworld. Many people have explored the role of racist
exclusions in art over the years, including Du Bois (in "Criteria of Negro Art"),
playwright August Wilson (in *The Ground on Which I Stand*), and film director
Robert Townsend (in *The Five Heartbeats*, which depicts a group of black singers
who achieve success and fame only after their early efforts get co-opted by
white music producers and marketed as the work of white singers).

Wallace, Du Bois, and others point out that racist exclusions have often
called forth anti-racist responses that sponsor their own, perversely parallel
exclusions. Black activists, keen to put the race's best foot forward, have
often denigrated and tried to suppress work in black aesthetics that they
deemed insufficiently respectable, progressive, or revolutionary. Houston
Baker, for example, relates the poignant story of Hoyt Fuller, a towering
figure in the development of mid-twentieth-century black aesthetics, living
in obscurity in Atlanta, around the corner from a conference on black
aesthetics that he was neither invited to nor informed of.[29] We will return to
this anti-racist restraint of trade below.

A slightly less familiar version of the simple disdain for black presence
involves not the denial that someone or something exists, or the refusal to let
the person or thing exist in a particular setting, but the acquiescence to or
encouragement of conditions that prevent certain realities from existing *at all*.
I have two things in mind here: the material precariousness of black expressive
objects in anti-black settings, and the unactualized potential of black culture
workers. Being written out of the hegemonic narratives of cultural produc-
tion often means, among other things, having one's work deemed unworthy
of promotion and preservation. For this reason, profound and historic works

of black expressive culture are more likely to get destroyed or lost than other works, and black artists, or black people who might have been artists, are unable to do the kind of work they might otherwise have done.

As an example of the work simply disappearing, think of the early black film industry in the United States, prior to the so-called "blaxpoitation" films of the sixties and seventies. Most people know little or nothing about early twentieth-century pioneers like the Lincoln Film Company and Oscar Micheaux. One reason for this is that authoritative accounts of film history have only recently started to credit the real diversity of the tradition, but also in part because most of the films by these people have been destroyed or lost. This is a standing danger with older films, most of which have been lost for one reason or another. But the risk goes up dramatically for independent films with no backing from the major studios[30] – a category that includes *every* film by a black director until Gordon Parks's *The Learning Tree* in 1969. In cases like this, a peripheral relationship to the dominant means of producing expressive culture – exclusion from the studio system – increases the risk of an artifact's disappearance.

Micheaux also gives us an example of work failing to become what it otherwise might have. Now uniformly lauded as the father of black filmmaking, Micheaux struggled mightily to make his films, and then to market and distribute them, all outside the studio system, all targeting a fairly small audience of black customers with the wherewithal and the relative leisure to buy tickets to his films. We have few pristine prints of his films: he continually recut them as they made the rounds, sometimes to meet the censorious demands of local authorities. But what we do have from Micheaux is of uneven quality. Some have argued that this is a matter of style, that he was consciously breaking with the conventions of classical Hollywood editing and shooting.[31] But most have simply concluded that Micheaux's work tends to have greater historical significance than aesthetic merit. This might mean that he was simply not a very good filmmaker; but this conclusion seems a bit hasty, or even unfair, in light of the constraints he was under. He was essentially a guerrilla filmmaker, doing every aspect of the job from writing and casting to distributing and selling tickets; and he did this with, by our standards, primitive technologies for filmmaking, communication, and transportation; and he did it during the era of Jim Crow. We simply don't know what sort of filmmaker he would have been if afforded the luxury of an editing suite, or a marketing staff, or a market not artificially constrained by racial barriers.

Personhood

A second way of thinking about invisibility comes into focus once we move from the material conditions of exclusion and distorted opportunity structures to the psychocultural conditions of denial and of distorted

intersubjective relations. The problem here goes beyond the denial of black presence, since, as Lewis Gordon puts it, even "black presence is an absence."[32] As we saw with Todd Haynes's red-faced man, the presence of a black person in a white supremacist society typically has different ethical, psychological, and phenomenological implications than the presence of a white person. The black person is precisely *not* a person, and in cultural representations appears most often as some sort of object.

"The denial of personhood," McGary explains, "means a lack of membership in the moral community."[33] Ethical belonging is a complex but familiar condition, closely related in the liberal tradition to the possession of rights and the ability to claim them, and to the possession of capacities and worth that make the condition of citizenship possible and important. Other traditions, growing out of Hegel's master–slave dialectic and converging on the likes of Sartre and Levinas rather than Rawls, deepen this condition by appealing to the dynamics of intersubjectivity and recognition. Here the person (or the equivalent concept, such as Levinas's "Other") is inextricably enmeshed in the interactive, relational, transactional processes that create the self. In this sense, the denial of personhood is an attempt to deny, constrain, or dictate the role that other people play in forming the self.

One of the principal tactics of anti-black racism has been to insist that blacks should be treated as non-persons – or, as Charles Mills puts it, as sub-persons.[34] The alternatives to personhood have, of course, varied: blacks have been treated as property, as sideshow attractions, as beasts of burden, as commodities, as capital, as permanent children, and much else besides. And the techniques of denial have varied, as has the commitment to it. For some purposes, like giving testimony in court, blacks might be the equivalent of a broom or a goat; but for other purposes, such as for sex or for overseeing the work of other enslaved people, blacks came much closer to counting as persons. And there have of course been anti-racist modes of expression and analysis as well. In general though, to borrow language from Fanon and Gordon, modern expressive practices all too often turn black persons into objects among other objects — what should be "consciousness in the flesh" instead becomes "a thing,"[35] or many things.

6 From Persons to Characters: A Detour

Of the many depersonalizing treatments of blackness in modern art and expressive culture, a few stand out sufficiently to warrant a brief digression from the main argument. I cannot hope to offer an exhaustive list of these objectifying aesthetic strategies, but I can organize some familiar ideas into a

slightly more perspicuous form than usual. Because objectification is a way of taking an attitude toward something, I will be concerned here with representations of one sort or another, and specifically with representations involving human individuals. For ease of exposition, I will refer to these individuals as "characters" throughout, whether they come from narrative or non-narrative representations.

Depersonalization strategies unfold on two levels: one involves diegesis or iconography, while the other involves narration and iconology. On the first level we find a dialectical interplay between, on the one hand, a character's individual traits and roles in the world of the representation, and, on the other hand, the assortment of racial themes that exist in cultural archives and repertoires as resources for constructing such characters. What happens on this level is a matter of diegesis or iconography because it concerns who and what we find in the world depicted by the representation. Here the characters emerge as if constructed in answer to this question: *How deeply should I bury the individuality of this character beneath an engagement with racial themes?* Or: *How completely should I let racial themes govern the depiction of the character's traits and the arrangement of the character's roles in the world of this representation?*

On the second level we find the first-level depiction turned to some further purpose. What happens here is a matter of narration or iconology because it concerns the real-world conditions and consequences of constructing a representation in one way rather than another. The uses of the character emerge here as if in answer to this question: *how can a character constituted in this way advance the psychocultural purposes to which this representation might be put?* Or: *what kind of real-world work can this representation do once it's been furnished with a character like this?*

Level 1: stereotypes and stock figures

On the first level of representation, stereotypes and stock figures eclipse black personalities and render them invisible. By "stereotypes" I mean characters that exist principally to embody some smallish proper subset of the features that modern racialism conventionally links to blackness. Here we have the toms, coons, tragic mulattoes, mammies, jezebels, bucks, dandies, pickaninnies, and other racial types that people like Donald Bogle and Marlon Riggs have so profitably studied.[36] These are archetypal personifications of anti-black prejudices, defined by single, characteristic traits — servility, buffoonery, sexual rapaciousness, brutishness, and so on — rather than by the complex configurations that make for unique personalities. Classic examples are hard to come by now, in the waning days of open and indiscreet anti-black racism. (One of the main contributions of Riggs's important documentary,

Ethnic Notions, is in fact its presentation of old animated shorts from Warner Brothers and others, shorts that, thanks to their unabashed reliance on insulting racial stereotypes, will almost certainly never reach the airwaves or cable currents again.) But the traces of these figures live on in less obviously objectionable televisual products that remain readily available in one way or another. Think of the pickaninnies of *Diff'rent Strokes* and *Webster*, Nell Carter's mammy in *Gimme a Break*, the tragic mulattoes of *Devil in a Blue Dress* and *Monster's Ball*, and, if Dave Chappelle's critics are correct, the neo-coon antics of *The Chappelle Show*.

In referring to "stock figures" I have in mind characters that play characteristic roles in the world of the narrative or image by means of an indirect relationship, if that, to the distinctive traits required by anti-black prejudices. These narrative devices lack the instantly recognizable names of racist archetypes like the coon and the mammy, but they are easy enough to recognize. Perhaps the most familiar example appears in films like *Mississippi Burning*, in which black characters provide the backdrop for a story about white people – even when, as in this case, the story might plausibly be construed as having some special resonance for black people themselves. In this film, ostensibly about *the civil rights movement in the US South*, the black characters become, in essence, scenery, blending together to form an anonymous mass of helpless victims.

The reduction of blackness to an anonymous mass may be the purest form of invisibilization and depersonalization. As Gordon points out, anonymity in this sense means that "to see *that* black is to see every black." (It is tempting to bow to the laws of syntax and restate this point in terms of seeing black *people*, but, and as Gordon means for us to realize, to do so would be to miss the point of the claim, and the depth of the problem it highlights.) Where anonymity comes into play, "[t]he black's individual life ceases to function as an object of epistemological, aesthetic, or moral concern.... The black representative emerges."[37]

For an equally familiar but perhaps obsolete example, we might think of the way that horror and action films for most of their history insisted on killing off a black character first (when they deigned to include black characters at all). This figure follows indirectly from ideas about black inferiority. It originates in classical racialist claims about the relative hardiness and strength of the various races, claims that eventuated in the "science" of eugenics as well as in the conventions of literary naturalism. But latter-day First Victims needn't directly display any particular weakness or vice – they just find themselves in the wrong place at the wrong time (stranded in the narrative, as it were, by an ossified representational practice that has forgotten its reason for being). As a consequence, they have fewer prospects for the kind of growth, change, and development that would make them

more closely resemble complex persons – they are plot devices, and hackneyed ones at that. (Quentin Tarantino seems to pay homage to this old, perhaps obsolete tradition in *Kill Bill*, Vol. 1, which presents the events of its story out of temporal order so that Uma Thurman can dispatch Vivica Fox before doing anything else.)

Robert Gooding-Williams examines another stock figure in his discussion of the "black cupid." This character may not himself or herself evince the stereotypical lasciviousness that has typically attended the black image in the white(ly) mind. But, as we see from examples like Whoopi Goldberg's Oda Mae in *Ghost* or Sam in *Casablanca*, the association of blackness with sexuality nevertheless seems to endow these characters with the power to mediate the romantic relationships between other characters.[38] Like the First Victim, the black cupid rests on deeper psychocultural motivations.[39]

Stock figures and stereotypes tend to obscure the character's individual personality rather completely, depending of course on the quality of the writing, or acting, or draftsmanship, or whatever. Other ways of balancing racial themes with the burdens of character construction tend to do better. On the far end of the continuum of depersonalization, the point at which the tension between personality and racial theme gets resolved in favor of personality, we find realistic depictions of blacks, which expressly aspire to treat blacks as individuals. Somewhere short of this are idealizations, which aspire to transcend or counter racist depictions by endowing black characters with superhuman reserves of nobility or virtue. (Think here of Dennis Haysbert in *Far From Heaven*. I fear that Bogle would think of this character as a modern-day "tom," in the guise of the long-suffering servant.) Perhaps most interesting, though, are the examples of what Toni Morrison, in her remarkable book of criticism, *Playing in the Dark*, calls "metonymic displacement."[40] This is what happens when black "traits" are used to modify and inflect non-black characters. In this connection Morrison points to some passages from Hemingway, in which a pair of white lovers discuss one's dogged pursuit of a tan, and the excitement that her "dark skin" engenders in both of them.[41]

Level 2: how to do things with Negroes; or, mirrors, fetishes, and deviants

The idea of metonymic identification points us squarely toward the second level of depersonalizing strategies. The distinction between levels is of course somewhat artificial, as the cultural and psychological conditions that shape the representations will shape the construction of their characters. The point of the distinction is just to anatomize the various techniques that tend to make black persons disappear in western expressive practices. Now that we have a stockpile of character traits and roles in place, we can examine some of the patterns of usage that emerge from the deployment of these symbolic resources.

Whitely representations obscure black personhood quite generally by inventing black characters that can serve as vehicles for the development of white characters, or as occasions for reflecting on the meaning of and prospects for white identity. Toni Morrison refers to this practice as "Africanism," and identifies distinct but related versions in European and US literature.[42] *Monster's Ball* is a good example of this Africanist, vehicular deployment of blackness, as the main function of the main black character is to redeem the white man with whom she shares the screen. Halle Berry's tragic mulatto – one of Bogle's basic archetypes – occasions Billy Bob Thornton's ethical and emotional awakening, warming his frozen heart and encouraging his tentative repudiation of his father's overt commitment to white supremacy. This venerable narrative of white revivification, perhaps most familiar from the surrealist and primitivist movements in modern art, relies on a dynamic that Fanon effectively summarizes with these words from an imagined white interlocutor: "from time to time ... we will turn to you.... We will turn to you as the childhood of the world.... Let us forget for a few moments our ... civilization and bend down over those ... adorable expressive faces. In a sense, you reconcile us with ourselves."[43]

In addition to exemplifying the general, vehicular use of blackness, *Monster's Ball* also points toward one of the more specialized forms that these vehicles often take. Building on Morrison's account, rhetoric scholar Aimee Rowe sums up these more specific forms by pointing out that black characters often represent "primitive impulses" with which the white characters must contend, and that these forces are "sometimes benevolent," but at "other times exotic, erotic, and terrifying."[44] We might disaggregate these primitive impulses by saying that black characters often appear in whitely representations as mirrors, fetishes, or markers of deviance.

Black characters function as mirrors when their presence in the work contrasts with and thereby clarifies the achievements and virtues of whiteness. As Morrison puts it on her way to a reading of Twain's *Huckleberry Finn* and Hemingway's *To Have and Have Not*, "Africanism is the vehicle by which the American self knows itself as not enslaved, but free; not repulsive, but desirable; not helpless, but licensed and powerful; not history-less, but historical; not damned, but innocent." In Twain's novel, the pursuit of freedom, thematized by the idea of lighting out for the territories, is dogged by "the specter of enslavement" – in the form of Nigger Jim, and his precarious position at the problematic end of the novel.[45] Hemingway, for his part, highlights the power and authority of his white protagonist by giving him a black shipmate who goes nameless for most of the novel, seems to do very little, and, when he does do something, has his agency torturously reassigned to the hero. (When the black man sees something important, Hemingway might have had the man simply announce his discovery. Instead, a masterpiece of convoluted

syntax leaves the action vested in the narrator. The narrator says, "The nigger was still taking [the ship] out and I looked and saw he had seen a patch of flying fish."[46] Not "He pointed" or "I heard him say," but "I *saw he had seen.*"We will return to this.)

Black characters function as fetishes, in the sense I have in mind, when they embody taboos and therefore externalize – "exorcise," Morrison says – whitely fixations. They do this with traits or behavior toward which the ruling ideologies of whiteliness officially counsel contempt, while nevertheless unofficially underwriting desire, fascination, and emulation. Examples of fetishization are easy enough to come by, from the primitivist movement in modern art to Josephine Baker's entire European career. One of the most notorious examples comes from Norman Mailer's famous essay, "The White Negro," which extols the virtues of hypersexuality, rebelliousness, and, well, more hypersexuality, while presenting all of these as "hip," essentially Negro traits. Mailer's essay is not a work of fiction – not intentionally, in any case – but it deploys a stylized, personified, invented blackness in its exploration of the prospects for *white* identity, as surely as a novelist might deploy Morrison's Africanist presence.

Black characters function as markers of deviance when their presence in a work symbolizes moral dissolution or provocation. Manet's *Olympia*, first exhibited in 1865, provides a particularly rich example. This famous nude depicts a courtesan, brazenly looking out at the viewer, demurely covering her genitals with her hand, attended by a black maid. Cultural historian Sander Gilman points out that "the figure of the black servant is ubiquitous in European art of the eighteenth and nineteenth centuries," and that this figure was often a marker for illicit or deviant sexual activity.[47] The maid is surely a secondary figure in the image, as the title suggests; but her presence reinforces the content of the piece – Manet's revolutionary decision to use the lofty tools of fine art to present the illicit image of a sex worker.[48]

Another example – a less complicated one, as it happens[49] – appears in Frank Capra's (1946) film, *It's a Wonderful Life*. Here the main character, George Bailey (James Stewart), magically gets to see his world as it would have been had he never been born (and we, of course, get to watch). Of the many indications that the world is the worse for his absence, one is particularly apt for our purposes here. In one scene, George attempts to cope with the newly George-free world by visiting his favorite neighborhood bar. He discovers that the bar has become a rowdy, dangerous, unfriendly place – a discovery that the film anticipates for the viewer by introducing the scene with the sounds of stride piano and the sight of a grinning black pianist. In an extension of the same idea – the idea of blacks as harbingers of danger, crime, and barbarousness – that turned the expression, "there goes the neighborhood" into a common saying, the film uses a black face and black music to show that George Bailey's absence has led to social decay.

Sweetback's revenge: anti-racist depersonalization

While the whitely effacement of black personhood has been a prominent subject in black aesthetics, it has also provoked the strangely parallel response of anti-whitely, sometimes pro-black, ways of obscuring black personhood. Anti-whitely but still depersonalizing deployments of blackness routinely take a handful of forms. We will return to these in the pages to come, and as a consequence can afford to be brief here.

One approach involves appropriating and revaluing the vision of blackness created by whitely expressive culture. The primitivists, mentioned above, might fit here as well, along with the surrealists. Their revolt against modern culture and industrial society was in part a criticism of what we've since learned to call whiteness, complete with the argument that, as Picasso used racialized language to explain to Léopold Senghor, "We must remain savages." (Senghor responded approvingly, "We must remain Negroes," and reported that Picasso "burst out laughing, because we were on the same wavelength.")[50] We might also think of Melvin van Peebles's groundbreaking film, *Sweet Sweetback's Badass Song* and, for that matter, of the so-called blaxploitation films which followed it, all of which can be seen as making Bogle's black buck – the brutish, hypermasculine, sexually predatory black man – into a hero.

A second anti-whitely but still depersonalizing approach deconstructs or parodies whitely images of blackness. Here we might return to Dave Chappelle, only this time to credit his supporters rather than his detractors. While some saw his program as a contemporary form of minstrelsy, or as a coon show, others took him to be offering a subtle and sophisticated manipulation of racial stereotypes and racialist themes. Chappelle, on this account, belongs to the family of post-black thinkers, or new black aestheticians, for whom racial meanings are objects of study, to be exposed, deconstructed, and creatively redeployed. These parodists of racial blackness often put the mechanisms of depersonalization at the center of their work, to let anti-black and whitely sentiments effectively expose themselves.

A final approach simply reverses whitely images of blackness, and sees virtue wherever white supremacist representations depict vice. This approach has led to a debate over the place of positive images in black expressive culture, with partisans to the debate including prominent black church leaders (like Calvin Butts of New York's historic Abyssinian Baptist Church), hip-hop performers (like Snoop Dogg), lauded visual artists (like Kara Walker), prominent television personalities (like the once-beloved, now-embattled Bill Cosby), and canonical figures in US and Afro-US letters (like Du Bois). Artist Kerry James Marshall speaks to the tension between defending black personhood

and effacing it anew in a recent interview. Here is his response to a question about countering "distorted" images of black people:

> An important part of my project as an artist is to address that issue. There has been a tradition of negative representation of black people and the counter-tradition to that has been a certain kind of positive image, a thrust on the part of some black artists to offset the degradation that maybe some of the other negative stereotypic images present. But both, in a lot of ways, ended up being a kind of stereotype that denied a certain kind of complexity in the way the black image could be represented. So I thought, well, there's got to be a way to do both, to do two things at once.[51]

We'll return to Marshall's solution to the problem of black complexity, and to the problem of positive images, in the pages to come.

7 Two More Varieties of Black Invisibility: Perspectives and Plurality

So far we've considered two forms of black invisibility, each proceeding from a distinctive form of denial or disregard. The denial of presence is the most straightforward, involving as it does the same kinds of racist exclusions that we find in plenty of other social institutions. And the disregard for black personality transforms black people into stock figures, stereotypes, and vehicles – call this "the objectification of blackness." The denial of person-hood goes hand in hand with a third mode of invisibilization, the disregard for black perspectives. And one way of working through this mode leads in turn to an engagement with a fourth form of invisibility, related to the denial of black plurality.

Perspectives

The various forms of anti-black objectification both facilitate and follow from the denial of black perspectives. As Gordon puts it, "In order to see the black as a thing requires the invisibility of a black's perspective."[52] Or, to paraphrase a line I once had the privilege of hearing Amiri Baraka deliver, in an explanation of the three-fifths clause that could only come from a poet: Who cares how a broom sees things?

While objectification strategies are sufficient for racist denials of perspective, they are not necessary. It is possible to accept black humanity and person-hood, in some form, while still refusing or problematizing black perspectives. The familiar exclusions and injustices of what hooks calls "white supremacist

patriarchy" often followed directly from the assumption that certain human kinds are naturally burdened with epistemic incapacities. So members of these kinds were barred from voting, and from testifying in legal settings, and so on, on the grounds that their testimony was – their perspectives were – inherently unreliable. (These policies were of course overdetermined, and overlaid with unambiguous yearnings for power and social control.) This sort of epistemic injustice dovetails neatly with a suspicion of or indifference to black aesthetic strategies. It is after all a short step from withholding opportunities for self-expression as a citizen – in voting or witness testimony – to withholding opportunities for self-expression as an artist, or vice versa.

To speak of the denial of black perspective is not, or not yet, to suggest that there is some *single* orientation to the world that we can think of as belonging to black people. It is, however, to suggest that certain ways of seeing are more likely to recommend themselves to people who occupy different racial positions in a racialized society. This follows from the recognition, mentioned earlier, that one of the fields of political contestation is the field of public meaning. White supremacy is constituted in part by the colonization of public meaning by whitely assumptions and prejudices, and these assumptions and prejudices collectively constitute a hegemonic whitely perspective that, as the theorists of visuality make clear, then shapes the prospects for perceptual experience. Whitely ways of seeing become the social defaults; they become the intuitive, commonsense standards, and the success of anti-racist activism must be measured in part by the degree to which non-whitely ways of thinking and seeing can be cultivated and made operative.

To say all of this is to put us in conversation with theorists of spectatorship and the gaze. There are different routes to the constellations of ideas that these terms mark out, passing typically through some combination of psychoanalysis, existentialism, poststructuralist and feminist film theory. But it is possible to state the basic ideas without prematurely committing to much of a theoretical apparatus.[53] Hegemonic ways of seeing posit a hegemonic spectator that accepts and acquiesces to the requirements of these perspectives. Films, paintings, photographs, and other elements of visual expressive culture are effectively addressed to this implied spectator, whose assumptions and biases the actual, empirical viewer of the work in question must share in order to appreciate the work in the ways that the dominant culture prescribes. Because spectatorship in this sense just is an aspect of the (dynamically nominalist) options for social identity construction that the dominant culture recommends, the spectator's perceptual activity – the spectator's *gaze* – can as a consequence be thought of as a manifestation of the major identity categories. For this reason we can speak intelligibly (if not altogether precisely) of "The Masculine Gaze," "The White(ly) Gaze," and the like.

The hegemonic perspective, with its implied spectator and tailor-made opportunities for perceptual experience, represents just one of the combatants on the field of public meaning. What I've simplistically described as "the dominant culture" is arrayed against the perceptual and critical practices of the disenfranchised and disempowered, which prescribe their own ways of seeing. These counterhegemonic or oppositional ways of seeing imply an oppositional or *resistant* spectator, one that resists the responses prescribed by objects constructed in accordance with hegemonic assumptions. A spectator opposing the masculine gaze will chafe at the way a work prescribes acceptance and approval of, and arousal by, techniques for objectifying and demeaning women. And a spectator opposing the whitely gaze – Manthia Diawara invites us to call this, simply, the black spectator – will chafe at the way a work prescribes acceptance and approval of techniques for demeaning and disregarding non-white peoples.[54] Just as important, these resistant spectators will chafe at the presentation of hegemonic meanings as commonsense, as unbiased, neutral, and natural, and will endeavor to construct an alternative experience of the work in question based on exposing the workings of hegemony, and on mobilizing counterhegemonic interpretive resources.

As with much else, I have presented the issues here in artificially neat ways. The hegemonic and counterhegemonic perspectives are not wholly distinct phenomena, and are in fact intertwined in all sorts of ways. Similarly, the various forms of hegemony – racial, gendered, sexual, and so on – are tightly interconnected, and mutually constitutive. For example, a work may motivate its masculine perspective by presenting white masculinity as a bulwark against black-inflected social chaos, or by presenting black masculinity as the key to anti-racist struggle.

Some examples will help to make the issues of spectatorship concrete. There are certainly many to choose from. *Gone With the Wind*, for example, idealizes and laments the passing of the Southern slaveocracy, which is to say that it prescribes that its viewers identify with and root for the expropriated Southern aristocracy. The film is simply not addressed to viewers who might enjoy seeing the collapse of the South's peculiar institutions, or viewers for whom the presentation of the black characters gets in the way of enjoying the film and identifying with the ostensible heroes. Some of these viewers will, like me, remain unable to engage the film, unable to identify with its heroes, to lament their losses and yearn for their restoration. Others might construct an alternate viewing experience, one predicated on the assumption that the black characters are dissembling, as enslaved African Americans were wont to do. On this alternate picture the black characters, like Hamlet's Rosencrantz and Guildenstern, become the heroes of an intersecting but distinct story, unfolding behind the scenes;

and through them we get a glimpse of a hidden life that is more interesting, plausible, and enjoyable to contemplate. Resistant spectatorship of this second kind led to the publication of *The Wind Done Gone*, which, as one reviewer put it, "ardently contests the romanticized view of the antebellum South set down in *Gone With the Wind* and proposes an Afrocentric version of history in its stead."[55]

In much the same spirit, we might consider a cinematic piece of colonial nostalgia entitled *Zulu*, which was once, in the days before cable, a mainstay of television syndication. This film's prescriptions for its viewers are quite clear. We must identify with a company of besieged British soldiers, who are on the verge of being overrun by Zulu soldiers (if you feel the impulse to refer to the Zulu fighters not as "soldiers" but as "warriors," then you're well on the way to getting the point). We must assent to the depiction of the Zulu men as an anonymous horde. *Or* we must find some alternative way to inhabit this fiction world, in the spirit of *The Wind Done Gone*. (When I saw this film as a boy, I found myself rooting for the Zulus, and acutely feeling the lack of an identifiable individual counter-protagonist on whom to confer my allegiance.)

As a final example we might consider the Reagan-era Hollywood crime thrillers, which treat the vigilante moralism of Dirty Harry as uncontroversially heroic. The viewer who means to enjoy these films must be unaware of or indifferent to the way that policing, corrections, "law and order" politics, and vigilante justice have historically been central to white supremacist mechanisms of terroristic social control. Diawara's resistant, "black" spectators may or may not be drawn from the ranks of actual black viewers; but the kind of awareness and sensitivity that make resistance possible are more likely to come from a robust engagement with the historic roles that the state has played in the lives of black communities – an engagement that black people are more likely than others to achieve by everyday socialization (as opposed to specialized study).

One of the central tasks of the black aesthetic tradition has been to expose the whitely pretensions to universality and neutrality that deny black perspectives, and to cultivate the resources that might inform these alternative ways of seeing. This has been one of the driving aims of criticism in the tradition, as evidenced by Morrison's re-reading of Hemingway, discussed above, and Diawara's discussion of the famous "Gus" sequence from *Birth of a Nation*. It has also motivated a great deal of creative work. Visual artist Bettye Saar, for example, reimagines Aunt Jemima as a gun-toting superhero, in the process excavating and questioning the assumptions we've been taught to bring to an image of someone named "Aunt Jemima." And the film that launched Robert Townsend's career, *The Hollywood Shuffle*, explores an African American actor's resistance to the demeaning bit parts that were,

for most of the history of moving pictures, the black performer's only point of entry into Hollywood films and broadcast television.

Plurality

Diawara introduces the idea of the resistant spectator in part as a commentary on extant accounts of film spectatorship. He has in mind the work of theorists like Laura Mulvey and Christian Metz, groundbreaking thinkers who, he says, have nevertheless "not ... accounted for the experiences of black spectators."[56] His concern is that these accounts of the gaze are in fact oriented to the white male gaze, and tell us little about the experiences and possible experiences of black viewers.

In a similar way, scholars like bell hooks, Eve Oishi, and Jacqueline Bobo are determined not to let invocations of black experience like Diawara's shrink to focus only on black *masculinity*. As hooks points out, one form of resistant or "black" spectatorship – what she calls "black looks" – might contest white supremacy by usurping certain of the visual pleasures of white masculinity. As she puts it,

> Given the real-life public circumstances wherein Black men were murdered/ lynched for looking at white womanhood, where the Black male gaze was always subject to control and/or punishment ... the private realm of television screens or dark theaters could unleash the repressed gaze. There they could "look" at white womanhood without a structure of domination overseeing the gaze.... In their role as spectators, Black men could enter an imaginative space of phallocentric power that mediated racial negation.[57]

She rightly goes on to point out: "This gendered relation to looking made the experience of the Black male spectator radically different from that of the black female spectator."[58] This complication of the idea of resistant spectatorship itself requires further complication, as this particular passage from hooks does not make clear, as she does elsewhere, that her black female spectator might be a lesbian, and therefore have an even more complex relationship to the responses prescribed by hegemonic images of feminine objectification.

Complicating the idea of spectatorship in these ways points to a final aspect of black invisibility, the denial of black plurality. Black people are, of course, not simply black, but are also male, female, gay, straight, rich, poor, citizens, immigrants, and much else besides. The symbolic machinery of whitely misperception tends to obscure this intra-racial diversity, as does the propaganda machinery of pro-black image-management. These mechanisms of homogenization return us to the terrain of the positive images debate, only now informed by the insights of intersectional analysis.

The whitely side of this phenomenon is simple enough to exemplify and understand. The whole point of the classical racialist symbolic apparatus, especially as embodied in the stereotypes and stock characters discussed above, was to deny the complexity of black people. This meant not just denying the specific individuality of single persons, as we saw above in connection with the denial of personhood. It also meant ignoring the multiple dimensions along which those single individuals might imagine their life-plans. To focus for a moment on two of the "Negro archetypes" that Donald Bogle finds in US cinema: the mammy was essentially desexualized, domesticated, and matronly, presented as if a black woman could not be both motherly and sexually active, both a domestic worker and someone who enjoyed dancing in her off-hours. But she was also *essentially* a servant, with that status imagined in a very specific way – as servile, poor, and ignorant. This conflation of employment status with ontological status ignored the fact that black women of all class and educational backgrounds might end up doing domestic work in white homes, and that the racial segregation of opportunities for employment and for securing community regard made it eminently possible for people to be servants in one world and respected community leaders in the other. As another example, the buck was essentially a hypermasculine sexual predator and a brute, presented as if a physically strong black man might not also be intelligent, or queer, and as if such a man would necessarily be incapable of moderating and directing his desires as ethics, prudence, and decorum require.

In these and other ways, the stereotypes, stock figures, and standard usages of "the black" that have populated western cultural representations have obscured the multiplicity of roles, identities, and categories that black people might play, embrace, and exemplify. Figures like the maid in Manet's *Olympia* were always the maid, and rarely the lady or even the prostitute – or the nude (for reasons that we'll explore in the chapter on bodily beauty). The "nigger" shipmate in Hemingway's *To Have and Have Not* is never anything else – neither husband, brother, lover, or citizen (Hemingway never bothers to tell us the man's nationality, or his citizenship status).

8 Unseeing Nina Simone

Having established a theoretical framework for exploring issues of invisibility and visuality, we can now return to the case of the Nina Simone biopic. The issue, you'll recall, was that casting Ms. Saldana as the film's lead seemed, in a way, to cause what one critic described as "the erasure of Ms. Simone's image." I suggested that this sense of erasure might be heightened by Ms. Saldana's need to resort to special effects, to appear, one might say,

in blackface, in order to have any chance at inhabiting the role properly. All this left us with questions: why are Saldana's special effects any different than any other actor altering his or her appearance for a role? And how does casting her as Nina Simone lead to any kind of erasure?

Now, after working through the four modes of black invisibility and the theoretical background to them, we can assemble answers to these questions. Ms. Saldana's casting actually implicates all four modes of black invisibility. That is to say, it raises questions of denial and disregard in relation to the four key problems of presence, personhood, perspectives, and plurality.

It will be easier to see these problems of disregard once we distinguish what Ms. Saldana was asked to do from the general phenomenon of actors wearing visage-altering cosmetics and prosthetics. It is one thing to change one's appearance to become a Hobbit or a Grinch, or even to track the dissolution of a formerly elite athlete – De Niro's transformations in *Raging Bull*. It is another thing entirely to change one's appearance to track the long-standing biases of anti-black visuality. Grinches and Hobbits are not – in the real world, anyway – racial populations. And Jake LaMotta didn't belong to a racial population that was specifically, explicitly, and aggressively targeted for the way its members looked. (Yes, Italian identity has a complicated racial history. But it was a history as a *white* race, even if only, for a time, as a probationary white race.) To be black in places like the United States has, for a very long time, involved having one's life chances indexed to the way one looks in quite particular and far-reaching ways. It has involved navigating a world that has for centuries endorsed and accepted the thought that, as that great exemplar of the African American homiletic tradition, Joe Lowery, often puts it, white is right and black should get back[59] – a world, I should add, that remains shaped by that thought, even if in the indirect (but still striking) ways that we need the voluminous research on implicit bias to reveal to us.

Black bodies remain a problem in US/western/North Atlantic cultures. They are not the only problem bodies – ask anyone who looks South Asian, or Arab, or Latino. But they are still a problem, as the most plausible reading of the Trayvon Martin case, and of the many other cases of official and quasi-official surveillance and policing of black bodies, shows. The election of Barack Obama makes people forget this, but should actually reinforce the point. Consider: would Mr. Obama have won the presidency if he looked like Alan Keyes? How much of his appeal has to do with the fact that, as the man who became his vice president famously said, he *looked* clean and articulate, apparently unlike most other black leaders?

There is more to say about the problematic nature of black bodies, specifically in connection with the peculiar pockets of resistance not to Mr. Obama

but to Mrs. Obama as the US First Lady. But that discussion will keep until a later chapter. The point right now is that the disdain for black bodies shapes the industries and practices that endeavor mightily to shape contemporary visual culture, and it does so in specifiable ways that bear on the Simone–Saldana controversy.

In deference to its conflicted orientation to black bodies – a later chapter will give us the resources to think about this as a mode of "ambivalence" – the mainstream film industry routinely whitens black people when it inserts them into its narratives. Sometimes it whitens the individuals themselves, by having white actors portray black characters (think of Angelina Jolie in *A Mighty Heart*), or by buffing dark-skinned black people to a high shine by portraying them with lighter-complected actors (like with Saldana). But most of the time it whitens the whole race by skewing its casting decisions toward light-skinned or visibly mixed actors. This dynamic is especially pertinent to the paths that women take through the film industry. In support of this point, I'll offer a provocation where a different sort of project would conduct a poll: if asked to name five reliably bankable young or youngish black actresses, how many Paula Pattons and Taraji Hensons and Thandie Newtons would most people call out before getting to, say, Viola Davis? Or, now that the ABC series *How To Get Away With Murder* has made Ms. Davis into what appears to be a counterexample to this claim: would a show featuring one of these other, lighter-skinned women work so hard, and make clear that it is working hard, to get us to buy its lead actress as a desiring and desirable person?

(This is a down payment on a reading of *Murder*, but I'll have to defer the rest of my obligations on the point until after this book is done. It is also, however, the beginning of a discussion that I will continue in a later chapter, a discussion of shifting norms for judging bodily beauty in racialized contexts. That discussion will have to reckon with what appears to be progress in this area, with, for example, the relatively recent emergence of Oscar winner Lupita Nyong'o as a star and beauty icon. Until we get to Chapter 4, I'll just say this: all that glitters ain't gold.)

There are perfectly straightforward movie-industry reasons for this version of Wallace's "restraint of trade." Making a film "too black" – even today, as hip-hop culture bestrides the earth – threatens, or is thought to threaten, its marketability across populations. And among the ways a film can be too black is by casting people who look too black in it. (There are other ways, like not casting enough white people, even if white people cannot plausibly be the subject of the film. Think here of the film about the Haitian Revolution that Danny Glover kept taking to potential producers, only to have them keep asking where the white heroes were.)[60]

None of this is obviously irrational, from the perspective of an industry that is trying to make money. If making a film too black eats into its profits – it's not clear that this is true, but grant it for the sake of argument – and if casting Zoe Saldana comes closer to guaranteeing ticket sales than casting a darker-skinned actress, *and if* we're willing to set aside worries about ethical blameworthiness for capitulating to racist prejudices (and about whether implicit biases count as prejudices in the way that can sustain this sort of critique), then casting Ms. Saldana is in some suitably narrow sense perfectly rational.

This is where the worry about erasure comes in. Granting all of the considerations adduced above, we're left with this question: if one is worried about the consequences of making a film too black, *why make a film about Nina Simone in the first place?* Nina Simone is worth making a film about in part because of her politics (which, apparently, will play little role in the Saldana film, sadly). And her political convictions were intimately bound up with a politics of the black body. She knew better than anyone about the demonization of black bodies, and about the attendant need to celebrate them in ways that contested the ambient anti-black racism of mainstream culture and commonsense bodily aesthetics. That's why her career took her from this:

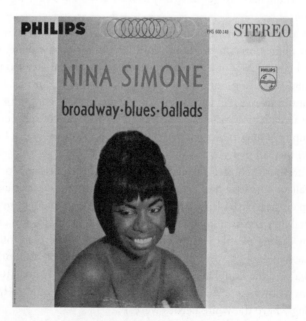

Figure 2.3 Nina Simone, *Broadway Blues Ballads*, album cover.

To this:

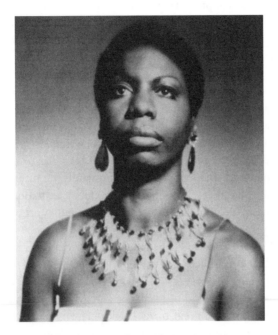

Figure 2.4 Photo of Nina Simone.

The fact that the filmmakers felt the need to do something to Ms. Saldana to make her look something like Ms. Simone suggests that they are at least minimally sensitive to this dimension of their subject. To treat it in the way they did is precisely to raise the question of erasure, which, we can now see, is a version of the problem of personhood. Ms. Saldana is a person who gets cast in films precisely *because of how she looks*, whatever her (in my view considerable) talents as an actor. To cast her as Nina Simone with anything like a realistic orientation to the subject – an orientation that the filmmakers signaled by resorting to prosthetics and cosmetics – is precisely to ignore and efface a great deal of what made Nina Simone who she was, as well as of what matters to people about her still. The personhood of Nina Simone, the ineluctably black personhood of a political activist and culture worker whose identity was bound up with black struggle and certain attendant modes of self-presentation, has been effaced by the market imperatives that attach to Zoe Saldana.

The casting of Ms. Saldana implicates the denial of personhood in part because it also implicates the problem of black presence. This mode of invisibility comes into play because of the restraint of trade that limits the pool of black actors that mainstream filmmakers consider viable. As we saw

above, the film industry capitulates to the problematization of black bodies in its casting decisions, preferring whites to blacks where it can, and light-skinned blacks to darker-skinned ones where it can. This artificially limits opportunities for black actors in a film industry that (again, in part for market reasons) is already less than hospitable to black folks. Nia Long has spoken eloquently about the impact of the film-industry version of the double-bind on her career. Her career aspirations have run up against two intertwined facts: she is a woman in a business that loses interest in women once they reach the age of 30, and she is black in a business that has little interest at all in black people who aren't rappers. Similarly, Spike Lee – for some, the dean of contemporary black filmmakers – has to troll festivals in search of distributors for his work (unsuccessfully, as often as not). In a business climate like that, imposing complexional limitations on actors – ruling black actors ineligible for black roles because they are *too* black – adds insult to injury. Or injury to injury.

The denial of presence and personhood in this case also connects to the disregard for black perspectives. Turning the Nina Simone story into a Zoe Saldana vehicle effectively sets aside the aspects of the story that make it interesting for a certain kind of black (or anti-whitely resistant) spectator. Ms. Simone was one of a great many black performers and public figures, stretching far back in time, who adorned, styled, and presented their bodies in ways calculated to attack colorist and anti-black biases. This was part of who she was, and part – though just a part, to be sure – of what sustains the interest of people who remain unmoved by the faux-universalism of racial liberalism. Removing Ms. Simone's political aesthetic from her story turns it into something else, something abstractly universal but concretely empty. Hers is a black story if anyone's is, and recognizing this – recognizing that there are black stories, and that these stories can exist without undermining the prospects for human sociality as such – is the key not just to doing this story justice but also to properly crediting the depth and richness of human experience. (There is of course more to say about how the particular relates to the universal, but it will have to wait until the next chapter.)

Finally, the casting of Ms. Saldana implicates the problem of plurality because it invites us to turn a blind eye to the different black experiences that follow from complexional differences. This casting decision seems reason-able, if it does, because Ms. Saldana is black *enough*, because any blackness would make her black enough. But the different paths that light- and dark-skinned blacks sometimes take through the world, the different meanings that attach to their bodies in properly racialized cultures, are in some settings worth taking seriously. If the setting is shaped by the imperatives of telling Nina Simone's story, then the difference between light- and dark-skinned blacks might matter for casting, just as the difference between blacks and

Southeast Asians might matter. That is: no one in their right mind would cast Lucy Liu as Nina Simone – again, if the narrative has any pretensions to realism. Once we abandon the thought that all blacks are the same, casting Ms. Saldana hardly makes any more sense.

To be clear, and to finish with the Saldana–Simone controversy for the moment, there are three points I have not tried to make above. I do not mean to suggest that light-skinned black actors have it easy, or that Zoe Saldana is ethically blameworthy in some way for taking this role, or even that the reading of the controversy that I've given here is necessarily the correct reading. My aim has been just to flesh out the intuition – widely shared in the blogosphere and debated in the entertainment press – that there was some problem with casting Ms. Saldana as Nina Simone, and that this problem had something to do with a kind of erasure. My claim is that the tradition of theorizing black invisibility can help illuminate the controversy. At the very least, though, reading the controversy through the tradition should have helped clarify the breadth and complexity of the idea of black invisibility.

9 Conclusion: Phronesis and Power

The themes, ideas, and examples introduced in this chapter will recur in the pages to follow, as each step of the argument builds on what came before. The problems of black invisibility and visuality are woven into the issues of politics and authenticity, ambivalence and appropriation, bodies and beauty, and the like, issues that will provide the subject matter for the chapters to come. The burden of this chapter has been to detach a single strand, or collection of strands, from the knotted tangle of themes that has over the years given black aesthetics its urgency and its agenda. Studying this strand in relative isolation should be illuminating in its own right, and should also introduce some of the issues and examples that we will soon explore in more depth.

The question of black visuality is a useful place to begin because some of the basic philosophic assumptions of this book have essentially to do with the phenomenon of perception. My sense is that perception is an essentially ethical, and hence political, phenomenon, and that aesthesis is the key to understanding the ethics of perception. This is not an original thought, and it comes to me in the way that it does thanks to people like the figures named above (Fanon, Wallace, et al.), as well as to Dewey, Henry and William James, Arthur Danto, and Martha Nussbaum. My aim is just to put this thought at the heart of a thoroughgoing engagement with *black* aesthetics, and to use it as one of the throughlines for a reconstructive survey of the black aesthetic tradition in the vocabularies of largely English-language philosophy.

Putting all this together, I'll want to say that perception is an achievement, especially in its immediacy; that one route to immediacy goes through the intuitive and habitual structuring of experience by the discursive resources of hegemonic social formations; that racial ideologies are among the most persistent and pervasive of these resources; that racialized perception both frames and follows from the dialectical, intersubjective processes that underwrite our social transactions and our self-understandings; and that expressive, or aesthetic, practices are an illuminating register of the racialization of perception, an indispensable resource in retraining these perceptions, and a vital tool in reconfiguring the power relations that the perceptions emblematize and facilitate. That is to say, the aesthetic can be a resource for moving, as Maria Lugones and Peta Bowden might put it, from perceiving racial "others" arrogantly to perceiving them lovingly, with the ethical attentiveness that combats reductionism and objectification.[61] I will, of course, principally concern myself throughout with the modes of racialization that specify the locations and parameters of blackness.

On the testimony of authorities like Fanon, Morrison, Gordon, Ellison, Wallace, Diawara, and hooks, I've argued in this chapter that many central features of black racialization can be thought of as forms of invisibility. This turns out to mean several things, related most clearly to the systematic and persistent disregard for black presence, personhood, perspectives, and plurality. These forms of disregard have been enshrined in the racial "commonsense" of white supremacy, have been enacted by whitely forms of cultural expression, and have been both enacted and contested by the antiracist and pro-black responses and alternatives to whitely hegemony.

If I've done my job here, the discussion to this point should have opened as many questions as it has answered, if it has answered any. One of those questions might arise from a moment's reflection on the examples I've used to this point. Many of them, including the one that opens the chapter, are not in any straightforward sense works that we might think of as examples of "black art." *Far From Heaven* is about race, among other things, but it seems not to be a black film, whatever that is. For one thing, its director and three of its four stars are white. For another, it is not so much about race as about *racism*, or intolerance, and principally about the effects of this intolerance on white people. Dennis Haysbert's character does have to leave Connecticut at the end of the film, as if in an effort to bear out the red-faced man's claim. But the last thing we see is Julianne Moore's character beginning to pick up her life in the wake of this departure. This change in the black man's fortunes is, as far as the implied spectator is concerned, a tragedy for the *white woman*. This is not a criticism of the film, but an attempt to locate its narrative center, and to raise the question of what a film like that is doing in a place like this.

One might think that a study of black aesthetics should limit itself to black art and criticism, and that there must be some way to specify the boundaries of the categories invoked in this way. I've touched on this question in the introduction, but only long enough to stipulate to the methodological orientation of this book. That short discussion did not address the *political* question of the blackness of black aesthetics, and it is to that question that we should now turn.

Notes

1 Todd Haynes, dir., *Far From Heaven* ([Vulcan-Focus], 2002); Todd Haynes, *Far From Heaven, Safe, and Superstar: Three Screenplays* (New York: Grove Press, 2003), 47–48.

2 Borys Kit, "Zoe Saldana To Play Nina Simone in Biopic," *The Hollywood Reporter*, August 15, 2012, http://www.hollywoodreporter.com/news/zoe-saldana-nina-simone-biopic-david-oyelowo-362864 (accessed September 20, 2013); "Controversial Casting For Nina Simone Biopic," NPR November 20, 2012, 10:00–11:00 AM, Morning Edition: *NewsBank* (accessed September 20, 2013); Tanzina Vega, "Stir Builds Over Actress To Portray Nina Simone," *New York Times*, September 13, 2012, http://www.nytimes.com/2012/09/13/movies/should-zoe-saldana-play-nina-simone-some-say-no.html?smid=pl-share (accessed September 20, 2013).

3 Tiffany Jones, "(Mis)Casting Call: The Erasure of Nina Simone's Image," http://www.coffeerhetoric.com/2012/08/miscasting-call-erasure-of-nina-simones.html, posted August 17, 2012 (accessed September 20, 2013).

4 http://www.clutchmagonline.com/2012/10/new-photos-of-zoe-saldana-as-nina-simone-emerge-were-still-not-impressed/ (accessed January 2, 2014).

5 Britni Danielle, "New Photos of Zoe Saldana as Nina Simone Emerge – We're Still Not Impressed," *Clutch Magazine* (Online), October 29, 2012, http://www.clutchmagonline.com/2012/10/new-photos-of-zoe-saldana-as-nina-simone-emerge-were-still-not-impressed/ (accessed January 2, 2014).

6 Ralph Ellison, *Invisible Man* (1952; New York: Vintage Books, 1989), 3.

7 See Daniel Kahneman, Paul Slovic, and Amos Tversky, *Judgment Under Uncertainty: Heuristics and Biases* (Cambridge: Cambridge University Press, 1982); Daniel Kahneman, "A Perspective on Judgment and Choice: Mapping Bounded Rationality," *American Psychologist* 58 (2003), 697–720; Anthony Greenwald, Debbie McGhee, and Jordan Schwartz, "Measuring Individual Differences in Implicit Cognition: The Implicit Association Test," *Journal of Personality and Social Psychology* 74:6 (1998), 1464–1480.

8 Cameron Lynne Macdonald and David A. Merrill, "'It Shouldn't Have to be a Trade': Recognition and Redistribution in Care Work Advocacy," *Hypatia* 17:2 (Spring 2002), 72.

9 W. E. B. Du Bois, *The Souls of Black Folk* (Chicago: A. C. McClurg & Co., 1903); Bartleby.com, 1999, www.bartleby.com/114/1.html, par. 3 (accessed May 12, 2009).

10 Maxine Sheets-Johnstone, *The Primacy of Movement* (Philadelphia: John Benjamins, 1999).

11 Shaun Gallagher and Andrew Meltzoff, "The Earliest Sense of Self and Others: Merleau-Ponty and Recent Developmental Studies," *Philosophical Psychology* 9:2 (June 1996), sec. 2, par. 10. The authors are keen to distinguish body image from body schema, and cite Merleau-Ponty for the point. "Merleau-Ponty ... names and identifies the body schema (rather than the body image) as the anterior condition of the possibility for perception. He calls the body schema a dynamic form, a being-in-the-world, of which we have a 'tacit understanding.' When he does say that the body schema involves a consciousness of the body, he quickly qualifies this by claiming that it is not a 'positional consciousness, a representation, Vorstellung.' In this sense, he suggests, the body schema might best be expressed as a set of laws rather than a set of images (1962, pp. 99–101, 104; 1964, p. 133)." Sec. 2, par. 13. See also Shaun Gallagher and Jonathan Cole, "Body Schema and Body Image in a Deafferented Subject," *Journal of Mind and Behavior* 16 (1995), 369–390; reprinted in Donn Welton, ed., *Body and Flesh: A Philosophical Reader* (Oxford: Blackwell), 131–147.

12 Frantz Fanon, Black Skin, *White Masks* (1952; New York: Grove Press, 2008), 90–92.

13 Fanon 92. On the Banania ads, see Brett A. Berliner, *Ambivalent Desire: The Exotic Black in Jazz-Age France* (Amherst: University of Massachusetts Press, 2002), 10–17. The Wikipedia entry on this helpfully tracks the ad's central image through the various stages of its evolution (http://en.wikipedia.org/wiki/Banania, accessed June 14, 2009).

14 Cynthia Bertelsen, "Banania – An Image of French Colonialism?" *Gherkins and Tomatoes* (blog), posted January 31, 2011, http://gherkinstomatoes.com/2011/01/31/banania/ (accessed January 22, 2015).

15 Claude M. Steele, "Thin Ice: 'Stereotype Threat' and Black College Students," *The Atlantic Monthly* 284:2 (August 1999), 44–54. Digital edition at http://www.theatlantic.com/past/issues/99aug/9908stereotype.htm (accessed November 22, 2015).

16 On the variety of forms invisibility takes for Fanon, see David Theo Goldberg, *Racial Subjects: Writing on Race in America* (New York: Routledge, 1997), 79–108.

17 Toni Morrison, *The Bluest Eye: A Novel* (New York: Simon and Schuster, 1970).

18 Michele Wallace, *Dark Designs and Visual Culture* (Durham, NC: Duke University Press, 2004), 186.

19 Among the many topics she explores under the rubric of black visuality are the "negative scene of instruction" that defines the relationship between black and white artists, critics, and theorists, with neither camp willing to credit the other's contributions to its own work and world; the erasure of gay black

men, of the body, and of sexuality from "respectable" black criticism and history, as an overreaction to the primitivist eroticization of blackness; the erasure of black women as subjects and agents in respectable black practices, in keeping with familiar patriarchal commitments; the overdetermined "restraint of trade" that minimizes black participation in the visual arts, thanks to, among other things, the still-segregated economy of the gallery and museum world; and the way music and literature take center stage in the accounts of black culture provided by black critics and intellectuals, thereby adding to the "restraint of trade" problem by squeezing out the contributions of black painters, photographers, and other visual artists. Wallace 366, 372–373, 191–192, 370, 366, 192.

20 Martin Jay, "Scopic Regimes of Modernity," in Hal Foster, ed., *Vision and Visuality* (New York: New Press – Dia Art Foundation, 1999), 3–28.

21 Mirzoeff writes, "Visuality was … the clear picture of history available to the hero as it happens and the historian in retrospect. It was not visible to the ordinary person whose simple observation of events did not constitute visuality." Nicholas Mirzoeff, "On Visuality," *Journal of Visual Culture* 5 (April 2006), 53–79.

22 Ernesto Laclau, "Discourse," in Robert Goodin and Philip Pettit, eds., *A Companion to Contemporary Political Philosophy* (Malden, MA: Blackwell, 1995), 431–437, 431.

23 Norman Bryson, "The Gaze in the Expanded Field," in Foster 87–114, 92–94.

24 David Natharius, "The More We Know, the More We See: The Role of Visuality in Media Literacy," *American Behavioral Scientist* 48:2 (2004), 238–247, 238.

25 Lynn Higgins, "Guy Debord (1931–1994) and the Situationist International," in Julian Wolfreys, ed., *The Edinburgh Encyclopaedia of Modern Criticism and Theory* (Edinburgh, Scotland: Edinburgh University Press, 2002), http://libproxy.temple.edu:2150/entry/edinburghmct/guy_debord_1931_1994_and_the_situationist_international (accessed May 13, 2009).

26 Ian Hacking, *Historical Ontology* (Cambridge, MA: Harvard University Press, 2002).

27 Laclau, in Goodin and Pettit 435.

28 Howard Winant, *Racial Conditions: Politics, Theory, Comparisons* (Minneapolis: University of Minnesota Press, 1994).

29 Houston A. Baker, *Afro-American Poetics: Revisions of Harlem and the Black Aesthetic* (Madison: University of Wisconsin Press, 1996), 164.

30 "50% of all of the motion pictures produced in the United States prior to 1950 have disintegrated and are lost, while only 10% of the movies produced before 1929 exist in any form. For shorts, documentaries, newsreels and other independently produced and 'orphan' films, the fate is much worse and there is no real way of knowing how much is missing from our motion picture history." http://www.film-foundation.org/common/news/reports/detail.cfm?Classification=report&QID=5316&ClientID=11004&TopicID=0&subnav=preserve, par. 3 (accessed May 24, 2009).

31 J. Ronald Green, "'Twoness' in the Style of Oscar Micheaux," in Manthia Diawara, ed., *Black American Cinema* (New York: Routledge, 1993).

32 Lewis Gordon, "Existential Dynamics of Theorizing Black Invisibility," in Lewis Gordon, ed., *Existence in Black* (New York: Routledge, 1997), 69–80, 73.

33 Howard McGary, *Race and Social Justice* (Malden, MA: Blackwell, 1999), 37. In a similar spirit, Rawls writes, "Historically (in the west), the concept of the person has been understood, in both philosophy and law, as the concept of someone who can take part in, or who can play a role in, social life, and hence exercise and respect its various rights and duties. Thus, we say that a person is someone who can be a citizen, that is, a normal and fully cooperating member of society over a complete life." John Rawls, *Political Liberalism* (New York: Columbia University Press, 1993), 18.

34 Charles Mills, *Blackness Visible* (Ithaca: Cornell University Press, 1998), 6–10.

35 Gordon, *Existence in Black* 72–73; Fanon 95.

36 Donald Bogle, *Toms, Coons, Mulattoes, Mammies, and Bucks: An Interpretive History of Blacks in American Films*, 4th ed. (New York: Continuum, 2008), esp. 1–18. Marlon Riggs, dir., *Ethnic Notions* (KQED, 1986).

37 Gordon, *Existence in Black* 75.

38 Robert Gooding-Williams, *Look, A Negro!* (New York: Routledge, 2006). Oda Mae is a particularly rich example, as Patrick Swayze's character, the eponymous ghost, actually uses Oda Mae's body to caress his still-living wife. This arrangement seems to insulate the film from charges – fatal charges, for a film targeting the market at which *Ghost* took aim – of hinting at lesbian and interracial sexuality. Because there are only so many symbolic options for black women on film, and because Goldberg is clearly not a sultry, rapacious jezebel, she must not be a sexual being at all, and can serve as an asexual bridge between living and dead white lovers.

39 In this case the motivations have to do with the desexualization of blacks. White supremacy could not countenance normal, healthy black sexuality, and so conjured up opposed, deviant alternatives to obscure the more complex, human reality. Blacks appeared in western culture either as bucks and jezebels, whose *raison d'être* just is sexuality, or as mammies, toms, and the rest, who were ostentatiously asexual, even repulsive. This legacy lives on in the frequency with which recent industrial films use blackness to evade romantic or sexual activity that the narrative would otherwise demand. Think of the otherwise traditional narratives of *Beverly Hills Cop* and *The Pelican Brief*, which go to some lengths to keep the male leads (Denzel Washington and Eddie Murphy) from getting the (white) girl that the male protagonists of action films and thrillers typically claim as their right.

40 Toni Morrison, *Playing in the Dark: Whiteness and the American Literary Imagination* (New York: Vintage, 1992), 68.

41 Morrison, *Playing in the Dark* 86.

42 Morrison, *Playing in the Dark* 6–7. Morrison focuses principally on American Africanism, but mentions a European version: see p. 38 for the distinction.

For more on the broader point, see Paul C. Taylor, "The Last King of Scotland or The Last N----r on Earth: The Ethics of Race on Film," *Contemporary Aesthetics*, special volume 2 (2009), "Aesthetics and Race: New Philosophical Perspectives," ed. Monique Roelofs, http://www.contempaesthetics.org/newvolume/pages/article.php?articleID=533.

43 Fanon 111.

44 Aimee Carrillo Rowe, "Feeling in the Dark: Empathy, Whiteness, and Miscegenation in *Monster's Ball*," *Hypatia* 22:2 (Spring 2007), 122–142, 126.

45 Morrison, *Playing in the Dark* 52, 56. See adds: "Freedom can be relished more deeply in a cheek-by-jowl existence with the bound and unfree, the economically oppressed, the marginalized, the silenced" (64).

46 Morrison, *Playing in the Dark* 72.

47 Sander Gilman, "The Hottentot and the Prostitute: Toward an Iconography of Female Sexuality," in Kymberly N. Pinder, ed., *Race-ing Art History: Critical Readings in Race and Art History* (New York: Routledge, 2002), 119–138, 119–121.

48 It is surely to the point to note that a website accompanying a PBS documentary on Manet's painting describes *Olympia* without making any reference to the maid, and concludes by saying, "The foreground is the glowing white body of Olympia on the bed; the background is darkness." http://www.pbs.org/wgbh/cultureshock/flashpoints/visualarts/olympia_a.html (accessed November 23, 2015).

49 Manet can be read, and has been read, as redeploying the symbol of the black maid in a way that highlights the class structure of French society, and individualizes the maid as well as her similarly *lumpen* employer. See Alexander Nehamas, *Only a Promise of Happiness: The Place of Beauty in a World of Art* (Princeton: Princeton University Press, 2007).

50 Elizabeth Harney, *In Senghor's Shadow: Art, Politics, and the Avant-Garde in Senegal, 1960–1995* (Durham, NC: Duke University Press, 2004), 29.

51 Charles H. Rowell and Kerry James Marshall, "An Interview with Kerry James Marshall," *Callaloo* 21:1, "Emerging Male Writers: A Special Issue," part 1 (Winter 1998), 263–272.

52 Gordon, *Existence in Black* 73.

53 The language I'll use here owes a great deal, perhaps manifestly so, to the work of Wayne Booth and Berys Gaut. See especially Berys Gaut, "The Ethical Criticism of Art," in Jerrold Levinson, ed., *Aesthetics and Ethics: Essays at the Intersection* (Cambridge: Cambridge University Press, 1998), 182–203; and Wayne Booth, *The Rhetoric of Fiction* (New York: Penguin, 1987).

54 Manthia Diawara, "Black Spectatorship: Problems of Identification and Resistance," in Diawara, *Black American Cinema* 211–220.

55 Michiko Kakutani, "CRITIC'S NOTEBOOK; Within Its Genre, A Takeoff on Tara Gropes for a Place," *New York Times*, Saturday, May 5, 2001 (New York edition), B9; http://www.nytimes.com/2001/05/05/books/critic-s-notebook-within-its-genre-a-takeoff-on-tara-gropes-for-a-place.html?pagewanted=1 (accessed May 29, 2009).

56 Diawara, "Black Spectatorship" 211. Nothing I say here depends on saving people like Metz from the criticisms brought against them by Noël Carroll. Noël Carroll, *Mystifying Movies: Fads and Fallacies in Contemporary Film Theory* (New York: Columbia University Press, 1988).

57 bell hooks, "The Oppositional Gaze," in Diawara, *Black American Cinema* 288–302, 290–291.

58 hooks, "Oppositional Gaze" 291.

59 Joseph Lowery worked with Martin Luther King, Jr. and others to establish the Southern Christian Leadership Conference, one of the five main organizations (with the Student Nonviolent Coordinating Committee [SNCC], the National Association for the Advancement of Colored People [NAACP], the Urban League, and the Congress of Racial Equality [CORE]) in the mid-twentieth-century US civil rights movement. A rhymed gloss on racial stratification has been a mainstay of his oratory for decades. This habit received little attention outside the black church community until Barack Obama's first inaugural, for which Lowery provided the benediction. See "Transcript of Rev. Lowery's Inaugural Benediction," *The Washington Post — Inauguration Watch* (blog), January 20, 2009, http://voices.washingtonpost.com/inauguration-watch/2009/01/transcript_of_rev_lowerys_inau.html (accessed February 26, 2015).

60 Rebecca Frasquet, "Danny Glover's Slavery Film Lacked 'White Heroes,' Producers Said," *Agence France-Presse*, July 25, 2008, http://infoweb. newsbank.com/resources/doc/nb/news/122265E025AF1458?p=AWNB (accessed February 26, 2015).

61 Maria Lugones, "Playfulness, 'World'-Travelling and Loving Perception," *Hypatia* 2 (1987), 3–19; Peta Bowden, "Ethical Attention: Accumulating Understandings," *European Journal of Philosophy* 6:1 (1998), 59–77.

3

Beauty to Set the World Right: The Politics of Black Aesthetics

I am one who tells the truth and exposes evil and seeks with Beauty and for Beauty to set the world right. That somehow, somewhere eternal and perfect Beauty sits above Truth and Right I can conceive, but here and now and in the world in which I work they are for me unseparated and inseparable.

W. E. B. Du Bois, "Criteria of Negro Art"[1]

Black Art is the aesthetic and spiritual sister of the Black Power concept.... One is concerned with the relationship between art and politics; the other with the art of politics.

Larry Neal, "The Black Arts Movement"[2]

[W]hen we got together, it was always Marx, Lenin, and revolution ... real girls' talk.

Jazz musician Nina Simone, on her conversations with writer Lorraine Hansberry[3]

1 Introduction

In the waning months of 1960, African American musician Louis Armstrong fielded political questions from reporters in Kenya. Armstrong had come to the East African state during an eleven-week tour of the continent, the last nine weeks of which were sponsored by the US Department of State.

Black is Beautiful: A Philosophy of Black Aesthetics, First Edition. Paul C. Taylor.
© 2016 Paul C. Taylor. Published 2016 by John Wiley & Sons, Ltd.

(Pepsi-Cola sponsored the first two weeks, a fact that we will return to later in this book.) The government-sponsored portion of the trip took him to Nairobi, where reporters were keen to have the legendary musician share his political views. This journalistic desire was understandable: Armstrong, an African-descended artist who had achieved worldwide fame, had arrived in Africa at an eventful moment in the history of anti-racist and anticolonial politics. The US civil rights movement was in full swing and making news around the world. At the same time, the transitions of African decolonization were under way, with Morocco, Tunisia, Libya, Sudan, and Ghana having gained their formal independence by 1957, and with sixteen other states following by the end of 1960.[4] And these developments had come with their share of violence and controversy, particularly in what had been the Belgian Congo, in French-dominated Algeria, and in the Jim Crow US South.

Armstrong responded to the Kenyan reporters' questions with an osten-tatious performance of ignorance and nonchalance. "I don't know anything about it," he said: "I'm just a trumpet player." He went on: "The reason I don't bother with politics is the words is so big. By the time they break them down to my size, the joke is over."[5]

For people who know less about Armstrong and about mid-century cultural politics than about the proprieties of post-civil rights black oppositional culture – for people, that is, like me, before I started doing this work – Armstrong's response will not be surprising. If one is moved by the defiant assertiveness of Black Power politics or by the dour pessimism of hip-hop culture, Satchmo's wide grin and jovial public sensibility can be as hard to take as a minstrel show. From an untutored post-soul perspective, Armstrong's ungrammatical avowal of ignorance might seamlessly represent the predictable servility of an older generation.

For people with a deeper sense of who and what Armstrong was, though, or with a deeper awareness of the ethical and historical complexities of black expressive culture under white supremacy, the response will be surprising. Or, better, it will seem incomplete, especially if one pays attention to the language. Armstrong was certainly *not* just a trumpet player, any more than he was a grinning fool or a monolingual speaker of Ebonics. His considerable musical gifts aside – Wynton Marsalis has spoken eloquently to that dimension of the man[6] – Armstrong was a worldwide phenomenon: a continent-hopping cultural agent of such global import that "first world" governments and multinational corporations alike sought to wrap themselves in his mantle. (Apparently Pepsi bought street signs in Kenya to assail their potential customers with a simple argument: "You like Satchmo. Pepsi brings you Satchmo. Therefore, you like Pepsi."[7])

The sense of incompleteness diminishes once we fill in the background: Armstrong had assumed his place in the State Department's "jazz ambassadors" program only after the US federal government committed to intervening in the crisis that had followed from desegregation efforts in Little Rock, Arkansas. In part because of this crisis, during which Arkansas governor Orval Faubus had pledged to resist federal desegregation mandates, Armstrong had previously *refused* to serve as a jazz ambassador. He made it perfectly and publicly clear that he would not use his performances to promote the image of the US abroad while racists at home were allowed to flout legal and ethical injunctions against racist practices. Armstrong's public pronouncements on the subject were unequivocal. President Eisenhower, he said, was "two-faced" and "had no guts"; and "it's getting so bad, a colored man hasn't got any country."[8]

In at least two ways, Armstrong's public evasion of his equally public negotiation with a US state still recovering from *de jure* white supremacy is a useful starting place for a study of the expressly political dimensions of black aesthetics. First, it highlights the way that even explicit disavowals of politics – and apparently apolitical figures – can be politically salient in the realm of expressive culture. More to the point, it reveals the ease with which practitioners of black aesthetics can accomplish this slippage from the "merely" cultural to the political. This slippage occurs quite readily because black aesthetics is an unavoidably political subject. It exists as a cultural phenomenon and as a subject of philosophical study because of political conditions. And its best known participants and proponents have often taken explicitly political stances.

The layered nature of Armstrong's stance points to a second point of affinity between his example and the work of this chapter. By engaging in public social criticism only long enough to have some concrete demand met, and then donning the guise of the simple, politically naïve performer for still other political purposes (those of the State Department), he revealed a kind of ambivalence that goes to the heart of any ethico-political approach to expressive culture. The particular mode of ambivalence that we find here emerged in the modern period, but the basic questions of course go back as far as Plato: Should culture workers get involved in formal politics? And should ethical concerns shape our approach to the practice of cultural expression? These questions – which are both, in their way, questions about autonomy in the aesthetic domain – took on a special resonance in the twentieth-century phase of the black freedom struggle, in ways we'll consider below.

A third question of aesthetic autonomy lurks behind these first two, and requires an answer before expressive culture can have any claim on the attention of political actors. Frankfurt School theorists raised this third

question most prominently, in forms indebted but not enslaved to Marxian traditions of social analysis: Can expressive culture transcend the social milieu from which it emerges, and serve as a resource for opposition to the status quo? Or, to put it in oversimple, crudely Marxian terms: Can activities like the creation and criticism of art, as parts of the superstructure, achieve some degree of autonomy from the economic base?

Black political actors across the ideological and organizational spectrum have routinely used expressive culture to do their work and advance their causes. But the proper relationship between cultural and political work has remained controversial, with different views becoming ascendant in different traditions and communities, and at different times within the same traditions and communities. Accordingly, the burden of this chapter will be to explore the question of just how politics and expressive culture can and ought to relate to each other. In deference to certain settled ways of thinking about art, expression, and politics – ways that we will revisit soon and interrogate some-what later – I will think of this as *the problem of aesthetic autonomy*, and approach it by way of the three questions introduced above: Should political actors enjoy freedom from interference by culture workers? Should culture workers enjoy freedom from interference by politicians and moralists? And can expressive culture escape and contest the influence of its originating social context?

My aim in taking up the questions of autonomy is not to provide definitive answers. I want instead to do three things: (1) to provide a glimpse of the way these questions register in the black aesthetic tradition, by (2) exploring W. E. B. Du Bois's iconic arguments about art and propaganda, an exploration I propose to undertake by (3) translating the arguments into the language of more or less mainstream Anglophone academic philosophy.

Of course, political questions about matters other than autonomy come to mind when one studies black aesthetics. Notions like authenticity, soli-darity, identity, ownership, and memory loom large in this tradition, and each has its own web of connections to questions of power, justice, citizenship, and freedom. We will explore these other issues, fully mindful of their political implications, in the chapters to come. For now the aim is to get clear on just how to think about the connections between aesthetics and politics, both as a conceptual matter and as a matter of the concrete development of these concepts in a specific, New World African context.

2 Blackness and the Political

Black aesthetics may be bound up with politics, but no single political stance defines the practice or study of black aesthetics. We spent some time in the previous chapter exploring the problem of racialized invisibility, which in its

most familiar forms points to the stew of integrationism and liberalism that we typically associate with civil rights activism. But liberal integrationism is clearly not the only game in town. Cultural nationalists and revolutionary socialists loom large in the history of black aesthetics, and the dialectical political reflections of (what I will soon call) deconstructive feminism, queer theory, and postcolonialism are powerful influences in the tradition's present. A proper understanding of the political dimensions of black aesthetics, then, will be elusive without a prior understanding of the ideological diversity of black political thought.

A proper study of the nature, varieties, and dimensions of black politics would of course take us far afield of our subject. There are many ways of approaching the political dimensions of black life, and many different ways of understanding the relations between these different approaches. There are also, however, some commonalities, the elucidation of which will help set the stage for a discussion of the relationship between politics, blackness, and aesthetics.

According to Michael Dawson, a distinctively black political orientation may have "counterparts in white society," but it grows out of, and is inflected by, the distinctive histories and conditions that define the condition of blackness.[9] This racial inflection leads to political ideologies with five basic features: (i) the explicit adoption of a black point of view; (ii) a commitment to communalism; (iii) a commitment to spirituality; (iv) insistence on an organic link between theory and practice; and (v) a commitment to the pursuit of black autonomy, whether for individuals, institutions, or the race as a whole.[10] These features are the common inheritance of political stances that are otherwise at odds with each other, and whose collisions in fact shape the terrain of black politics.

The manner in which these different political orientations publicly and practically manifest themselves will of course vary with the broader political commitments in play. For example, Marcus Garvey pursued autonomy for the black race by working to turn the diaspora into a unified nation, on a par with modern empires like Japan and Great Britain. Clarence Thomas, by contrast, wants individual black people to be free not just of white racism but also of the expectations that they will comply with oppressive racial scripts concerning, among other things, their political affiliations and convictions. Both men are concerned, in their way, with specifically black autonomy, with the fortunes of the black community as a whole, with the need for political theories to answer to the concrete needs of actual, living black people, with the extra-material – the spiritual – aspirations and welfare of black communities, and with the way social arrangements look from the perspectives that black people have typically been afforded on them. But they branch off in quite different directions from this core of shared commitments.

Thomas's conservatism and Garvey's nationalism represent just two of the general forms that black political thought can take. Still following Dawson, we might consider black nationalism and conservatism alongside racially inflected variants of other familiar political orientations, like feminism, liberalism, and Marxian radicalism. We might develop Dawson's picture – which really is like a picture, as it aims to provide a social-scientific "snapshot" of the most prominent political orientations in contemporary Afro-US communities – by adding in categories for less prominent but still influential approaches. I'm thinking here of black radical democrats and of what we might call "deconstructive" radicals – the postcolonial thinkers, black queer theorists, and others who deploy the skeptical and dialectical spirit of postmodernism, poststructuralism, and existentialism to provide a phenomenology of the political.[11] These views are of course not hermetically sealed off from each other. For example, black radical democrats and deconstructive radicals may converge, for different reasons, on broadly liberal or Marxian political commitments. (Then again, they may not.)

We might complicate Dawson's picture further by layering over it the rather different picture that comes from focusing not on political ideologies but on genres of political thought. Genres of political writing are defined by their attention to specific questions, figures, and modes of argumentation. And the categories marked off by these defining characteristics do not necessarily map onto familiar ideologies like liberalism and Marxism. The genre of social contract theory, for example, includes liberals like Locke as well as non-liberals like Hobbes and Rousseau. At the same time, each of Dawson's major ideologies sustains debates in a variety of genres. For example, analytic philosophers and existentialists have created distinct, and largely incompatible, genres of Marxian thought.

The dominant genre in black political thought is what Gooding-Williams calls "Afro-Modern political theory." This view cuts across Dawson's major ideologies and recommends different lines of division. Black feminists, liberals, Marxian radicals, and conservatives are all likely to be Afro-modernists: they all appropriate the basic tenets of modern political thought in the shared settings of black counter-public spheres; and they undertake this work to answer questions about the "political and social organization of white supremacy, the nature and effects of racial ideologies, and the possibilities of black emancipation."[12] Deconstructive radicals, by contrast, are likely to refuse or question modern ideas of emancipation and racial identity on broadly deconstructive (though not necessarily deconstructionist) grounds, thereby enacting a form of Afro-*post*-modernism. Certain kinds of nationalists will enact a similar refusal but from the opposite direction, as it were: they will reject the modern idea of racial blackness in favor of a broader, and older, *African* identity, thereby marking themselves as what we might call Afro-*classicists*.

This very broad conceptual geography of black politics begins to fill in the background to a responsible study of black aesthetic politics. Each of the positions noted above offers itself as an appropriate political stance toward the condition of blackness, and each has adherents that turn the resources of expressive practice to its broader ideological purposes. Conservative Afro-modernism gives us Bill Cosby's performances and moving pictures, Afro-post-modernist queer theory gives us Audre Lorde's poetry and criticism, liberal Afro-modernism gives us Spike Lee's "joints," Afro-modern Marxism gives us Du Bois's epic novels, and so on. After a few words on the general relationship between the political and the aesthetic, we will be able to consider some of the specific issues that emerge from the work of figures like these.

3 Politics and Aesthetics

All experiences and practices have their aesthetic dimensions, but the connections between politics and the aesthetic are particularly interesting. There are many ways of thinking about these connections, but for current purposes I want to focus on a quite general way of mapping the connections that yields three options. On this approach, aesthetic practices and objects can serve as resources for political work, as models or metaphors for political work, and as occasions for political contestation and controversy. Each of these options for linking aesthetics and politics comprises a wide variety of possible activities and actual historical examples, some of the most familiar of which point us toward the distinctive concerns of black aesthetics.

The aesthetic serves as a resource for political work – and manifests as various forms of *political aesthetics* – when aesthetic practices advance political projects. This thought about the aesthetic and the political as allied enterprises might point us first to the aesthetic saturation of everyday life, and encourage us to notice, with Richard Iton, such things as the relationship between Malcolm X's comic timing and his oratorical power. After noting that political action, like every other kind of action, has its aesthetic dimensions, we might think next of the way aesthetic work can contribute to the politics of habituation or subject formation, as figures as far apart as Plato, Adorno, and Laura Mulvey have discussed at length. Building on Plato's quarrel with poetry, we could insist here on the role of expressive culture in shaping expressly *political* subjects, and on the importance of engineered, reason-disabling spectacles to this process. We might think next of the way political agendas can inform aesthetic projects. We see this kind of political aesthetic in work that emerges from and is shaped by definite political perspectives, like socialist realism or surrealism.[13] But we see it also in work that

is not just informed but distorted by its political commitments – in other words, in propaganda: in plays that sacrifice character and complexity to extol the virtues of patriotism, novels that eschew historical accuracy to inflate the achievements of a particular group, and paintings that depict the enemies of the state as uniformly ugly or fearsome.

If we move from thinking of the aesthetic and the political as allied enterprises to thinking of them as *analogous enterprises*, we move from the domain of political aesthetics to the domain of *aesthetic politics*. Here the actual practice of art is less important than the idea of art, which can serve political actors as a model or inspiring metaphor. The easiest examples of this approach are auteurist, avant-gardist, and Arendtian. We see the auteurist approach in fascists like Mussolini, who may think of themselves as artists of the polis, imposing harmonious form on the chaos of social life (and insulated from criticism by the formalist elevation of creativity over ethics). Foucault provides one of the more famous examples of the avant-garde approach, with his Nietzschean determination to break through preexisting ethical forms and create an original life, thereby making himself into a work of art. The Arendtian approach takes its name from Hannah Arendt's determination to use a Kantian model of aesthetic judgment as a model for political judgment, to emphasize the ungrounded, uncoerced agreement that is the aim of political life.[14]

The various forms of political aesthetics and aesthetic politics are of course not hermetically sealed off from each other. The socialist realists and surrealists wanted to help create new political subjects, and took this goal as a reason to frame their norms for the evaluation and production of art in light of their political commitments. Similarly, mid-twentieth-century fascists relied heavily on the subject-forming powers of expressive culture, as well as on the persuasive powers of propaganda. And finally, the political "artist" may go beyond the metaphor of statecraft as creative composition, and borrow the performance and production techniques of great entertainers.

In addition to being allied with or analogous to politics in the ways noted above, the aesthetic can clearly become a *politicized* enterprise. As an enterprise that routinely ignites and interrogates political contests and controversies, and as a space where political struggles routinely get worked out, the aesthetic *implicates and is implicated by* the political. Of the many examples we might consider here, perhaps the most obvious come from controversies like the ones surrounding Chris Ofili and Robert Mapplethorpe, artists whose work got caught up in debates about the propriety of state support for disturbing or challenging art. There are also, of course, the public debates about the ethico-political import of popular films, like *The Last Temptation of Christ*, or, more recently, *The Passion of the Christ* or *Avatar*. And there are debates, particularly among Marxists and critical theorists, about the

political valences of specific approaches to artmaking – about, for example, whether some idiom or set of techniques is inherently problematic, as Adorno famously argued in connection with jazz.

In addition to the three modes of aesthetico-political relation discussed above, a fourth approach argues that the very idea of the aesthetic – of a realm of human experience and practice that is somehow distinct from other realms – might be bound up with a particular political project. As we noted in Chapter 1, the idea of the aesthetic, like the idea of race, is a modern invention, which is to say that it emerges along with, and as part of, the social formation that cultural theorists have taught us to refer to as "modernity" or "the modern." The familiar elements of this social formation – liberal democracy, capitalism, nation-states, science as we know it, industrial economies, and gender relations as we know them – assumed the forms we know during overlapping periods of time, along with and underwritten in some ways by ideologies of progress and autonomy. These familiar, widely praised elements emerged along with others – like the practices of European colonialism and anti-black racism – that the enthusiasts of the modern are less keen to insist on. Enrique Dussel refers to these other elements as "the underside of modernity," and argues, with Charles Mills and many others, that modernity is not just complicated and compromised by this underside but constituted by it in deep and abiding ways. We'll return in later chapters to the question of whether the idea of the aesthetic is "a key brick in the wall of [a racialized] modernity."[15] For the remainder of this chapter we will focus on the other three modes of relation.

4 The Politics–Aesthetics Nexus in Black; or, "The Black Nation: A Garvey Production"

The link between aesthetics and politics has been unusually central to the practice of black politics. One way to make this point pertains most clearly to black peoples in the Americas and in Europe. Having been barred, for the most part, from the spaces and settings that their societies of residence set aside for the formal conduct of politics, black people turned disproportionately to expressive culture (a detour that dovetailed with the imperatives set by the reigning ideologies of anti-black racism, which often imagined blacks as naturally sensuous and artistic). Another way to make the point links blacks across the diaspora. Racialization is in part an aesthetic project, in both its stigmatizing and its solidaristic phases; and the idea of blackness derived much of its political content in the twentieth century from efforts to use expressive culture to help bring a transnational political community into being. For these and other reasons, expressive culture has played a larger role

in the political lives of black people *qua* blacks than it has in the lives of people identified in other ways – as, say, Swiss, Turkish, or even Ghanaian.

Because of the centrality of aesthetics to the conduct of black politics, the various forms of the aesthetic–political relation figure prominently in the history of black aesthetics. Some of the most familiar moments in this history emerge from enterprises that are allied with, analogous to, or implicated by the political. Of the many examples that we might choose to exemplify these moments, I propose to focus on the single case of Marcus Garvey, which has the virtue of clearly showing the three modes of relation at work in black politics all at once.[16]

Marcus Garvey is rightly regarded as a canonical figure in the history of black politics. Like the other figures considered here, though, his importance transcends racial considerations. He belongs to the broader history of late modern culture and politics in ways that cannot be responsibly ignored. His dealings with the Ku Klux Klan, his impact on global anti-imperialist activism (beginning with his perhaps apocryphal encounter with Ho Chi Minh), and his mastery of modern political technique – mastery enough to mobilize "the largest ... [and] broadest mass movement in Afro-American history"[17] – are, or ought to be, part of the story of twentieth-century politics, race notwithstanding.

That said, Garvey's claim on our attention begins with his pioneering roles in the histories of black nationalism and Pan-Africanism. As the founder of the Universal Negro Improvement Association (UNIA) and its journal, *Negro World*, he was an inescapable presence in the ferment of new world African political modernism. And as a symbol of the emancipatory aspirations of black freedom fighters, he remains an unavoidable cultural presence, featured prominently in world-spanning matrices of cultural expression like Rastafarianism, reggae music, and North American and African hip-hop.

One of the more interesting features of Garvey's political work, and one of the keys to his success, was his insistence on manipulating the aesthetic markers of national self-determination. The UNIA was known as much for its pageants and parades as for Garvey's scintillating public speaking and the incendiary articles of *Negro World*. One historian describes it this way:

> Garvey created a host of groups: an African legion clad in blue military garb, Black Cross Nurses, uniformed marching bands, choristers, and various auxiliaries. The pageantry implicit in all of this was revealed during the UNIA's First International Convention in 1920. Spectators lined the streets of Harlem for miles to watch Garvey in military uniform and plumed hat lead his impressively arrayed followers marching under such banners as: "We Want a Black Civilization," "God and the Negro Shall Triumph," [and] "Uncle Tom's Dead and Buried."[18]

Garvey's work with the UNIA implicates all three modes of aesthetico-political relation. Most obviously, he relied on political aesthetics by putting prose and poetic writing, costume design, musical composition, performance, and more in the service of his nationalist project. Somewhat less obviously, he enacted a form of aesthetic politics. Because he had no state to coerce or materially reward popular commitment to his nation, Garvey had to win the support and sustained attention of his followers with an ornate *performance* of sovereignty. This turned his nation-building project into a kind of dramatic production, complete with colorful characters like "President-General Garvey ... Nile dukes, [and] Ethiopian counts."[19] Finally, Garvey's project clearly served to politicize the aesthetic. His holistic approach to nationalism, as concerned with African cultural and spiritual revival as with traditional questions of sovereignty and uplift, required definite stances on black cultural expression. As a result, occasions for aesthetic criticism became opportunities to insist on an agenda for cultural politics – as when the President-General used his articles and public addresses to complain about the anti-black nature of the theatrical productions in which Paul Robeson appeared, and to describe Claude McKay's novel *Home To Harlem* as "a damnable libel against the Negro."[20]

5 Autonomy and Separatism

Having spent the last two sections exploring various ways of linking politics to expressive culture both in the black aesthetic tradition and beyond, we can turn in this section to questions about how and how much to resist these links. This is another way of raising the questions with which this chapter began. The initial formulation privileged the notion of autonomy, primarily in deference to the prevailing custom in one of the relevant areas of philosophical inquiry. In light of the preceding discussions, though, we can now state these questions in an idiom with somewhat less in the way of philosophical baggage.

To say that the guiding questions of this chapter are about autonomy is nearly to say that they are about the prospects for separatism: they are about *complicating* or breaking the links between the aesthetic and the political that we've spent the last two sections identifying. As has been noted, these questions are not peculiar to black aesthetics. They do, however, take on particular forms in and around the work of people like Marcus Garvey and Michele Wallace. Three of these forms are particularly relevant to our inquiry. First: Should culture work be separated from formal political activity? That is, should political actors insist on their autonomy from the sphere of expressive culture? (Call this Rustin's question, after Bayard Rustin, whose form of

the view Richard Iton finds most influential.[21]) Second: Should expressive culture be kept separate from ethico-political concerns? That is, should artists, artworks, curators, and critics demand and receive their autonomy from the burdens of ethical judgment and political appraisal? (Call this Gaut's question, after one of the central contributors to the recent debate in analytic aesthetics over ethical criticism.[22]) And, finally: Can expressive culture separate itself from the influence of wider social forces effectively enough to serve as an instrument of progressive social change? That is: Can the sphere of culture work achieve some degree of autonomy from other social spheres, and thereby, paradoxically, achieve an even higher ethical purpose? (Call this Adorno's question, after the critical theorist who, with Walter Benjamin, may have done more than anyone else to put this query on the map.[23])

Here as in so many other places, W. E. B. Du Bois provides us with an indispensable starting point. In June of 1926, more or less in the middle of the Harlem Renaissance, he delivered an address entitled "Criteria of Negro Art." The address would subsequently appear in print, and mark the aging scholar-activist's contribution to an ongoing debate over the proper role of politics in black expressive practice. The address is famous for marking out a rather controversial position on the uses – on the necessity, really – of propaganda in expressive culture. The position has clear resonances for later work by various figures in the anticolonial and Black Arts movements. But the position itself is not as clear as the most quotable phrases from the address make it appear. Attending with some care to the argument of Du Bois's famous piece will clarify what's at stake when the three questions of aesthetic autonomy come up in black life-worlds, while also allowing for a reassessment of a central artifact in the black aesthetic tradition.[24]

6 Propaganda, Truth, and Art

By the time of Du Bois's address, many influential participants in the Harlem Renaissance were committed to a political strategy that David Levering-Lewis calls "civil rights by copyright." This strategy involved using literature and the other arts to prosecute the battle for civil rights on the terrain of expressive culture. Different people had different reasons for committing to this approach. For some the key was that the pathways to artistic excellence were not as vigorously policed as were the pathways to success in politics and business, not least because anti-black racist ideologies were constituted in part by ideas about blacks as natural entertainers (call this the question of the sensuous negro, and reserve it for discussion in a later chapter). For others the idea was that black art could demonstrate to white society that blacks lived, loved, struggled, and died like anyone else, and therefore ought to be treated like

anyone else. For still others, the aim was to use the interracial partnerships between black artists and white patrons as models for interracial comity and as beachheads for making further inroads into sympathetic white society.

By 1926, this "arts and letters" strategy seemed to many to have run its course. The strategy declined in part because of a generational conflict, a conflict that had in large part to do with the question of artistic autonomy. For some, the commitment to civil rights by copyright meant that art should answer to the demands of politics. In practice, this meant that the content of art was subject to political criticism. Black artists were to present black folks in the best light, for the sake of hastening the racial rapprochement that expressive culture supposedly made possible; and they were to refrain from exploring the seedier aspects of black life – the reality of black crime, poverty, and immorality notwithstanding. For others, the political triumph of black art would come only after black artists were granted the same freedom that other artists enjoyed – the freedom to answer the muse, without regard for the political ramifications of their work. On this view, blacks would be accepted into the modern human family only after they proved themselves properly modern, which they could not do while kowtowing to parochial community norms that conflated ethics with aesthetics. ("Detached from propaganda," Charles S. Johnson wrote, "sensitive only to beauty.")[25]

With "Criteria," Du Bois dove headlong into the debate over expressive autonomy, albeit in misleadingly accessible prose that resolutely underplays the depth of the philosophical framework in play. The essay clearly advances five basic claims: (i) all art is propaganda, (ii) this art-propaganda is problematic or inappropriate only under certain conditions, (iii) these conditions are not uniquely or routinely instantiated by black (or "Negro") artists, from which it follows that (iv) black artists needn't evade politics. At the same time, (v) political concerns cannot dictate the artist's agenda. Du Bois refuses the dilemma that haunts the prospects of aestheticism and of propaganda: in his view, it is not the case that artists can be free or properly answer their calling only by evading politics, *nor* is it the case that politically responsible artists will make their work a direct transcript of narrowly conceived political imperatives.

The key to this argument for a middle way on the question of propaganda lies in the two less obvious views that inform some of the essay's murkier passages. These have to do with what propaganda is and what experience is. Du Bois develops these claims, and provides glimpses of the deeper phenomenological and philosophical commitments from which they proceed, in an intense but meandering, essayistic argument that deserves more careful scrutiny than I can give it here.[26] I propose to look at it closely enough to make the main lines of the argument clear, while, for the most part, postponing for another time the careful exegetical work that the essay demands.

Du Bois begins by justifying an interest in art – more broadly, in cultural politics – at a time of brutal and systemic repression, oppression, exclusion, and exploitation. He insists that cultural work is not a diversion from higher or more important pursuits, whether that diversion is imagined as a problematic distraction or as a revitalizing reprieve. Art, he writes, is "a part of the great fight" against white supremacy and for democracy that the NAACP and other organizations are waging (par. 2). Expressive culture is politically relevant, he explains, because it celebrates and cultivates "beauty" – a dimension of experience that ought to be widely and readily available (he writes, "in normal life all may have it and have it yet again" (par. 9)), but that, for broadly political reasons, is inappropriately rare and distant in the lives of most modern peoples.

The modern world's self-anaesthetization – its determination to constrain and compartmentalize the prospects for aesthetic enjoyment – is, Du Bois argues, particularly important for black expressive culture. Like many others at the time, he was a member of what David Levering Lewis calls "the primitive transfusion school": he thought that black culture held the key to reviving and redeeming the joylessness of European-dominated civilization.[27] Black culture workers have a privileged role to play in restoring beauty and joy to modern life, he suggests, because they remain open to these values in ways that other peoples tend not to be, and because black life remains full of the "romance" – the adventure and the tragedy and the grand passions and purposes – that modern life, with its routines and drudgery, no longer has room for.

Having demonstrated to his satisfaction the importance of cultural politics, thereby blocking the claim that politics can dispense with art, Du Bois turns his attention to the other horn of the dilemma. He points out that artists cannot defeat white supremacy by themselves, and that the practitioners of cultural politics will, along with everyone else, continue to rely on the traditional political work undertaken by groups like the NAACP. Anti-black racism will continue to erect material and practical obstacles to full black participation in modern life, not least by complicating or blocking the paths that aspiring black artists might take into the mainstream artworld. This is just one reason why "civil rights by copyright" is insufficient: black artists seeking training, recognition, and support will find themselves looking up at their white peers through the veil of segregated institutions – unless organizations like the NAACP continue their work.

With the preliminaries out of the way, Du Bois turns to the question of what the connection between aesthetics and politics means for artists. This meditation prepares the way for his famous claims about propaganda, and is obscure enough to quote at length. He writes:

> [I]t is the bounden duty of black America to begin this great work of the creation of Beauty, of the preservation of Beauty, of the realization of Beauty,

and we must use in this work all the methods that men have used before. And what have been the tools of the artist in times gone by? First of all, he has used the Truth – not for the sake of truth, not as a scientist seeking truth, but as one upon whom Truth eternally thrusts itself as the highest handmaid of imagination, as the one great vehicle of universal understanding. Again artists have used Goodness – goodness in all its aspects of justice, honor and right – not for sake of an ethical sanction but as the one true method of gaining sympathy and human interest.

The apostle of Beauty thus becomes the apostle of Truth and Right not by choice but by inner and outer compulsion. Free he is but his freedom is ever bounded by Truth and Justice; and slavery only dogs him when he is denied the right to tell the Truth or recognize an ideal of Justice. (par. 28–29)

This passage – call it "Du Bois's argument for the unity of value" – will make little sense without some insight into the philosophical background to Du Bois's thought. So a brief detour is in order, after which we can continue to make our way to the argument about propaganda.

7 What is Life but Life? Reading Du Bois

Philosophically speaking, Du Bois is many things, and his work bears the traces of these many lines of influence and affiliation.[28] But the clearest way to locate his commitments for current purposes, and to gesture at the connections between the many other labels we might assign to him, is to think of him as an expressivist. I use this term in the sense worked out by Charles Taylor, for whom it captures the core of a crucial strain of North Atlantic intellectual culture. This strain begins in earnest with Spinoza, and informs such crucial nineteenth-century developments as romanticism, philosophical idealism, Marxism, nationalism, pragmatism, and evolutionism.

What unites these offshoots of expressivism, despite their very real differences, is that they approach the world as a dynamic, changing place – an idea often captured with metaphors of organic growth. Appeals to growth are fitting because they neatly capture two key aspects of the expressivist picture. When organisms grow, they (i) become more complex over time, and they (ii) enact a dialectical encounter between an internal "plan" and external conditions. The genetic code sets the parameters within which the rose bush will grow – it will never become a cow or a sea anemone – but the precise form that ultimately emerges from the directives of the code will depend on the contingencies of the environment – on the

amount and quality of the light and nutrients available, and so on. Attending carefully to this sort of process shows us, these thinkers argue, that life (or reality, or political community, or whatever they take as their subject) is a matter of transformative exfoliation: the world unfolds itself into new forms the way a seed unfolds itself into a tree – not by following a script or copying a picture, but by clarifying, over time, what was inchoate and implicit: by actualizing in history what formerly existed only *in potentia*.

The key to this expressivist picture is a determination to think of things as determinate but provisional expressions of an evolving world. Depending on which thinkers we're dealing with, this view might cover *all* things, from facts and scientific laws to ethical sensibilities, political arrange- ments, and human subjectivities. Hegel provides the clearest example of this, with his determination to show the basic mechanism of self- clarification at work from every angle. But the most useful examples for studying Du Bois are Marx and Dewey. Both the Marxian and Deweyan revisions of Hegel's narrative insist on holistic self-cultivation and, in good romantic fashion, reject the alienation of modern industrial civilization. On both approaches, ethical life is bound up with an essentially artistic or poetic revisioning of the landscape of agentive possibility, and human per- sonalities are always works in progress, fashioned at the intersection of community resources, social conditions, and ethical agency. In addition, both see individual human subjects as expressions of deeper cultural and material forces. This line of thinking is controversial in both the Deweyan and Marxian traditions, and gets taken in many different directions by the founding thinkers' many heirs. But the basic view is clear enough: individuals do not enter history and culture as, in Michael Sandel's words, essentially unencumbered selves. They are social products, or *expressions*, of their social milieu, shaped by such things as history, language, and economic structures. They can intervene in the processes of subject formation and begin to create themselves as social products. But they cannot do so, as Marx said, under conditions of their own choosing; and they cannot do so without recognizing their immersion in the grand, moving stream of human social life in history.

With more time we could trace out these commitments in Du Bois's work by tracking his academic, cultural, and political education – by explor- ing, in other words, the consequences for his work of having been raised on Carlyle, Emerson, and Wordsworth, having taken the requisite course on "self-realization ethics" at Harvard from George Herbert Palmer, and having spent his most crucially formative years studying under Rankean historicists at the University of Berlin. In lieu of that approach, we can simply show him explicitly endorsing these ideas.

In an early entry from his journal, Du Bois writes, "What is life but life, after all? Its end is the greatest and fullest self – and this end is the Good."[29] Much later, in a 1938 commencement address at Fisk University, he develops the same idea:

> Life is more than meat, even though life without food dies. Living is not for earning, earning is for living.... Life is the fullest, most complete enjoyment of the possibilities of human existence. It is the development and broadening of the feelings and emotions.... It is *the free enjoyment of every normal appetite*.... [H]ence rise Love, Friendship, emulation, and ambition, and the ever widening realms of thought, in increasing circles of apprehended and interpreted Truth.[30]

The only other passage I'll point to comes from the text I've been trying to prepare the way for, "Criteria of Negro Art." He explains there that the "world we want to create for ourselves and for all America" is "a world where men know, where men create, where they *realize themselves* and where they enjoy life" (par. 7, emphasis added).

I take all of this to show that Du Bois was a committed expressivist. I say this not for the sake of pigeonholing this most expansive of thinkers, but to locate the proper interpretive context for his ideas about the relations between art and politics. Putting the expressivist background in place helps clarify Du Bois's aims in the passage reproduced above, and positions us to remove the air of archaic grandiosity that attends his emphasis on norms like Truth and Right. These notions typically appear portentously capitalized in Du Bois's work, as if to stress their distance from the grubbiness of the empirical. But the expressivist background allows us to read them not as abstract and distant Platonic ideals but as evolving public resources.

As I say, the expressivist background helps, but it isn't enough by itself. One of the keys to taking the history of philosophy seriously is the willingness to flirt with anachronism. We find contemporary language for views that earlier thinkers articulated in different ways, navigating all the while between the twin dangers of over-reading – assigning views that the thinker in question simply didn't, perhaps couldn't, hold – and insufficient generosity – assuming that the thinker in question means whatever silly view the plain-language reading of his or her argument entails to us now. Contemporary scholars like Brandom and Pippin find Hegel attempting to create a vocabulary for things we would say differently now, thereby blocking the thought that Hegel was just a verbose pantheist. In a similar way, I propose to find language in contemporary aesthetics and pragmatism for some of Du Bois's post-Hegelian uses of expressivist discourse, thereby blocking the thought that he was just a lazy romantic or Platonist.

8 Apostles of Truth and Right

Du Bois's argument for the unity of value links truth, goodness, and beauty in the work, or in the person, of the artist. He claims that artists approach truth not as scientists, but as people "upon whom Truth eternally thrusts itself." Approached in this non-scientific way, Truth is "the highest handmaid of imagination" and "the one great vehicle of universal understanding." In a similar way, they use goodness not in the way moralists do – "not for sake of an ethical sanction" – but in another way: "as the one true method of gaining sympathy and human interest." This is obscure language, to be sure, but the expressivist background, with its emphasis on the discursive and dialectical dimensions of human subjectivity and sociality, points us to the necessary interpretive throughline.

The idea of truth has three layered meanings here. It refers first of all to the shared and evolving *domain of discourse* that helps define the character and shared inheritance of a culture. This has in part to do with the shared body of truths that constitute the cultural commonsense; but it has also to do with, as Foucault puts it, the rules that determine the limits of the sayable and thinkable – the universe of discursive practice that encompasses but goes beyond the store of public truths.

The second meaning of "truth" here points to *the commitment to "getting things right,"* as contemporary third-wave pragmatists put it. This is the basic epistemic impulse that gives content to the idea of truth, that animates the practice of inquiry, and that distinguishes assertion from emotive ejaculation, and collective deliberation from public polling. As Robert Talisse and others have argued using Peircean and other resources, garden-variety human practices presuppose that there is a distinction between being right and being in error, and this distinction animates our communicative practices.

The third meaning of "truth" points to *a particular body of truths*, specifically, the picture of the social world that discloses itself to people on "the underside of modernity." Du Bois puts this layer of truth-talk in play earlier in the essay, when he writes, "We who are dark can see America in a way that white Americans cannot." (This echoes the claim in *Souls* that black people are endowed with a kind of "second sight," enabling them to see what hegemonic conceptions of modernity try to obscure.) The reference here is not to a collection of "black" truths, but to a way of correcting the artificially circumscribed picture of the world that white supremacy has created and promoted. This is the idea that Charles Mills discusses under the heading of the "epistemology of ignorance" – white supremacy's ideological determination to obscure certain forms of knowledge about itself.

With this layered appeal to truth on board, we can see what it means to say that "Truth eternally thrusts itself" on the artist as "the one great vehicle of universal understanding." As we saw in the discussion of visuality, preexisting fields of meaning create the conditions under which perception, cognition, inquiry, and debate take place. These fields set the parameters within which we seek, articulate, and identify the true and the false (as well as the sayable and the unsayable). In this sense, existing *regimes* of truth impose – or "thrust" – themselves on the artist, as on everyone else.

Because this imposition is a shared condition, it also creates the conditions for mutual intelligibility. That is: we all inhabit the same fields of meaning, as far as we know; so our shared immersion in the same domains of discourse enables us to recognize and understand when the artist accesses and interrogates the public store of truths. It also enables the artist to produce an intelligible but individualized world-picture that recognizably develops public ideas and advances public debates. This is one step toward the possibility of "universal understanding."

Truth is the vehicle of "universal understanding" in a second way, a way that is related to the epistemology of ignorance and that is of particular interest to black artists. The publicly shared *interest in finding the truth* gives all of us a stake in, and a corresponding interest in, those works of art that explore the real world instead of fleeing to a separatist realm of escapist fantasy. So artists who lift the veil, as Du Bois was fond of saying, on the workings of white supremacy and on the lives of the people most grievously impacted by it will be more likely to gain and hold the attention of people who understand the purpose of art and its role in modern social life.

This dialectical and dialogical conception of the subject, of the social, and of culture work, in concert with contemporary ideas about the ethical criticism of art, helps us clarify Du Bois's reference to the artist's use of "Goodness." He claims that artists have used goodness "not for the sake of an ethical sanction but as the one true method of gaining human sympathy and interest." I take this to mean that for artists *qua* artists, ethical views function constitutively and communicatively rather than didactically. That is, ethical principles help constitute the framework within which we respond to works of art, and as a consequence can be relevant to the work of art without turning it into what Adorno calls "committed proclamation."[31]

Noël Carroll, building on Gaut's work, invites us to put the relevant points in this way: Artworks prescribe responses to their audiences. We are supposed to fear the monster, pull for the heroine, and suspend disbelief when presented with people popping in and out of vast computer simulations powered by brains in vats. If a work fails to earn the responses that it prescribes, it is aesthetically deficient. If the monster or villain makes us laugh in ways that are manifestly not in the spirit of the work (I think here of

the final, oddly Frankenstein-like unveiling of Darth Vader in the third epi-
sode of the *Star Wars* movies, but I fear I am alone in finding this laughable),
if the heroine is utterly unlikable (I say with some confidence: think *Sex and
the City 2*), or if the narrative goes too far to allow for the continued
suspension of disbelief (think *Matrix: Revolutions*), then the work fails of its
purpose.[32]

Ethical principles also fit into this picture of prescribed, or "merited,"
responses. Carroll asks us to imagine a narrative work that establishes a
sadistic colonizer as its hero. The reader/auditor is meant to respond with
equanimity, if not with approval, to the hero's acts of cruelty against the
oppressed indigenous people, because the hero is supposed to be *admirable*.
But this prescribed response is not available to most of us: the hero is, by the
lights of reigning ethical standards, manifestly *not* admirable. To the extent
that the work prescribes and requires our admiration for a cruel, sadistic
hero, it fails of its purpose.[33]

In light of this picture, we can restate Du Bois's point: the successful artist
must attend to ethical principles – he or she will "use goodness" – not in the
sense that artwork must insist on a moral point of view, but in the sense that
the work must of necessity orient itself to reigning ethical standards. The
work that declines to use goodness in this way will fail to gain our sympathy
and interest as surely as will the story of Carroll's sadistic colonizer. Once
more, in more clearly expressivist terms: artist and audience share a net-
work of normative commitments, and establishing a recognizable and not-
off-putting relationship to this network is a precondition of aesthetic uptake.

Having identified these discursive, epistemic, existential, and ethical con-
ditions of aesthetic uptake, we can make sense of the idea that "the apostle of
beauty" – the artist – becomes "the apostle of Truth and Right not by choice
but by inner and outer compulsion." The "inner compulsion" is just the pre-
sumptive force assigned to the store of shared meanings and commitments
that constitute a culture. As we've seen, preexisting discursive structures
shape and constrain the prospects for claiming and producing knowledge.
They work behind the scenes of cognition and inquiry, pretheoretically, intu-
itively, to set the parameters within which truth-seeking and communication
take place. As Foucault famously insisted, regimes of truth set the conditions
under which human subjects come into being. They set the parameters
within which we form our self-concepts and imagine our life-plans and
existential prospects. So the burden of orienting oneself, negatively or posi-
tively, to the "conventional wisdom" of one's culture would be felt as an
"inner compulsion."

The reference to an "outer compulsion" is doubly significant. It is in
part just about the prudential aspects of artistic creation. If the artist
wants to gain "human sympathy and interest," he or she will not willfully

ignore the aspects of the artistic enterprise that this expanded expressivist picture emphasizes. He or she may seek artistic freedom by abstracting away from politics, and by ignoring all the reigning ethical principles. But to do this is to ignore the degree to which "freedom is bounded by Truth and Justice" – the degree to which aesthetic uptake depends on satisfying the auditor's interest in getting things right, as well as on meeting the artist's burden of prescribing reasonable ethical responses to the work's subject matter. In addition, though, the idea of an outer compulsion also points to the social nature of the fields of meaning that shape the prospects for human experience and artistic creation. World-pictures and bodies of normative commitment are public – that is, *external* – impositions. To borrow and slightly misuse a hoary philosophic formula: discourses ain't in the head.

The qualification that public meanings come *in a sense* from the outside is crucial. Like Du Bois's juxtaposition of inner *and* outer compulsion, it highlights the dialectical nature of the subject's immersion in and orientation to public fields of meaning. The external compulsion works through the intentionality of individual agents, by inviting individuals to imagine themselves and their prospects in light of, perhaps in opposition to, the resources that they provide. These individuals in turn revise these public meanings, creating a kind of feedback loop of ongoing modification and adjustment of both subject and discourse.

The dialectical nature of subject formation is important here because it sets the conditions under which we aspire to and understand freedom, including artistic freedom. And this link between subject formation and freedom allows us to make sense of the last step in Du Bois's unity of value argument. While the apostle of truth/right/beauty is free, "his freedom is ever bounded by Truth and Justice." What's more, "slavery only dogs him when he is denied the right to tell the Truth or recognize an ideal of Justice." I take this to mean that artists, like everyone else, are dialectically enmeshed in wider webs of meaning concerning the true and the just, and must create themselves as individuals by working out their orientation to these networks. As Rousseau and Kant first worked out clearly, this is not so much a constraint as a condition of properly human agency. Because of this condition, we cannot think of freedom as an abstract possession, as absolute willfulness and complete detachment from ethical or political imperatives. We must think of it as self-legislation in the face of, and in recognition of, the wider resources for seeking the truth and pursuing the good. Slavery, or unfreedom, then, consists not in recognizing one's inevitable rootedness in preexisting discourses of truth and right, but in being prevented – as it might be, by a ban on political art – from working out one's relationship to these discourses.

9 On "Propaganda"

Du Bois proceeds as if this dialectical and dialogical picture of artists working out their relationship to public stores of meaning directly entails his stance on propaganda. "*Thus*," he says, immediately after the discussion of freedom, "all art is propaganda, and ever must be," before going on to explain why this is not a bad thing (par. 30). The lines of entailment are not as clear as his "thus" assumes, but it is not too difficult to bring them into focus. The expressivist picture underwrites a disguised linguistic proposal whereby Du Bois carefully, or not so carefully, tweaks the meaning of "propaganda" until it encapsulates his mediation of the debate over Harlemite aestheticism.

Du Bois begins with a more or less commonsense notion of propaganda, on which the term denotes the class of expressive objects whose members derive their content *not* from a distinct and inviolate domain of aesthetic value, as some "purists" might require, but from the domain of ethico-political value. Interestingly, if the expressivist view worked out above is right, then *all* expressive objects fall into this class. All expressive objects orient themselves to public systems of ethical value – remember the sadistic colonizer – and cannot plausibly claim to proceed solely from aesthetic and abstractly individual sources. Thus all art is propaganda, and, unless human psychology changes in some unforeseeably radical way, ever must be: Q.E.D.

This unavoidable propaganda becomes problematic only when the expression of truth and right is (a) *one-sided* and/or (b) *constrained by "prejudgment*." Acts of expression are necessarily partial, selective, and provisional, just by virtue of human finitude. But this unavoidable partiality does not mean that we have to cultivate partiality by artificially excluding or suppressing views that conflict with ours. Nor does it mean that we must tether ourselves to views that have been declared normative or veridical in advance, without regard for the evidence of experience or for the tension between that evidence and the claims required by one's prejudices and prior commitments. These are the marks of one-sidedness and prejudgment, the negative practices that, in Du Bois's view, give propaganda a bad name, and that join aestheticism as the problematic alternatives to a properly political view of expressive culture.

Du Bois is keen to note that "bad propaganda" is not the exclusive preserve of anti-black racists. Just by virtue of white supremacy's grip on the levers of power, white people can require and impose one-sidedness in a way that other people cannot. But blacks and whites alike traffic in the "distortions" of prejudgment, albeit with different valences. Whites distort reality by appeal to anti-black and pro-white prejudices, while

blacks distort it by appeal to pro-black prejudices – by making black people into angels, without faults or problems, and often enough, in a way that Du Bois found particularly galling, without sexual desires or pleasures.

This rebuke to the genteel tradition of black letters – a tradition that Du Bois held in greater regard than this argument reveals – leads the essay back from its phenomenological reflections to the issue of the day. What should black artists *do*? Should they evade the complexity of black life as it stands and specifically evade the demands of politics? Or should they do the bidding of political actors? Which way leads to the vindication of black humanity in an anti-black world, and to the redemption of humanity full stop in a decadent modern world?

Du Bois's view was that blacks will be seen as human, and black artists will properly disclose the human, when their art eschews prejudgment and reveals the complex, mediated truth of human being as it achieves concrete expression in the specific contexts of black life. There is, therefore, no conflict between the particularist call for propaganda and the universalist appeal to human truth. Human truth is unavoidably particular, and concrete, and will find expression in the work of the sincere artist who invites the world to pass through the alembic of his or her experience and sensibility.

10 Conclusion

In the introduction to this chapter I promised to lay the groundwork for later discussions of the unavoidably political dimensions of black aesthetics, and I proposed to do that by exploring the prior question of just how the aesthetic and the political can and should relate to each other. I proposed further to do that by focusing on three questions of separatism or autonomy: (1) Should artists stay out of politics? (2) Should we exclude ethical criticism from our scrutiny of aesthetic objects? And (3) should we despair of the capacity of aesthetic objects to transcend and somehow oppose the societies that form them?

In "Criteria of Negro Art," Du Bois argues in his own way for the orientation to these questions that has been ascendant in the black aesthetic tradition. For Du Bois as for many others, artists are political actors, *contra* Rustin; ethics is a resource for art criticism, *contra* Oscar Wilde;[34] and the aesthetic is a resource for oppositional politics, *contra* crude readings of Marx. This view has been popular in part because white supremacy's systemic exclusion of blacks from the conduct of formal politics has helped make black expressive culture a vital political resource. Some of the most prominent figures in black

political history earned or cemented their places in that tradition by their mastery of expressive practice – think here of the oratory of Frederick Douglass and Martin King, or of Léopold Senghor's poetry, and his commitment, as president of Senegal, to cultivating the arts. Conversely, some of the most important figures in the history of black aesthetics approached their work as an unavoidably political venture – think here of Sonia Sanchez, Lorraine Hansberry, Paul Robeson, or, for at least some of the time, Robert Nesta Marley.

There have been dissenters from this orientation to be sure, especially after the apparent gains of the various black freedom movements and struggles. The idea of connecting politics and aesthetics anchors one of the problem spaces, one of the persistent occasions for argument, reflection, inquiry, and debate, that defines the black aesthetic tradition. Many people have held that culture work ought to give a wide berth to politics "properly so-called"; or that ethical considerations have no claim on the black artist; or that expressive culture is little more than a reflection of the society from which it emerges, and that social change has less to do with culture than with political mobilization.

These dissenting views have however been in the minority. The towering presence of W. E. B. Du Bois has, to some degree, made this the case. The long shadow he casts simultaneously over the histories of intellectual work, cultural production, and political activism in black life-worlds makes it difficult to establish bright lines between these different dimensions of human striving. And as we've seen, he achieved this influence by word and by deed. His broadly political agenda led him to set the example, to cross the boundaries between social-scientific knowledge production and artistic cultural production not just in his overall body of work but also in single texts, like *Souls* and *Darkwater*. And it led him to develop, in "Criteria," a philosophical argument for the unity of truth, beauty, the good, and the right, and for the inseparability of propaganda and expression.

I noted above that one might draw out the connections between black aesthetics and politics in a variety of ways, and that most of these ways would not play any role in this chapter. While we have focused here on the three forms of the question of autonomy, we could have discussed the ethical uses and abuses of the idea of authenticity, the existential burdens of creating selves and communities in anti-black environments, the racially asymmetric distribution of modernity's aesthetic values and enjoyments, or the controversies of interracial cultural appropriation. Having used the idea of aesthetic autonomy to put the aesthetics–politics relation on the table, we can now turn to the issues raised in those other problem-spaces.

Notes

1 William Edward Burghardt Du Bois, "Criteria of Negro Art," *Crisis* 6:32 (October 1926), 290, 292, 294, 296–297; 292 (par. 11).

2 *Drama Review* 12:4 (New York: New York University, School of the Arts, 1968), 29–39 (accessed at Black Art and Culture database, via Temple University, January 26, 2008).

3 Richard Iton, *In Search of the Black Fantastic* (New York: Oxford University Press, 2008), 67.

4 "African Independence," in Gerald D. Jaynes, ed., *Encyclopedia of African American Society*, vol. 1 (Thousand Oaks, CA: Sage Reference, 2005), 25–27. *Gale Virtual Reference Library* (online), November 8, 2010.

5 Penny von Eschen, *Satchmo Blows Up the World* (Cambridge, MA: Harvard University Press, 2004), 71.

6 Wynton Marsalis, "Why We Must Preserve Our Jazz Heritage," *Ebony* 46:1 (November 1990), 159. See also his comments in Shantella Sherman, "Jazz At Lincoln Center Brings Armstrong Tribute to Kennedy Center," *Washington Informer* 38:10 (Washington, DC, January 3, 2001), 15.

7 Von Eschen 67.

8 Iton 47, 198.

9 Michael Dawson, *Black Visions: The Roots of Contemporary African-American Political Ideologies* (Chicago: University of Chicago Press, 2002), 22.

10 Dawson identifies four (p. 22), then seems to add a fifth a bit farther on (p. 27).

11 I use the term "deconstructive" to denote a range of philosophical approaches to the political that includes but is not limited to work that relies on "deconstruction" in the technical sense. An approach may be deconstructive in this sense if it uses dialectical investigation to dig beneath the surfaces of attempts at political justification, and is at least as interested in articulating a phenomenology of the political sphere as in offering norms for organizing social life. "Poststructuralist" would capture the idea were it not for the critical theorists and others who are deconstructive in this sense but not poststructuralist. On this use of "deconstructive" see David Ingram's introduction to his edited volume, *The Political* (Oxford: Blackwell, 2001).

12 Robert Gooding-Williams, *Look, A Negro!* (New York: Routledge, 2006), 3.

13 For studies of the political dimensions of surrealism, see Helena Lewis, *The Politics of Surrealism* (New York: Paragon, 1988); Gavin Parkinson's review essay, "Surrealism and Politics," *Oxford Art Journal* 29:2 (2006), 306–312; and, specifically in relation to black aesthetics, Robin D. G. Kelley, *Freedom Dreams: The Black Radical Imagination* (Boston: Beacon, 2002).

14 See Lydia Goehr, "Political Music and the Politics of Music," *Journal of Aesthetics and Art Criticism* 52:1 (Winter 1994), "The Philosophy of Music," 99–112. Goehr cites Kant for the following proposition: "Though beauty is an end in itself, it nonetheless still serves as a symbol or analogue of morality and of the political good" (105).

15 Iton 16.

16 Sartwell makes a similar point, though in the context of a project rather different from this one. Crispin Sartwell, "Red, Gold, Black, and Green: Black Nationalist Aesthetics," *Contemporary Aesthetics* 2 (2009).

17 Lawrence Levine, "Marcus Garvey and the Politics of Revitalization," in John Hope Franklin and August Meier, eds., *Black Leaders of the Twentieth Century* (Chicago: University of Illinois Press, 1982), 105–138, 121.

18 Levine 120–121.

19 David Levering Lewis, *When Harlem Was In Vogue* (New York: Penguin), 40.

20 Iton 7.

21 Iton 5, 82.

22 Berys Gaut, "The Ethical Criticism of Art," in Jerrold Levinson, ed., *Aesthetics and Ethics* (Cambridge: Cambridge University Press, 1998), 182–203.

23 See Lambert Zuidervaart, "The Social Significance of Autonomous Art: Adorno and Burger," *Journal of Aesthetics and Art Criticism* 48:1 (Winter 1990), 61–77; David Held, *Introduction to Critical Theory* (Berkeley: University of California Press, 1980), 77–110.

24 The piece originally appeared as "The Criteria of Negro Art," *The Crisis* 32 (October 1926), 290–297. It is available for free online at http://www. webdubois.org/dbCriteriaNArt.html, and in many anthologies of Du Bois's writings, of writing on black art, and of Harlem Renaissance texts. In deference to this wide range of sources, I will cite the text by parenthetically indicating the relevant paragraphs in the original, using the edition made available by the *Black Thought and Culture* database from Alexander Street Press.

25 David Levering Lewis, "Dr. Johnson's Friends: Civil Rights by Copyright during Harlem's Mid-Twenties," *The Massachusetts Review* 20:3 (Autumn 1979), 501–519, 502.

26 There are surprisingly few careful studies of this essay. One of the best that I know of is Eric King Watts, "Cultivating a Public Voice: W. E. B. Du Bois and the 'Criteria of Negro Art,'" *Rhetoric & Public Affairs* 4:2 (2001), 181–201. Ron Judy's study of Du Bois's views on the Harlem Renaissance is valuable, but reads Du Bois as contradicting himself on the question of propaganda rather than as looking for a middle path. Ronald A. T. Judy, "The New Black Aesthetic and W. E. B. Du Bois, or Hephaestus, Limping," *The Massachusetts Review* 35:2 (Summer 1994), Special issue: "W. E. B. Du Bois: Of Cultural and Racial Identity," 249–282, 276, fn. 11.

27 Levering Lewis, "Dr. Johnson's Friends," 514–515.

28 I have myself described Du Bois as both a pragmatist and a Dionysian expressivist. See "Du Bois's Erotics" (with Michele Birnbaum-Elam), in Susan Gillman and Alys Weinbaum, eds., *Next to the Color Line* (Minneapolis: University of Minnesota Press, 2007); "What's the Use of Calling Du Bois a Pragmatist?" *Metaphilosophy* 35:1–2 (January 2004); reprinted in Richard Shusterman, ed., *The Range of Pragmatism and the Limits of Philosophy* (Oxford: Wiley-Blackwell, 2004). I now appeal to an even wider context, the one that pragmatists share with Hegel, Wordsworth, and many others – expressivism. See also

Richard Cullen Rath, "Echo and Narcissus: The Afrocentric Pragmatism of W. E. B. Du Bois," *Journal of American History* 84:2 (September 1997), 461–495.

29 Reported in Claudia Tate, "Race and Desire: *Dark Princess, A Romance*, by William Edward Burghardt Du Bois," in *Psychoanalysis and Black Novels* (New York: Oxford University Press, 1998), 47–85, 68.

30 W. E. B. Du Bois, "The Revelation of Saint Orgne the Damned," in W. E. B. Du Bois, *Writings*, ed. Nathan Huggins (New York: Library of America, 1987), 1048–1070, 1061, emphasis added.

31 Held 83.

32 Noël Carroll, "Art and Ethical Criticism: An Overview of Recent Directions of Research," *Ethics* 110:2 (January 2000), 350–387.

33 Carroll 377.

34 In the preface to *The Picture of Dorian Gray*, Wilde famously writes, "There is no such thing as a moral or an immoral book. Books are well written or badly written. That is all." http://www.upword.com/wilde/dorgrayp.html par. 4. Carroll 351.

4

Dark Lovely Yet And; Or, How To Love Black Bodies While Hating Black People

Dark am I, yet lovely, O daughters of Jerusalem, dark like the tents of Kedar, like the tent curtains of Solomon.

Song of Solomon 1:5, New International Version

After centuries of being told, in a million different ways, that they were not beautiful, and that whiteness of skin, straightness of hair, and aquilineness of features constituted the only measures of beauty, black people have revolted. The trend has not yet reached the point of avalanche, but the future can be clearly seen in the growing number of black people who are snapping off the shackles of imitation and are wearing their skin, their hair, and their features "natural" and with pride.

Hoyt Fuller, "Towards a Black Aesthetic" (1968)

"Introducing Dark & Lovely® 6 Week Anti-Reversion Cream Serum, our first styling product developed specifically for relaxed hair, allowing you to preserve your straight, smooth hair up to six weeks in-between relaxing."

Dark & Lovely brand, "What's New" advertisement, SoftSheen-Carson (2013)[1]

Black is Beautiful: A Philosophy of Black Aesthetics, First Edition. Paul C. Taylor.
© 2016 Paul C. Taylor. Published 2016 by John Wiley & Sons, Ltd.

Figure 4.1 Dark & Lovely Announces Bria Murphy As New Global Brand Ambassador.

1 Introduction

"Dark & Lovely" is a familiar brand name in Afro-US communities, one as intimately associated with the sphere of activity and enterprise to which it belongs as Coke, Xerox, and Kleenex. This metonymic association is fitting, as it keeps before us the ambivalence about black bodies that has been a constant feature and condition of Afro-US beauty culture. The name "Dark & Lovely" signifies on the famous passage from the Song of Songs while flattening out the air of disbelief, or dissonance, or surprise, that words like "yet" convey in most translations of the biblical text. Darkness and loveliness are not in tension with each other, the people at SoftSheen want us to think, so they turn "dark *yet* lovely" into "dark *and* lovely," and invite their consumers to cultivate the black beauty that they now know to claim as their birthright.

But the beauty practices that SoftSheen supports are entangled in a dense web of evaluative rhetoric that undermines the brand name and hearkens back to that biblical "yet." The products most central to these practices, including the one touted in the ad above, support the desire to straighten black hair – to unwind the curls that, along with dark skin and broad facial features, are the clearest physiognomic markers of black raciality. And the work these products do is routinely described – even now, some decades after the "revolution" that Hoyt Fuller predicted in 1968 – in ways that locate it on one side, the wrong side, of a Manichean divide. Straightened hair is relaxed, and smooth, and silky, not kinky, tough, or nappy.[2] And the best products guard against what is without irony called "*reversion*," or "turnback" – the frightful regression that leaves black hair in the "unimproved" natural condition with which most of us have to contend.

The complexities of black hair care provide a useful point of entry to the problem of theorizing, experiencing, judging, and pursuing bodily beauty in racialized contexts. As Paulette Caldwell explains, "Hair seems to be such a little thing. Yet it is the little things, the small everyday realities of life, that reveal the deepest meanings and values of a culture."[3] And the deepest meanings and values of North Atlantic modernity and of the worlds it has shaped have involved the peculiar ambivalence that we find in the Song of Songs: the determination to treat black bodies as paradigm cases of human ugliness, coexisting uneasily with varying degrees of admiration, fascination, and desire for these same bodies.

This chapter aims to catalogue and clarify some of the philosophical questions that arise from this negrophobic somatic aesthetics. I will eventually start toward answers to the most pressing questions, questions that demand the attention not just of aestheticians and ethicists, but also of students of natural science and the philosophy of existence. Here are the questions I have in mind:

1. Is there anything philosophically interesting about the gaps between pro-black and anti-black modes of judging human beauty?
2. This "beauty gap" – the gap between negrophobic and negrophilic somatic aesthetics – seems to have narrowed in recent years, but in ways that seem compatible with a persistent anti-black animus. So how substantial an achievement can this increased aesthetic tolerance be? (Or: What are the prospects for an emancipatory, anti-racist, somatic aesthetic?)
3. Can we make sense of the thought, common in anti-racist activist communities and traditions, that blacks should not emulate anti-black styles of bodily stylization? Or, put differently: How can black subjects authentically and responsibly inhabit and navigate anti-black aesthetic contexts?

I'll use some examples to clarify the terms and stakes of this discussion, and to work through the intuitions from which I'll build my answers. But before I do that there are some preliminary issues to settle. I'll need to define some key terms, make some crucial distinctions, and locate my discussion here against some important pieces of the social-theoretic background.

2 Circumscribing the Topic: Definitions and Distinctions

My subject here involves judgments of human bodily beauty. When the need arises, I will refer to these as "body beauty judgments," in order to distinguish them from judgments about the beauty of other things, like landscapes or paintings. To think about or use body beauty judgments is to enter the domain of what I will call "somatic aesthetics," which for me refers to any aesthetic considerations relating to the human body.

"Somatic aesthetics" is an umbrella term for two narrower areas of reflection and practice, both of which I've learned to think about with the help of Richard Shusterman's pioneering work. One of these has to do with the way the body is regarded from the outside, as "an object grasped by our external senses."[4] This is the body treated as an object of aesthetic value, and as an object of representation. The other kind of somatic aesthetics has to do with embodiment – with the way the body is experienced, as it were, from the inside. We achieve this second orientation to the body not by way of representations presented to the external senses but through the "inner" senses of proprioception, which enable us to treat the body not as an object of aesthetic value but as a medium or site for the creation of aesthetic value.

Shusterman attends most carefully to proprioceptive somatic aesthetics, which he calls "somaesthetics." He gives no special name to representational somatic aesthetics, so I will propose one. Shusterman's determination to contest the centuries-long denigration of the body that infects western philosophy and culture leads him to employ the Greek term "soma" to name his approach, which he defines as the "study of the experience and use of one's body as a locus of sensory–aesthetic appreciation … and creative self-fashioning."[5] In the same spirit, I'll use the Greek term that the New Testament authors used to distinguish the body from the spirit or soul: "sarx," which refers to, among other things, "the sensuous nature of man" and "the earthly nature of man apart from divine influence."[6] This term was often used to communicate the suspicion of the body indicated above, and specifically to insist on the fallenness or sinfulness of the body. But it was not always used in this way, and I mean to borrow the non-evaluative sense of the word.

"Sarkaesthetics," then, is my name for the practices of representational somatic aesthetics – which is to say, those practices relating to the body, as it were, as flesh, regarded solely "from the outside." As with somaesthetics, sarkaesthetic practices range across three dimensions.[7] The descriptive dimension identifies the norms and principles that in fact govern the aesthetic evaluation of the body, and the practices that issue from and conform to them. The normative dimension prescribes rules and principles for our judgments and pursuits of bodily beauty. And the meta-theoretical dimension takes up broader questions about "the basic nature of bodily perceptions and practices," and relates these to still broader philosophical questions, pertaining for example to phenomenology, epistemology, ethics, and social theory.[8]

Distinguishing the soma from the sarx is provisionally useful, not least as a matter of intellectual bookkeeping. But it is not meant to mark a hard and fast, unbridgeable divide. The sarkaesthetic practices with which I will be most concerned, which involve styling the body in accordance with rules for its representation and visual consumption, are intimately related to somaesthetic practices of bodily stylization. As students of black history and expressive culture have exhaustively documented, black beauty culture involves the creation of social rituals that make a hairstyle or fashion choice a process as well as a product.[9] And these processes can be more than simple means to the end of a properly styled body. They can become ends in themselves.

I've introduced the distinction between sarx and soma so that I can clarify and delimit the scope of the argument I'll soon make. In what follows I will focus principally on sarkaesthetics – on the body as experienced from a third-person perspective, through the external senses. For reasons noted above, though, I will not pretend that this focus allows us to block all reference to somaesthetic considerations. An example may help sharpen the distinction in play here while also showing its limits. The Miss America pageant presupposes criteria in representational somatic aesthetics, criteria that are familiar and have long been grist for the mill of feminist and profeminist criticism. But the sarkaesthetic ideals of these pageants require the cultivation of certain skills and habits – to start with, certain definite ways of walking, sitting, talking, and standing. And the cultivation and deployment of these skills and habits can themselves become sources of and occasions for somaesthetic evaluation and enjoyment. We see this perhaps most clearly in contexts that link these skills and habits to the performative dimension of sexual and gender identity formation. In certain drag balls, for example, physiologically male contestants perform the behavioral markers of mainstream femininity, and do so in ways that make it clear that the phenomenon of embodiment, the lived experience of moving and inhabiting – living – the body this way rather than that, is itself an object of somaesthetic enjoyment. (That sentence would work better if it

came with a video of RuPaul – RuPaul Andre Charles – teaching aspiring female models how to walk in heels.)

3 Circumscribing the Topic, cont'd: Context and Scope

The obviousness of pageants and drag balls as case studies in somaesthetic and sarkaesthetic practice points us to the next preliminary issue to settle. To take an interest in the beauty of human bodies is, as a matter of sociological and historical necessity, to take some interest in gender and sexuality. "Beauty" here is shorthand for a kind of generalized aesthetic merit that applies to men as much as to women, and that might implicate values like ruggedness and machismo as much as, say, daintiness and femininity. But the hegemonic somatic aesthetic regimes in North Atlantic modernity have been so consistently gendered that art historian John Berger could plausibly sum up several hundred years of figurative art with a single pithy phrase: men act while women appear.

As I say, I am interested in an account of somatic aesthetics that does not reduce it to narrow conceptions of beauty – to the distinctively feminine attractiveness that heteronormative, patriarchal, and masculinist imperatives have made hegemonic. I am as interested in the norms that we use to evaluate Mr. Olympia contestants or attempts at "urban" male youth fashion as in our criteria for female – which is not yet to say "feminine" – beauty. More to the point, I am interested in the way negrophobia and negrophilia inform these norms and criteria, from the whiteliness of feminine beauty standards to the recent wave of "pull up your pants" municipal ordinances aimed at black youth – to the occasional surges of public support for natural black hairstyles.

With that said, though, the clearest examples of racialized sarkaesthetics come from the history of debate and practice around feminine beauty culture. In deference to this fact, I will likely spend a disproportionate amount of time on the kind of eroticized, desire-centric sarkaesthetic practices that either call out for or have already been the subject of feminist critique and analysis. I don't have the space or the expertise to do justice to those critiques, or to the rich and complex stories one has to tell in order to make sense of the nexus of relationships – call it "the beauty–gender nexus" – between beauty discourse, desire, sexuality, and gender. So I will orient my work here to those discussions by stipulating to a few methodological and theoretical assumptions.

First, the right story about the beauty–gender nexus will involve the kind of approach that we associate with Foucault, but that Susan Bordo[10] and

others remind us to trace back to much earlier feminists. This approach will be genealogical, and locate our desires and beauty-judgments in a polyhedron of intelligibility bounded by political economy, cultural symbolism, local social histories, ideologies of sexual propriety, evolving scientific accounts of human difference, the way and the degree to which scientific accounts get shared with the public, and much more. Second, the polyhedron must enclose some reference to the evolutionary dimensions of human organisms, which is to say that biology is not destiny in accounting for our likings and desires, but it is also not nothing, and must be taken account of in some way. And finally, an account constructed in this nuanced, complex way will make room for the thought that eros and desire are not in principle problematic – that they can under the right conditions be reconciled with the requirements of virtue, goodness, and right. I don't propose to say here what those conditions are, not least in order to avoid duplicating the superior efforts of other scholars.[11] But if I were to try to specify them, they would mark out a space of permissible desirings that could in principle include the laddie magazines that we will soon encounter, along with certain modes of post-racial play. But little of what I will say here depends on the permissibility of these practices. They appear here most often as data from which we can draw certain conclusions, irrespective of the propriety or permissibility of the practices.

4 The Cases

I promised to use some cases to fix ideas around my guiding questions – questions, you'll recall, about the philosophic import of the beauty gap, about just how much the gap has narrowed and what this narrowing means, and about how blacks can authentically orient themselves to anti-black sarkaesthetic norms. I'll just introduce the cases below, in order to provide a broadly chronological sketch of the negrophobic sarkaesthetic that has been at the heart of North Atlantic modernity. The chronology will be loose and non-exhaustive, meant only to draw a broad outline of the way sarkaesthetic negrophobia has developed during the contests of modern racial formation processes. After introducing the cases in this section, I'll return to them as necessary for comment and elaboration.

The cases, being cases, will be somewhat specific and highly context-dependent. Race theory always walks a fine line between honoring the details of specific contexts and identifying general principles that apply across contexts. One way to do this work is to identify representative dynamics – features of specific transactions that may not generalize across contexts, but that point to broader dynamics about which one can generalize. In this spirit,

I will focus on cases that emerge from Afro-US life-worlds, not on the assumption that everything about the cases will translate to, say, Brazil, Germany, or South Africa, but on the assumption that the cases will reveal general dynamics that we can find working in those other settings, even though the details will surely differ. Call this the principle of diasporic contextualism.

Setting the stage: Jefferson's beauty shares

In his *Notes on the State of Virginia*, Thomas Jefferson explains why formerly enslaved Africans should be repatriated, and cannot be incorporated into the new US populace (not even as laborers, certainly not as citizens). His answer, while justly famous and notorious, is still worth reporting at length. It begins in the way you'd expect, by appealing to white prejudices and black resentments and the dangers of race war. Interestingly, Jefferson moves from these basic ethico-political considerations to something else:

> To these objections, which are political, may be added others, which are physical and moral. The first difference which strikes us is that of colour.... [T]he difference is fixed in nature, and is as real as if its seat and cause were better known to us. And is this difference of no importance? Is it not the foundation of a greater or less share of beauty in the two races?[12]

Jefferson goes on to explain in no uncertain terms what he means by beauty, and why it matters:

> Are not the fine mixtures of red and white, the expressions of every passion by greater or less suffusions of colour in the one, preferable to that eternal monotony, which reigns in the countenances, that immoveable veil of black which covers all the emotions of the other race? Add to these, flowing hair, a more elegant symmetry of form, their own judgment in favour of the whites, declared by their preference of them, as uniformly as is the preference of the Oranootan for the black women over those of his own species. The circumstance of superior beauty, is thought worthy attention in the propagation of our horses, dogs, and other domestic animals; why not in that of man? [13]

I have argued elsewhere that Jefferson is a fitting representative of the moment at which modern racialism began to move into a new phase, the phase that gave us scientific racism and, eventually, eugenicist state policies. These passages from his *Notes* — expressing sentiments that we can find in any number of other figures, including philosophical giants like Hume and Kant — show that this phase, this high modern racial project, was also an aesthetic project. It shows

that the contests over racial meaning that constitute the racial formation process were, from the earliest moments, contests over human beauty.

Writing the hidden transcript: hair affairs

As I noted above, the clearest, most consistent, most ubiquitous examples of the struggle over – which is not the same as "capitulation to" – sarkaesthetic negrophobia may appear in the history of black hair-care practices. Caldwell explains some reasons for this:

> Among distinct physical characteristics associated with race – skin color, hair texture, size and shape of nose and mouth, and posterior musculature – skin color and hair texture are most often the focus of popular attention.... Unlike skin color and other physical manifestations of race, hair has both mutable and immutable characteristics. Change in the mutable and in the appearance of the immutable characteristics of hair can be accomplished with relative ease.... Hair can be cut off, straightened out, curled up, or covered over either in the exercise of individual preference or to comply with the tastes or preferences of others.... Because the appearance of hair and some of its characteristics are capable of change, the choice by blacks either to make no change or to do so in ways that do not reflect the characteristics and appearance of the hair of whites, represents an assertion of the self that is in direct conflict with the assumptions that underlie the existing social order. Such self-assertions by blacks create fear and revulsion in blacks and whites alike.[14]

Of the physiognomic keys to thin racial identities, black hair is the only one susceptible of relatively easy alteration. This effectively charges it with political significance. Styling black hair in ways that accentuate its racially marked characteristics – as Caldwell puts it, making no change in the hair's "natural" textures – means breaking with the prevailing norms that Jefferson articulates. But changing the hair's texture – straightening or "texturizing" it – may mean expressing fealty to those same norms, and to the social order that they help constitute. This funding of black hair with political meaning intensified over time, as the technologies of cosmetic alteration improved, and as racial conditions changed. For that reason my second case is not a single event or text but the transgenerational development of a domain of practice. This process bears somewhat differently on the lives of black men and black women, so for simplicity's sake I will focus on the woman's version.[15]

In 1905 Madam C. J. Walker launched the business that would make her the first African American woman millionaire. The business was based on a system for black hair care that simplified the arduous process of hair-straightening.

Walker claimed that the point of the system was to promote healthy hair, not to approximate European standards of beauty. But what I've elsewhere called "the straight hair rule" was already firmly entrenched and highly controversial, and so must factor into our understanding of Walker's success, whatever her intentions for her products. This rule insists that black women must have long, straight hair in order to maximize their potential for beauty, and can be argued for in different ways. Vanishingly few of these arguments require any commitment to a sense of overall black inferiority, but the almost compulsory nature of the rule – straight hair, along with light skin, was for many years, and in many settings still is, a marker of elite status and a precondition of entry into elite spaces – has long encouraged critics like Marcus Garvey and Alice Walker to worry that whatever the argument for it, what really motivates the rule is an inferiority complex born of internalized anti-black racism. The Garveyite side of this contest over the meaning of black female hair made its clearest inroads during the sixties, when "Black is Beautiful" became a mantra. The mantra came to life in the coronation of Howard University's homecoming queen in 1966, when, after much political maneuvering and argument, "students ... elected Robin Gregory to be the first Howard homecoming queen with a natural hairdo."[16]

What counts as a widely acceptable black female hairstyle has surely changed over the years in the United States, with natural styles less frequently demonized or exoticized. One of the clear markers of this shift is that African American flight attendants can now wear natural hairstyles without fear of reprisal. Still, as I'll discuss below, it may matter that Oprah, Beyoncé, and Michelle Obama all have straightened hair.

The multicultural consensus and the post-racial epiphany

Just as mainstream US society and its Afro-US counterpublics grew more accepting of a variety of black female hairstyles, they also grew more accepting of the other physiognomic markers of racial blackness. We appear in fact to have achieved a kind of multicultural consensus, making positive sarkaesthetic evaluations available to all comers regardless of "skin color, hair texture, size and shape of nose and mouth, and posterior musculature." The easiest evidence for this appears in the places you'd expect: the industries and institutions responsible for mobilizing figurative representations for pleasure and gain. Dark-skinned models now appear somewhat less infrequently in fashion magazines, and some, like Tyson Beckford and Alek Wek, become supermodels; televisual advertisements routinely feature ostentatiously "multicultural" groups of happy young people; white and black "laddie" magazines, usually operating from rather different criteria for ogling, occasionally agree and propose the same women as objects for their viewers' gaze – women

like Jennifer Lopez, Vida Guerra, and Beyoncé Knowles; Hollywood films somewhat less infrequently feature non-white leading men and ladies – roles for which physical beauty tends to be a prerequisite; and the artworld has opened its most august galleries and institutions to exhibitions on the black nude, male and female, on blacks in European portraiture, and on post-black figurative art.

Once the multicultural consensus was in place, it was a short step to a further condition that one might productively describe using some variant of the idea of post-racialism. If we take seriously the "post" in "post-racialism," we might think of it not as the transcendence of all racial distinctions and hierarchies but as the suspicion and parodic debunking of racial metanarratives. In the spirit of this sort of post-racialism, one refuses the idea that race means anything beyond what we use it to mean, and one embraces racial meanings as grist for the mill of playfully creating identities and culture. Having enacted these refusals and embraces, one might then do for racialized sarkaesthetic principles what Dave Chappelle's "Racial Draft" skit does for racial essentialism in expressive culture: signify on the existence of classically racialist and negrophobic principles by invoking them with evident insincerity, or quoting them in a comic mode. And that might look like this:

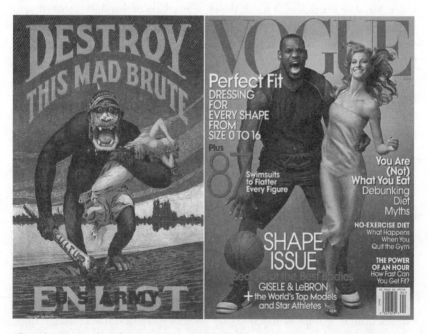

Figure 4.2 Cover of *Vogue* (April 2008), by Annie Leibovitz, compared with H. R. Hopps's World War I US Army recruitment poster by media critic Harry Allen.[17]

5 Reading the Cases

The cases above are supposed to show, in very broad and gestural outline, a shift from a rigidly, vehemently, and explicitly negrophobic sarkaesthetic regime to one that is much more open. They are meant to show also that the active contestation of racial meanings and structures helped bring us to this more enlightened place. One element of this contestation is implicit in what I've said so far, but needs to be made explicit. As I've noted, shifts in sarkaesthetic regimes help constitute the symbolic dimension of racial formation processes. As such, they are dialectically linked to the structural dimension of those same processes. That is: Body beauty judgments are not just about what we say when presented with representations of certain bodies; they are also related to the conditions of entry into all manner of social institutions and practices, including the ones that distribute the means for satisfying basic material needs. The greater acceptance of black bodies has been both condition and consequence of what racial integration we've been able to achieve in the United States. And like the story of integration, the shift in sarkaesthetic regimes from Jeffersonian racialism to Chappellian post-racialism seems like a story of progress, albeit uneven and fragile progress.

With this reading of the cases in hand, we can return to the questions that I used to launch this inquiry. What does the narrowing of the "beauty gap" mean? Is there anything of lasting philosophical interest about the gap? And how does one authentically navigate those spaces that are still to some degree shaped by the gap?

Answering these questions requires that we flesh out the story I've begun to weave around my cases. It may already be apparent that the progressive narrative of tolerance and integration is not at all the entire story, even though I've tried so far to give it a generous reading. Digging into the complexities of this story suggests that the beauty gap has not narrowed as much as it might appear; that racialized beauty judgments are important at least in part because they reveal the way race functions as a phenomenological inhibitor *and* catalyst; and that, here as elsewhere, authentic engagement comes from an ongoing struggle to deal responsibly and experimentally with the forces that condition our choices.

Re-reading Jefferson

One way to complicate the narrative of sarkaesthetic progress is to complicate the role that Jefferson plays at the beginning of the story. His relevance obviously derives at least in part from his status as a representative semantic expert for high modern US race-thinking. But his representativeness extends

also to certain features of his personal life, and to the way these features interact with his public avowals.

I am thinking here of Jefferson's relationship with Sally Hemings, the enslaved woman of African descent with whom he seems to have had a long-term sexual relationship. Remembering this relationship reinforces two thoughts that will be key to understanding the connections between race and beauty. First, the abhorrence of black bodies has also always – as long as the idea of ascribing blackness to human bodies has made sense – coexisted with considerable fascination, admiration, and desire for those same bodies. Second, the dialectical relationship between aversion and desire in contexts of racialized beauty judgments is layered over a similarly complicated relationship – though perhaps one of emergence or supervenience – between the baser impulses of sex appeal and the more rarified considerations of aesthetic admiration.

So the Jeffersonian beginnings of US racial sarkaesthetics point us not to a distant low point from which we've uniformly ascended, but to a moment of complexity with which we still have a great deal in common. The Jefferson–Hemings case exemplifies the intermingling of desire, aversion, and power that routinely attends the phenomenon of racialized aesthesis. We can see this in Jefferson's own words – more to the point, in the way his explicit assertion of black ugliness, noted above, opens itself for re-reading in light of later passages like this one:

> There must doubtless be an unhappy influence on the manners of our people produced by the existence of slavery among us. The whole commerce between master and slave is a perpetual exercise of the most boisterous passions, the most unremitting despotism on the one part, and degrading submissions on the other.[18]

Christina Sharpe's account of "monstrous intimacies" suggests a way to think through the nexus of connections between aversion and desire, sex and admiration, race and beauty.[19] "Monstrous intimacy" is Sharpe's name for those racialized social transactions that involve "violence and forced submission" in interpersonal spheres usually or ideally marked by affection, romance, or warmth. These transactions often involve sex, are as a result often connected with the "transgenerational transmission" of "shame and trauma," and are therefore routinely "read or reinscribed as consent and affection."[20] Sharpe argues that white supremacy is to an underappreciated degree constituted by these intimacies, and that we can't understand the textures and mechanisms and ongoing impact of high modern racial formation processes without coming to grips with "the complicated articulations of sex, violence, and use" that we find in transactions like the one involving Jefferson and Hemings

(or, in Sharpe's account, Strom Thurmond and Carrie Butler; or Frederick Douglass's Aunt Hester and Captain Anthony; and so on).

In its insistence on the "complicated articulations" of sex, violence, and use, the idea of monstrous intimacies highlights precisely the factors that shape the racialized experience of human beauty. And it encourages us to think about how we use, or decline to use, beauty-talk in our efforts to account for our sexual desires. I'll return to what this means below; but first I want to finish settling accounts with Jefferson.

The monstrousness of modern racialism's intimacies is constituted in part by their inability to flower into (what we might think of as) *proper* intimacies. In all human sexual intimacies, sexual desire gets layered over with something beyond physiological impulsion, whether that something is the intention to dominate, to express affection, or to cultivate pleasure. Intimacies become *monstrous* in part because white supremacy short-circuits the social and phenomenological transactions that might otherwise develop around phenomena like desire and attraction, and skews them in the direction of violence and domination (while pretending that it does otherwise). Jefferson and Hemings, Thurmond and Butler, were not simply intimate; their intimacy was stunted, prevented from becoming what it might otherwise have become in a different setting. ("Stunted" isn't quite the right word, suggesting as it does that the relationships started off properly and went off the rails somewhere along the way. This is of course very much not what happened, as these relationships – "relationships," if like me you cannot help hearing that word loaded with honorific meaning – were problematic from the start.)

I want to argue that judgments of human beauty are among the transactional dynamics that white supremacy short-circuits in intimate settings. Put differently, judgments of human beauty can under certain conditions emerge from acknowledgments of desire and attraction, and become bound up in experiences of other persons as *desirable* and *admirable* in fully human ways that go beyond sexual objectification. This phenomenon once went by the name of "crystallization" and sometimes now gets referred to as "decision bias"; and it is part of the passage from the erotic to the romantic, from desire to love, from judgments of attractiveness to judgments of beauty. The beloved comes to be seen as beautiful, perhaps out of proportion to what people outside the relationship would regard as his or her real merits. But this is possible because, or only if, the personhood of the beloved colors or inflects the otherwise impersonal judgment of erotic desirability (where "impersonal" means something like what "selfish" means when students of evolutionary theory speak of selfish genes).

White supremacy short-circuits the process of crystallization, and prevents attraction from growing into the judgment of bodily beauty. Jefferson's racism

allows him to desire Sally Hemings but prevents his desire from expressing itself as anything more, like love, admiration, or aesthetic appreciation. Instead of explaining and developing his attraction by rhapsodizing about Hemings's beauty, he has to lament the temptations of his "boisterous passions." To put this in the language of our earlier discussion of invisibility, Hemings was invisible: her personhood and her individuality were obscured by her status as a negro. Or: Hemings the negro was *hyper*-visible, and left Hemings the woman hidden in her shadow.

(Jefferson was of course thinking also of political considerations in keeping the relationship quiet, and deferring to widespread custom. But this reinforces the point rather than undermining it: high modern white supremacy was built on an elaborate structure of ambivalence, denial, and repression, as well as on a political economy of rape and stolen labor. Slaveholders routinely did what Jefferson did, and routinely lied about it, and usually admitted to no conflict between their sexual desires and their aesthetic evaluations.)

Jefferson's confession – that is how I read the business about "boisterous passions" – effectively locates a volitional and ideological barrier that separates sexual desire from aesthetic admiration or esteem. There are obvious points to make here about the difference between oppression and sexual violence on the one hand and attraction and sexual enjoyment on the other, and I have tried to gesture at them above. But we can use Sharpe's framework to make these points in the idiom of phenomenology, and by reference to judgments of beauty. The physiological impulsion of attraction or desire can blossom into a variety of experientially rich and ethically permissible forms under the right conditions. But under white supremacy, it all too often gets stunted – perverted – and turns only into exploitative and violent transactions in which the language of beauty and the experience of crystallization – the leap from attraction to aesthetic admiration that we typically equate with romantic experience – are firmly ruled out.

Re-reading the hair affairs

I've just tried to complicate the narrative of sarkaesthetic racial progress by re-reading Jefferson's aesthetic preferences in light of his erotic attachments. Now I want to re-read US hair affairs in light of certain contemporary realities for a similar reason: to complicate the related narrative of growing appreciation for black hair. In doing this I am pleased to note that I am joining a growing community of like-minded social and cultural critics, from writers like Ayana Byrd and Lori Tharps[21] to Hollywood A-listers like comedian, actor, and director Chris Rock. Rock's 2009 documentary *Good Hair* takes up some of these issues, though Hemamset Angaza's 2012 film, *In Our Heads*

About Our Hair, covers some of the same ground as Rock's piece with much less fanfare and much greater openness to the perspectives of black women themselves.

Here's how the narrative of sarkaesthetic racial progress is supposed to go in relation to black hair: once upon a time black folks were profoundly self-hating, and were keen to adopt white standards of beauty (and everything else). There were dissenters from the beginning (Garvey, Alice Walker, etc.), and, as we saw with the Suriname barbers from the beginning of this book, some styling practices survived the Middle Passage and shaped everyday life for many people. But elite opinion – and, after Madam C. J. Walker's technological triumph, working-class opinion too – skewed heavily in the direction of the straight hair rule: the closer one could get to the hair textures marked as racially white (which of course not all white people enjoyed), the better off one was, and the *better* one was. Then the sixties came, and we realized black was beautiful, and everything became fair game. Oprah can wear braids on her shows without fear of backlash from her viewers or advertisers. Black women who work outside the home can wear locks and afros, even in professional settings. And wearing natural hairstyles seems to have no bearing on a woman's prospects for securing a mate or a romantic companion.

There is a great deal to say here, but most of it is either very much like what I'll say in the next section, or unavailable to me until I acquire the expertise and space to gather and work through a great deal of empirical data. That leaves me little to do here but muster some intuitions and write a blank check for work to come later. I'll start with the intuitions.

I have to think it means something that the most visible black women in US society and in US-driven global expressive culture almost all have straightened hair. The (remarkable!) amount of money that Beyoncé Knowles spends on her hair weaves is public knowledge, and is casually accepted as a cost of doing business for people like her. Or perhaps it is not so casually accepted, if the exclamation points after this headline from mediatakeout.com are any indication: "Beyoncé Unveils Her New $145 THOUSAND WEAVE … She Got A WESTERN EUROPEAN … ORGANIC BLONDE WEAVE!!"[22]

Michele Obama has never, not since she became a national figure, appeared in public in any hairstyle that a stereotypically straight-haired white woman could not achieve (with the aid of an expensive stylist). What's more, I'll wager anything that she never will, not until the First Couple are many years into retirement. One can imagine the reasons for this, and they are not surprising or irrational: in a political climate that somehow allows people to think of a center-right politician like Barack Obama as a socialist and a terrorist, any sign of radicalism must be carefully expunged from their public personae, including "radical" hairstyles.

I promised a blank check along with the intuitions, so I'll list the kinds of things I'd need to know, or the kinds of questions I'd need to have answered, in order to cash the check. This too is an exercise in intuition-pumping, but I have a clearer sense that these intuitions can be plausibly backed up with persuasive evidence. How much do black people spend a year on hair-care products, and what percentage of this goes to hair-straightening techniques? What percentage of Afro-US women have straightened hair, as opposed to, say, locks or afros? What percentage of Afro-US girls have their hair straightened before they reach what the Catholics once called "the age of reason"? What attitudes about all this would a good survey reveal – do Afro-US communities still think, either explicitly or implicitly, of "natural" hair as backward, dirty, or primitive?

Perhaps this is not so much a blank check as an acknowledgment of the limits of this project, and of the boundary between the research that I can do now and the research that I might do later to discover what to say about this, or what other people have already said about it. That said, you'll be able to guess my intuitions about what further research into these areas would tell us. Attitudes around the straight hair rule may have become more tolerant and flexible, as evidenced by, among many other things, the fact that black flight attendants can wear natural hairstyles without being reprimanded or fired. But if the social media commentary around recent black hair controversies – like the ones involving Gabby Douglas and Oprah – are any indication, a common perspective on Afro-US hair affairs inclines toward the post-racial millennial view. Everything is possible now, we're meant to think, and no style choices mean anything beyond their status as individual choices.

This millennial view strikes me as naïve, or at the very least, too quick, for two kinds of reasons. First: If the overwhelming majority of a people participate in a practice that at its core invites them to think that they are, as they stand, not good enough; if they leave the womb needing aesthetic *improvement* (hence my question about the age of reason), how can they not consign themselves to an unnecessary struggle in the quest to develop a healthy self-concept? How can this not implicate the right to an equal opportunity to cultivate the social bases of self-esteem? And second: If a relatively poor people spends a significant portion of its disposable income in order to participate in a practice, this suggests that the practice matters, and matters deeply (hence my question about annual expenditures). More to the point, if the individuals who constitute this people conjure up manifestly incoherent justifications for participating in the practice, that suggests a degree of self-denial or self-delusion that might warrant some attention. I am thinking here of the people who say, like Gabby Douglas, that straightened hair is simpler and easier to take care of, which is manifestly, *demonstrably*, false – it is easier

to take care of, *if* the care regimen is already shaped by whitely assumptions about technology (what kinds of implements to use, what taking care of it looks like) and style.

I keep mentioning Gabby Douglas, so I should explain why. Ms. Douglas's appearance on a national magazine cover with her hair not quite properly straightened prompted a viral social media debate with three basic positions. The first group complained that she wasn't taking care of her hair and so was representing the race badly. The second group complained that she should take pride in her natural hair and not even try to straighten it. And the third group complained that the first two groups were making a big deal out of nothing, because her accomplishments were her accomplishments and hair doesn't mean anything. All three groups were wrong, and were proven so by Douglas's statement on the matter. She said that her hair was the least of her concerns: she attended to it only after doing all the other things she needed to do, like training for the Olympics. What I take from this: Hair – the straight hair rule – does matter if *an Olympic athlete* thinks that the way to keep hair care off of her busy schedule is to *go to the trouble of straightening it*, especially since straightening requires upkeep – remember the danger of "turnback"– and upkeep is precisely what she doesn't have time for. Douglas's mother gave away the game when she reported that "Gabby just did with her hair what all the other girls did" – which is to say, all the other *white* gymnasts, for whom ponytails really are the easiest way to go. This is not about self-hatred or misrepresenting the race or about a meaningless style choice. It is about whiteliness shaping a black person's expectations and preferences, and her choices about how to allocate scarce resources like a high-level athlete's time and energy. A ponytail makes sense for white girls in a way that it just doesn't for a black girl. It makes sense in the way that a short afro makes sense for black women, like the ones worn by South African schoolgirls and Afro-US businesswomen.

Re-reading multiculturalism

The arguments about black hair converge on arguments that arise from multicultural and post-racial sarkaesthetics. The sort of progress narrative that we find in the hair affair also marks our orientation to other features of black bodies, from skin color to facial features and body shape. And here too, attending to some contemporary realities should complicate the thought that we are on a seamless upward march, or that the march has brought us to a post-racial nirvana.

Insisting on the errors of the progress narrative should not prevent us from crediting the resistance nature of the work that has given us what progress we've seen. This is part of the philosophic pay-off of attending to

questions of race and beauty: doing so points us to some remarkably clear examples of counterhegemonic struggle and the political mobilization of cultural resources in counterpublic spheres. The prospects for pro-black beauty judgments have changed, to be sure, and they have changed for the better in specifiable ways. And these changes are the result of black people and their allies insisting on black dignity, humanity, and beauty, and cultivating these virtues and capacities in distinctively black public and private spaces. Even campaigns with equivocal or uneven motivations and results emerge from a resistance project that must be credited. The "beauty of the week" feature in *Jet Magazine*, for example, is perhaps the last remnant of a patriarchal resistance tradition, a tradition of insisting on black humanity and beauty and respectability in a world that denied both – and of doing so by presenting images of provocatively clad young women in what were otherwise general interest periodicals. It is a far cry from *Jet* to Lorna Simpson's revelatory nude self-portraits, or to Kara Walker's striking visualizations of "monstrous intimacy." But all come from the same ethical and volitional space, the space that Fuller marks out in my epigraph: a space devoted to reclaiming black humanity in an anti-black world by reimagining and re-presenting the black body.

Once we credit the resistance nature of the work that has integrated our sarkaesthetic transactions, though, we have to grapple with the degree to which these transactions remain problematically stuck in an integrationist mode. I take "integrationism" to refer to the view that racial injustice is most centrally a matter of keeping the races separate, and that undoing this separation – defeating segregation – is the key to achieving racial justice. There are many ways to contest the general reduction of racial justice to integration. We might, for example, revisit the express motivations of participants in black freedom struggles – which civil rights historians now insist were usually about things other than integration, like self-determination or the provision of basic needs. Or we might argue that racial justice requires social justice, and that social justice is impossible without a radical overhaul of social relations of the sort that integrationism tends not to countenance. Whatever line we take, the common thread will be that focusing on integration leaves something in place that justice tells us to uproot.

A critique of distinctively *aesthetic* integrationism follows this same pattern. Aesthetic integrationism admits race-related expressive objects and practices into previously segregated spaces, and even does so enthusiastically. But it does little to explore or contest the aspects of stratifying racial formation processes that underwrote the segregation and that outlive its annulment. Specifically *sarkaesthetic* integrationism reproduces in relation to the body the achievements and oversights of the wider set of commitments and practices to which it belongs: it admits previously devalued bodies into

previously segregated spaces and contexts, while leaving untouched the deeper raciogenic conditions that preceded and that persist beyond surface segregation.

The multiculturalist narrative of sarkaesthetic progress seems clearly to presuppose an integrationist picture; otherwise it would be harder to accept its evidence of progress as evidence. We can prepare the way for this thought by thinking about the career of racial aesthetics beyond the body. Hollywood studios now embrace "black" movies in a way that would have seemed unthinkable not that many years ago. But what counts as a black movie tends to be bound up with stereotypical characters and formulaic, whitely plots. And the black characters cannot be *too* black, especially if they are women, which is to say that leading ladies must be able to pass the brown paper bag test. Similarly, "black" music is all the rage, all over the world, thanks to the US music industry. But what this means is that a highly commodified version of hip-hop culture has been wrenched from various complicated real-world settings and sold to the world as an authentic rendering of black life and culture. In both cases, a very particular kind of blackness has found its way into the mainstream culture industries: a kind of blackness that is consistent with the dangerous, brutish, congenitally criminal, hypersexual, hypersensual image of the black that we can trace to the very beginning of cinema, in D. W. Griffith's *Birth of a Nation*, and beyond that to Griffith's sources, and their sources.

Sarkaesthetic integrationism functions in similar ways. It is what happens when we admit black bodies into the spaces of estimation and evaluation that were once closed to them without doing much to change the broader terrain on which those spaces are found. Think here of beauty pageants, or of pornographic and near-pornographic magazines, or of art-world portraiture, or of fashion and fashion photography. In all of these spaces we have seen a number of breakthroughs in recent years, if one consents to think of them as breakthroughs. (As I noted above: Whether these count as examples of progress or as problems will depend on how one analyzes the gender and sexual politics of these phenomena.) To take just a few unsatisfying but still representative examples:

1. The Miss America pageant has been in existence since 1921. The first black winner was Vanessa Williams, in 1983. Since then there have been seven others (counting the woman who took over after Williams resigned). That's eight in ninety years.
2. *Playboy Magazine* has been around since 1953. That's sixty years of covers and centerfolds, at least twelve of each every year for sixty years. An enterprising writer recently undertook to celebrate black playmates for black history month. (I know; but let's press on.) He found twenty-six.

Out of 720. The first black solo cover model appeared in 1971 – some eighteen years in.[23]

3. *People Magazine* has been anointing one actor or another as "The Sexiest Man Alive" since 1985. Only one black man has ever made the cut: Denzel Washington, in 1996.[24]

These examples take us back to the desire–aesthetics nexus, discussed above. In doing so, they also point us to another virtue of reading these questions through the idea of monstrous intimacy. I found in that idea the resources for an argument about phenomenological inhibition – about the way white supremacy does its work in part by blocking the development of certain kinds of experiences. The version of this inhibition that we saw above concerned crystallization, and focused on Jefferson's inability to make the phenomenological journey from judgments of attraction to judgments of beauty. We no longer inhabit Jefferson's world, of course, and one indication of that fact is the much greater esteem with which black bodies are publicly regarded. But the liberal-multicultural racial rapprochement that allows for one or two black supermodels while squeezing most of the others out of the business undermines the thought that we've reached a multicultural nirvana, and points to a different kind of phenomenological inhibition. Where Jefferson could not experience crystallization in the presence of a black body, and make the passage from attraction to admiration, multicultural integrationism foregrounds a mode of interracial consumption that blocks the recognition of moral personhood.

Multicultural integrationism is built on what bell hooks calls "eating the other." This is what happens when one treats racial others as opportunities to enhance one's own experience by, as it were, consuming them, instead of as full persons. It is, in short, a version of invisibilization, of the arrogant, inattentive perception that we considered in Chapter 2. We see this inattention at work among hooks's white college students, who brag about sleeping with women of other races in order to demonstrate their worldliness and breadth of manly experience; we see it when multinational corporations declare their progressiveness by showing us ostentatiously diverse collections of happy consumers in their advertisements, even though their products are likely made by underpaid brown people in some faraway place; we see it when televisual fictions include one black or brown friend among their main characters, usually without doing anything to connect that one friend to the wider social context from which he or she is likely to have come.[25]

Eating the other is not identical with Jeffersonian phenomenological inhibition. It does not divert the inchoate experience of admiration into an experience of domination and "boisterous passions" while denying the

possibility of black beauty. Instead it grants the judgment of beauty, but stifles the experience that might grow out of this judgment.

In something like the spirit I have in mind, Nehamas defines beauty in this way:

> 'Beauty' is the name we give to attractiveness when what we already know about an individual ... seems too complex for us to be able to describe what it is and valuable enough to promise that what we haven't yet learned is worth even more, perhaps worth changing ourselves in order to come to see and appreciate it.[26]

This strikes me as importantly right, and consistent with the naturalistic picture I gestured at above. Body beauty judgments are what judgments of attractiveness become when they begin to play a role in, and get transformed by, the distinctively human contexts of cultural meaning. What might then happen in these contexts is that we find ourselves to some degree opened to the personhood of the other. (To put this in the language of evolutionary social psychology: we activate a capacity that overrides the judgment of attractiveness in deference to considerations of social bonding and attachment.) We might see the other not just as *sarx* but also as *soma*, as an embodied presence; not just a bearer and object of aesthetic value but also a creator and subject of that value. Eating the other is precisely not a matter of respecting the personhood of the other, and is consistent with accepting the kind of dehumanizing prejudices that sarkaesthetic integrationism means to have vanquished.

What I've said so far falls short of the condition of argument, and I don't have space to make the kind of argument that I need. So once again, I'll just mobilize some intuitions. I've argued elsewhere that the real payoff for developing a critical race aesthetics has to do in large part with developing the resources to retrain our immediate perceptions. Many years of research on implicit racial attitudes have exhaustively shown what we've known for a long time. People of all races routinely and immediately read black bodies as threats or problems. This happens to blacks much more often than it does to other people, and it happens in a variety of contexts. The most distressing contexts are the ones involving the potentially lethal application of coercive force, such as the (also routine) shootings of black people by the police (and, now, by ordinary citizens empowered by "stand your ground" laws). But it also happens in job interviews, in meetings with lenders, and in many other familiar contexts. All of this, the persistence of immediate, preconscious, negrophobic racial aesthesis, bears on the question of sarkaesthetic racial progress because *it still happens, even though Beyoncé is on the cover of GQ.* Sarkaesthetic integration is consistent with the persistence of anti-black

implicit bias – the sort of bias that is reinforced by and shines through our mobilization of images in expressive culture. Once again we have a kind of phenomenological inhibition, this time preventing the experience of accepting black bodies in one context – on a magazine cover, or in a centerfold – from changing the reaction to them in others – on an empty street, with a gun in your hand.

Re-reading post-racialism

The shooting of Trayvon Martin strikes me as the clearest repudiation of facile post-racialism that we have. It does not, however, quite as clearly refute the more subtle mode of post-racialism that I meant to offer above. On this approach, post-racialism is postmodernism about race. It is the condition we achieve once we develop the appropriate level of suspicion toward racial metanarratives, once we realize that racial history has no telos, and that racial categories are about nothing deeper than the realities that racial practices have brought about. These realities are nevertheless real, with their achievement gaps and colonized lands and the rest. But the specifically racial dimensions of these realities are of our own making, and are subject to our own manipulation.

Construed in this more subtle way, post-racialism is an essentially aesthetic matter. To accept the possibilities that post-racialism represents is to recognize that racial meanings are fair game, and can be manipulated and toyed with. One might think that this is the answer to the dead end of sark-aesthetic integrationism. If we need to retrain our immediate perceptions so that future Trayvon Martins will not be in danger because they *look* dangerous, then what better instrument to employ than postmodern parody and irony? We are already postmodern racialists, one might think, when it comes to expressive culture, with white talk show hosts performing hip-hop classics with white hip-hop artists on their shows – and doing so creditably, with the backing of a well-regarded black hip-hop band. (Thinking here, once again, of Jimmy Fallon, Justin Timberlake, and the Roots.) Why not take the next step and play with the meanings of the body, the way Glenn Ligon does?

Unfortunately, this subtle post-racialism has more in common with its facile variants than it first appears. White performers have always borrowed from, and participated in the development and distribution of, "black" expressive practices. Jimmy Fallon and Justin Timberlake play the roles that Glenn Miller and Elvis Presley once played. This history of cross-racial collaboration, or borrowing, or appropriation, raises the question of love and theft – of the ethical valence of these appropriations. But I mean to bracket that question for the moment and focus not on the ethics but on

Figure 4.3 Glenn Ligon, *Self-Portrait Exaggerating My Black Features and Self-Portrait Exaggerating My White Features*, 1998. Courtesy Regen Projects, Los Angeles, © Glenn Ligon.

the historical data. Racial formation theory reminds us that the history of race has *always* been a history of contesting and revising racial meanings, and this has always happened, to some degree, without regard for racial boundaries. That's how we came, many years ago, to have black performers performing *in blackface*, providing an interpretation of white interpretations of black behavior.

Again, the issue right now is not whether minstrelsy was a theft or an insult, or whether, or when, cultural appropriation is impermissible. The

issue is that the cross-racial borrowings that are now supposed to make us post-racial have been going on for quite some time. This should slow down any rush to endorse the post-racialist picture.

The implications of all this for sarkaesthetics are fairly straightforward. We think racial meanings are grist for the mill of post-racial play, so we throw them around freely, without regard for their ability to offend or for their roots in expressly offensive racial meanings. Members of white fraternities and sororities don blackface and afro wigs for their parties because they can: because the university is integrated, and black people have all that they could want, and because we all know that race doesn't mean anything anyway. It doesn't occur to them that dressing up as a leprechaun is not like dressing up like *a negro*, or that the only way to form the latter intention is to accept extremely crude ideas about what "a negro" is. And this doesn't occur to them because whitely perspectives on the history of US racial politics and on the contemporary sociological landscape enable them to think, without irony, that black people in fact *do* have all that they could want.

Similarly: Annie Leibovitz recruits LeBron James to play an ape in a photographic restaging of an iconic image because, as Allen points out, the association between blacks and apes is long established, and readily available in public perceptual habits. It is permissible, we think, to cast a black man as King Kong[27] because we know better than to be insulted by this. These images and images like them have been defanged, deprived of their ability to wound or persuade.

Unfortunately, like the glibly libertarian and voluntarist account of hair-straightening, this reading of LeBron as Kong is too quick at best, and naïve at worst. King Kong doesn't make sense without a backdrop of assumptions about race and sex and beauty and desire, as well as about modernity and technology. Think about it: *why on earth* would an ape, especially a twenty-foot-tall ape, be transfixed by the beauty of a white woman? The only possible answers must appeal to ideas about the transcendent beauty of white womanhood and the unquenchable desires of lower racial types. Most people today don't know about the tradition of ape-carrying-off-white-woman stories that King Kong epitomizes, which is a point in the post-racialists' favor. It also supports the thought that it is possible to recuperate the cultural objects that embody these ideas, as Leibovitz has done and as filmmaker Peter Jackson did in his 2005 remake of *King Kong*, while leaving aside the ideas themselves. But to recycle these allegedly defanged narratives and images in a world that *still* thinks of black men as brutes, and that is still marked by the asymmetries and gaps that I cited in the previous section, and that still generates these realities with the assistance of negrophobic aesthesis, seems an odd choice.

To say that the Kong–LeBron image is the fruit of "an odd choice" may seem a little unsatisfying. I may have seemed on the way to something stronger – condemnation of the image, to be sure; critique of Leibovitz, perhaps. But I'm less interested in moralistic critique, of the image or its author, than in using social analysis to inhabit and expand the reflective space that the image opens for us. We can use images like that as "teachable moments," as opportunities to excavate the ideology of black brutishness that informs *King Kong and* the shooting of Trayvon Martin. And the fact that it would pay us to do this work, that black lives are endangered by the same meanings that inform Peter Jackson's cinematic fantasies, suggests to me that the scope for post-racial play is real but nevertheless severely circumscribed by negrophobic realities. Or: Neither Peter Jackson nor Annie Leibovitz is Glenn Ligon.

6 Conclusion

Many subjects and cases that bear on our topic have received little or no mention here. I've said nothing about Sara Baartman and her haunting of contemporary figures like Jennifer Lopez and Vida Guerra. I've said very little about colorism, or the discrimination in favor of people with lighter complexions that we find at work inside black communities. And I've said nearly nothing about the way black bodies are made and remade in performance and embodied experience.[28]

In an ideal world, or in a document devoted solely to somatic aesthetics, I would take up all of these issues and more besides. But in the space available to me here, I wanted to lay a foundation that would make it easier to take up those other questions. I hope to have done that by introducing sarkaesthetics and distinguishing it from nearby concepts, by using Sharpe's idea of monstrous intimacy to introduce the idea of racism as a phenomenological inhibitor, and by using this complex of ideas to refine the distinction between judgments of attractiveness and judgments of human bodily beauty.

All of this should have taken us some distance toward answering the questions with which I began. The beauty gap has not narrowed as much as it might appear, and this narrowing has been accompanied in some ways by an *intensification* of the mechanisms of racial violence and dehumanization. Studying the gap is nevertheless philosophically interesting because it yields realizations like this, and because it reveals the way race functions as a Jeffersonian phenomenological inhibitor *and* Garveyite catalyst. And finally, an authentic engagement with these dynamics comes not from piously praising and blaming others for their choices, as in the debate over Gabby Douglas's hair, but from the continual struggle to excavate, clarify, and domesticate the forces that condition our choices.

Notes

1 http://www.softsheen-carson.com/_us/_en/dark-and-lovely/whatsnew.aspx (accessed February 20, 2013).

2 See Shirley Tate, "Black Beauty: Shade, Hair and Anti-Racist Aesthetics," *Ethnic and Racial Studies* 30:2 (2007), 300–319, 302.

3 Paulette Caldwell, "A Hair Piece: Perspectives on the Intersection of Race and Gender," *Duke Law Journal* 40:2 (April 1991), 4.

4 Richard Shusterman, "Somaesthetics: A Disciplinary Proposal," *Journal of Aesthetics and Art Criticism* 57:3 (Summer 1999), 299–313, 299.

5 Richard Shusterman, "Somatic Style," *Journal of Aesthetics and Art Criticism* 69:2 (Spring 2011), 147–159, 158 fn. 16.

6 *New American Standard New Testament Greek Lexicon*, "Sarx," http://www. biblestudytools.com/lexicons/greek/nas/sarx.html (accessed March 15, 2013); Geddes MacGregor, "Soul: Christian Concepts," in Lindsay Jones, ed., *Encyclopedia of Religion*, 2nd ed., vol. 12 (Detroit: Macmillan Reference USA, 2005), 8561–8566.

7 I share the commitment to a tripartite scheme with Shusterman, but we draw the distinctions differently. See Shusterman, "Somaesthetics" 305–308.

8 Shusterman, "Somaesthetics," 304.

9 See Noliwe Rooks, *Hair Raising* (New Brunswick: Rutgers University Press, 1996); Ingrid Banks, *Hair Matters: Beauty, Power, and Black Women's Consciousness* (New York: NYU Press, 2000).

10 Susan Bordo, *Unbearable Weight: Feminism, Western Culture, and the Body* (Berkeley: University of California Press, 1993).

11 See Sherri Irvin and Sheila Lintott, "Sex Objects and Sexy Subjects: A Feminist Reclamation of Sexiness," in Sherri Irvin, ed., *Body Aesthetics* (Oxford University Press, forthcoming).

12 Thomas Jefferson, *Notes on the State of Virginia*, in Thomas Jefferson, *Writings*, ed. Merrill D. Peterson (1781–1782; New York: Library of America, 1984), 264–265; publicly accessible on the web at http://etext.lib.virginia.edu/modeng/modengJ.browse.html.

13 Jefferson, *Notes*, 264–265.

14 Caldwell, "A Hair Piece" 10.

15 I begin a discussion of the male version of this dynamic, and of much else that appears in this chapter, in "Malcolm's Conk and Danto's Colors, or: Four Logical Petitions Concerning Race, Beauty, and Aesthetics," *Journal of Aesthetics and Art Criticism* 57:1 (Winter 1999), 16–20.

16 Maxine Leeds Craig, *Ain't I a Beauty Queen? Black Women, Beauty, and the Politics of Race* (New York: Oxford University Press, 2002), Kindle edition, Kindle location 1046.

17 Harry Allen, "Monkey See, Monkey Doo-Doo," *Media Assassin* (blog), March 31, 2008, http://harryallen.info/?p=363 (accessed August 27, 2014).

18 Jefferson, *Notes*, Query XVIII, "On Manners."

19 Christina Sharpe, *Monstrous Intimacies: Making Post-Slavery Subjects* (Durham, NC: Duke University Press, 2009), Kindle edition.

20 Sharpe, *Monstrous Intimacies*, introduction, par. 5 (Kindle locations 83–84).

21 Ayana Byrd and Lori Tharps, *Hair Story: Untangling the Roots of Black Hair in America* (New York: Macmillan, 2014).

22 "MTO World Exclusive," *mediatakeout.com*, March 19, 2014, http://mediatakeout. com/68264/mto-world-exclusive-beyonce-unveils-her-new-145-thousand-weave-she-got-a-western-european-organic-blonde-weave.html (accessed August 27, 2014). Apparently the hair came from Norwegian sisters who ate organic food for two years in order to produce the hair that Ms. Knowles purchased.

23 Josh Robertson, "A History of Black Playboy Playmates," *Complex.com*, February 1, 2013, http://www.complex.com/pop-culture/2013/02/a-history-of-black-playboy-playmates/ (accessed February 22, 2013); Alexis Garrett Stodghill, "Black Women of Playboy," *Madame Noire*, October 26, 2011, http://madamenoire. com/82355/black-women-of-playboy-eat-your-heart-out-lindsay-lohan/ (accessed February 22, 2013).

24 *People Magazine* online archive, http://www.people.com/people/archive/ topic/special/0,,20188535,00.html (accessed February 22, 2013).

25 bell hooks, "Eating the Other," in *Black Looks: Race and Representation* (Boston: South End Press, 1992), 21–40.

26 Alexander Nehamas, *Only a Promise of Happiness: The Place of Beauty in a World of Art* (Princeton: Princeton University Press, 2007), 70.

27 See Dodai Stewart's discussion of the "LeBron Kong" cover in the "MagHag" feature of Jezebel.com, posted on March 25, 2008, http://jezebel. com/371923/maghag (accessed August 27, 2014).

28 Among many other texts, see Daphne Brooks, *Bodies in Dissent: Spectacular Performances of Race and Freedom, 1850–1910* (Durham, NC: Duke University Press, 2006).

5
Roots and Routes: Disarming Authenticity

Q. Tell us about this new album.... You draw on traditions from Cuba, Peru, Mexico, Brazil, Puerto Rico, even New Orleans. Why did you choose these songs?

A. I wanted to show the Africanness of America. Our Africanness. To celebrate this Africanness.... [I]t is marvelous to see that when we interpret music of Puerto Rico, and a bomba dance seems to be so much ours, because the rhythm, well, it's not the same, but it's similar. What excites me so much, for example, is how one can manage to make a funk song end in a Peruvian festejo, and you don't lose authenticity.

Afro-Peruvian singer and Peruvian minister of culture,
Susana Baca[1]

1 Introduction

In a review of Richard Wright's novel *The Outsider*, Lorraine Hansberry raises a mildly surprising complaint about the novel's – or the author's – lack of authenticity. She doesn't directly invoke that loaded word, but the words she does use should leave no doubt about the nature of the concern. The novel's protagonist, she writes, is "someone you will never meet on the Southside of Chicago or in Harlem." She goes on: "Wright has been away from home a long time."[2]

The merits of Hansberry's charge are debatable, or they would be if we had the time to work through its motivation and details. I'm less interested in her brief against Wright, though, than in the kind of argument that her review exemplifies. Concerns about the authenticity of the products or producers of

Black is Beautiful: A Philosophy of Black Aesthetics, First Edition. Paul C. Taylor.
© 2016 Paul C. Taylor. Published 2016 by John Wiley & Sons, Ltd.

black expressive culture are as old as the idea of a distinctively black expressive culture. These concerns take different forms at different times, from white critics complaining that Phyllis Wheatley merely copied European styles – as opposed to working through idiomatic conventions like any other poet – to Dave Chappelle joking about how much white people love Wayne Brady (and then crafting an entire episode of his show around a meta-reflection on the joke). But the basic structure of the worry is always the same: the candidate for the status of black art or for the title "black artist" is supposed to have strayed too far from some version of what Hansberry calls "home," and to have as a result lost touch with something crucial to black life and experience.

These questions of expressive authenticity indicate the degree to which the vocabularies of blackness and of raciality are bound up with assumptions about *rootedness* – assumptions, in other words, about being empirically attached and ethically committed to some formative experiences and to the hallowed sites of their occurrence. What triggers these thoughts about rootedness varies widely depending on whose account of blackness one has in mind. For some the key sites and experiences may emerge from chattel slavery or the Middle Passage. For others they may involve certain commitments and practices that survived these conditions and that continue to link contemporary diasporic Africans to their forebears. For still others the key may lie in the glories of classical Egyptian culture, as passed down through the ages and disseminated across the continent and the diaspora. And for people like Hansberry (so far as her concern is revealed in the passages cited so far, anyway), the locus classicus may be places like Harlem. But in one way or another, blackness has for most people, for most of its history, seemed to require talk of more or less precisely located roots.

The tight connection between racial identities and roots has been called into question in recent years. Some of these questions follow directly from the demolition of overly simple, essentialist notions of racial identity, and as a result get little traction with the more complicated accounts of racialization that are our concern in this book. Other ways of questioning the rootedness of racial identities emerge from the fine work that has been done in recent years to show the centrality of *up*rooting and rerouting to black life-worlds. Some of this work explores the lives and careers of specific figures like Wright, Paulette Nardal, James Baldwin, and Josephine Baker. These are figures at the heart of anything we might refer to as a black aesthetic, but they are also figures whose blackness was constituted by their transnational connections, which is to say, by their rootless – or multiply rooted, or *rhizomatic* – life paths. Other studies of uprooting and rerouting focus less on specific figures than on broad trends. Here we might think of the fascinating recent studies of the slave trade's forced migrations – "commercial deportations," George Lamming calls them[3] – first to the African coast and then through the Middle Passage to the Americas. Or we might think of the Great Migrations that brought blacks

in the southern United States to the northern states, or of the "reverse coloni-zation" that still brings denizens of Europe's former colonies back to the metropoles. Whether focused on émigré individuals or migrant populations, studies like these show just how much the allegedly rooted identity of racial blackness depends on various kinds of migration and mobility.

The tension between homes and migrations, or, as Paul Gilroy says, *roots and routes*, mirrors a broader philosophic tension between discourses of authen-ticity and of instability. Authenticity in this sense has to do with the thought, as Charles Taylor puts it, that there is a way of being that is *my* way, or the way of my people, which I am bound, on pain of ethical, political, or psychological failure, to endorse and advance. But appeals to authenticity often seem to downplay the fluidity of human experience and the dynamism of social prac-tice, especially as the exigencies of living set our experiences and practices in motion across time and space. One can insist on this fluidity and dynamism in a variety of ways, from criticizing the metaphysics of presence to insisting on the processual or dialogical character of subjectivity. But the punchline for authenticity discourse will be the same: The quest for an authentic subject, a stable *me* or *we* that can utter Taylor's mantra of authenticity ("this is my way, and our way"), often leads to arbitrarily truncated narratives of individual and collective origin, insulating the subject from the messy processes of subject formation and cultural transmission under conditions of historical change.

These tensions between roots and routes and between authenticity and instability frame one of the central problem-spaces in the black aesthetic tradition. In light of the role that appeals to authenticity have played in the tra-dition, and in light of the complications that, as we've seen, come with those appeals, we have to ask: What kind of work can appeals to authenticity appropriately do? Are they grounds for criticism, as Hansberry seems to think? Or are they something else? One way to approach questions like these, and perhaps the best way to do so, is to consider some cases.

2 An Easy Case: The Germans in Yorubaland

The first case comes from art historian and curator Sidney Kasfir, and is best related in her own words.

> In 1978 in Ibadan I watched a crew of perfectly serious German filmmakers systematically eliminating the Jimmy Cliff T-shirts, wristwatches, and plastic ... from a Yoruba crowd scene at an Egungun festival. They were attempting to erase Westernisation from Yoruba culture, rewriting Yoruba ethnography in an effort to reinvent a past free of Western intervention – a pure, timeless time and space, an "authentic" Yoruba world.[4]

This example seems to show pretty clearly what an inappropriate appeal to authenticity looks like. The tension between roots and routes disappears entirely for Kasfir's Germans: authentic, genuine blackness is for them entirely a matter of roots, to the exclusion of anything that does not map onto their conception of African practice. The filmmakers saw a "traditional" ritual that had been sullied, tainted, altered, by "outside" forces like Coca-Cola, forces that are, on their view, not really, *authentically*, part of contemporary life in and around Nigeria. The ritual's proper home, in their view, was an isolated and timeless Yorubaland. And the proper way to respect this anthropological artifact was to become hamfisted multiculturalists: to separate the traditional elements from the modern (or the primitive from the civilized, though they can't really put it that way these days), and to present this purified Other for consumption in the irremediably distinct West.

The difficulties with this sort of thinking will become clearer if we take a moment to refine the questions that animate this chapter. I began by asking when appeals to authenticity are appropriate, if they ever are, and how we can tell. Cultural theorist Mieke Bal captures what's at stake in these questions in her study of what she calls "migratory aesthetics."[5] This is her name for an interdisciplinary practice of inquiry that emerges when analysts of expressive culture take "the mobility of people as a given … and as at the heart of … the contemporary, that is 'globalized,' world" (23–24). This orientation to cultural inquiry encourages her to ask the following question: "How can we be culturally specific in our analyses of cultural processes and artefacts, without nailing people or artworks to a provenance they no longer feel comfortable claiming as theirs?"

With this question, Bal clearly puts the tension between rootedness and rerouting at the heart of work, but clarifies it by insisting on the way peoples and practices routinely transgress against geopolitical boundaries. The point of Bal's migratory aesthetics, and the point of calling it that, is not just to study the expressive culture produced by migrants – by people who find themselves, as she puts it, in a "culture of displacement" (33). The aim is also to see what becomes of culture work when it takes the centrality of migration and mobility as its point of departure, and when it refuses the easy appeal, as she puts it, to geographic provenance.

Following Bal's lead, then, we'll put the fact of mobility and migration at the heart of this inquiry, though we will not focus on specifically transnational migrations as much as she does. Suitably reframed, her question cuts to the heart of our study of authenticity, roots, and routes. She wants to know: How can we credit the cultural specificity of expressive practices without assuming that the practices are primordially anchored to specific spatiotemporal coordinates? Or: Since people and practices emerge from shifting, dynamic processes of cultural transmission, driven often enough by

literal processes of human migration, how do we reconcile the dynamism of cultural practice with the ossification that besets our practices when we render them in language and recruit them into politics?

Focusing on mobility points very clearly to two problems with the German filmmakers' sojourn through Yorubaland. First, they assumed that there is and must be no traffic, no migration, no cultural transmission between the West and the Rest of us. And second, they ignored Bal's injunction to balance cultural specificity against local self-understandings. The self-understandings of the participants in the Yoruba festival, with their t-shirts and wristwatches, were never at issue. In these ways, the filmmakers demonstrate the dangers inherent in appeals to authenticity. They don't use the word, as far as we know from Kasfir's account. But their actions perfectly exemplify the sort of sensibility that motivates and finds expression in standard appeals to authenticity – hence Kasfir's willingness to hurl the term at them as an accusation.

3　A Harder Case: Kente Capers

The case of Kasfir's Germans highlighted certain obvious difficulties with the way authenticity-talk has often been invoked in reflections on the aesthetic dimensions of black life. (In so doing, it also enabled us to refine our vocabulary for describing these difficulties, using Bal's talk of migration and mobility.) The next two cases, if I understand them properly, should to some degree show why authenticity discourse remains appealing despite its problems. These are cases in which an appeal to something like authenticity seems not just plausible but necessary, even if the likely outcome of the appeal is not entirely clear.

When I began to think about issues like the ones that animate this book, the US civil rights movement had just started to become a normal, unremarkable part of the US social landscape. One way to say this is to say that this was the beginning of the post-civil rights era. The first Afro-US generation not born in the shadow of segregation was reaching maturity, and its members were taking certain cultural markers of the recently concluded 1960s as reference points for consumption and self-fashioning. What that means: We bought a lot of "X" hats (for Malcolm X, or El-Hajj Malik Shabazz, not Malcolm the Tenth), and we wore, even those of us who aspired to the upward mobility of the newly prominent black bourgeoisie (think *The Cosby Show*), a lot of allegedly African fashions.

Chief among the fashions that attracted our interest were designs involving kente cloth. Kente is a complex, colorful, strip-woven fabric originated either by the Asante people of Ghana or by the Ewe people of Ghana and

Togo. The Asante textile tradition has become more famous outside of Africa principally because of its symbolic role in the history of Ghana. Beginning in the 1600s, kente-weaving was the prerogative of Asante royalty, and the fabric was reserved for special occasions. In 1957, when Ghana became the first country in sub-Saharan Africa to regain its independence, President Kwame Nkrumah drew on this history of symbolic significance and made kente cloth a staple of his official dress. Famous African Americans like Malcolm X and Muhammad Ali visited Nkrumah's Ghana and brought kente back with them, and Nkrumah's well-chronicled travels to the United States, with what one scholar calls "an entourage of kente-adorned Ghanaian dignitaries," brought the fabric to even wider attention.[6]

The same connection with royalty that recommended kente to Nkrumah also inspired our suspicions about the authenticity of the fabrics that were presented to us. The fabric that the old Asante royalty commissioned and wore was heavy and hand-woven (traditionally by men, which adds another layer of complexity that we haven't space to consider). The cloth we got, by contrast, was often lighter and mill-woven (or we, most of us, wouldn't have been able to afford it). Worse, the Asante typically reserve kente adornments for special occasions, beginning with a variety of annual festivals.[7] The merchants trying to exploit our burgeoning Afrocentric consumerism often had no interest in this fact, and were happy to attach kente to all sorts of pedestrian objects for daily use, from baseball caps to messenger bags. Perhaps worst of all, the kente of Ghanaian royalty and presidents was the work of weavers who paid particular attention to the distinctive patterns into which the constitutive strips were organized. The patterns had meanings and names, and made reference to particular occasions or proverbs, and were often associated with specific weavers, whose skill and originality were manifest in the pattern of the fabric. As before, our mass-produced cloths were indifferently, often identically, patterned – not that we would have known the difference if we'd been given designs that actually meant something.

These seem like reasons to worry about something like the authenticity of our fabrics, and, by extension, about what we were doing with those fabrics. But some of us argued that there was no reason to worry: that the *in*-authenticity of the fabric made our actions less worrisome rather than more so. According to this argument, alternative fabrics made simply to evoke the kente style would allow us to signal our African heritage without disrespecting traditions we didn't understand. We could gesture at the proud traditions of the Asante and Ewe with our neckties and Barbie outfits (yes: Barbie) without dragging any actual kente fabric into these inappropriate contexts.

I present this as a harder case because the answer to Bal's question seems more elusive here than in the case of Kasfir's Germans. A problem of

something like authenticity, apparently understood as a property of some object, is clearly in play, and seems urgently in need of resolution. But what gives that problem its urgency has less to do with the object than with the people who seek to use the object. And this slippage from object to agent, from certifying evaluation – *Is this real kente cloth?* – to aesthetic *and* moral evaluation – *Should you be wearing that?* – suggests that the problem is as hard to locate as it is to resolve.

4 Varieties of Authenticity

This slippage between the occasions for authenticity-talk shows that what looks like a single problem is in reality a set of related but distinct questions. Consequently, it will pay us to get clear on the different meanings that one might assign to the language of authenticity. We might distinguish at least five grades of authenticity discourse, all with their roots in the Greek word for "principal or genuine" (*authentikós*).[8]

Metaphysical rhetoric; or, "real!"

The least interesting sort of authenticity discourse uses the vocabulary rhetorically, as a way of emphasizing genuineness. Imagine a bird-watcher rhapsodizing over seeing a dodo in the wild. She might say, "It was an *authentic* dodo!" But this just seems a roundabout way of saying that yes, it *really was* that bird that we all thought was extinct. One could make this point about the dodo without using the language of authenticity at all. "Authentic" here maps precisely onto "real," with no remainder requiring special accounting.

Historical location; or, not-a-forgery

Instead of merely emphasizing the otherwise unproblematic reality of something, the second grade of authenticity discourse distinguishes a thing's reality from a quite specific sort of unreality. The sense of genuineness at issue here leads English speakers in certain settings to speak of "the genuine article": it distinguishes the real thing from a counterfeit. Some of the considerations in play here lead to questions about originals and copies, but what's interesting about those considerations in this context is the thought that originality is the key to reality. This sense of authenticity figures prominently in various artworld debates about fakes and forgeries. In fact, Kasfir's discussion of the German filmmakers first appeared in an issue of *African Arts* that sought to revisit an earlier issue's discussion of authenticity. That earlier discussion

took place under a telling rubric, announced by the title of the issue's introduction: "Fakes, Fakers, and Fakery."[9]

Fakes and forgeries raise a number of important problems for inhabitants of the artworlds, with the most obvious of these problems having to do with ethics, epistemology, and, one might say, sociology. If you sell me something you describe as a Jackson Pollock painting, and you extract from me the price that a Pollock should fetch, and if furthermore this painting turns out not to be a Pollock, then I have suffered harm. It is then in my interest to develop ways of distinguishing real Pollocks from fakes, which means that it is in my interest to cultivate relationships to reliable sources and reputable dealers.

Next to these problems, questions of ontology seem somewhat less complicated. Either this thing is what it purports to be or it isn't, which is to say that the difficulty is not metaphysical but empirical and epistemological. The challenge is *not* to figure out what kind of a thing, philosophically speaking, this thing called "a Pollock" is; it is just to find out whether, in fact, it is a Pollock. But thinking about fakery in the context of human artifacts does point us to some nice metaphysical complexities. The object *qua* object was *made*, which is to say that it was brought into being at a particular moment in time, by actions unfolding in time. And the object counts as a genuine instance of what it purports to be only insofar as it was brought into being in the right ways, by the right person or persons, at the *right* time.[10] Whether Jackson Pollock or your Uncle Pookie made my painting makes all the difference to me, and to my bank account.

Putting these points together in a way that Arthur Danto might endorse: the metaphysical complexities of identity and historicity work together in aesthetic contexts to frame our reflections on fakery and genuineness. The difference between Pollock and Uncle Pookie is that Pollock is an art-historical figure: he represents a moment in an unfolding tradition. More precisely: he represents a moment that found its first original expression through him, and that thereafter must move on or become derivative. That's why Pookie's painting doesn't register for us like a Pollock even if it is molecule-for-molecule identical to the Pollock that your uncle copied. The ideology of genius gives us one route to this thought, but not the only one. The point is not that Pollock was inspired by some mystical force that he and only he could turn in this direction; it's that he appropriated certain cultural resources, passed them through the alembic of his personal vision, and produced something that now stands for many people as an important and unique marker in the development of a creative practice. It matters that *he* made this object because he represents this historical step forward. The fake or forged Pollock isn't just pretending to be something that it isn't; it's falsely claiming a definite relationship to a particular history and to the agent of history that we call "Jackson Pollock."

My point is that fakes and forgeries are not just objects; they are attempts to feign a relationship to an historical practice. Even in this first sense, then, authenticity is not just an empirical matter, depending simply on whether an object is what it is supposed to be. Or, put better: it is not a *crudely* empirical matter, dependent on a notion of the empirical that is not shot through with historical and phenomenological considerations. The empirical fact of "a Pollock" is an historical achievement, an achievement that we conflate with the name of the man who accomplished it, and whose imaginative inhabitation and appropriation of history allowed him to repeat and build on this achievement. The forgery does not have and cannot have this relationship to history, but pretends that it does. This less-crude empiricism points us also to a deeper kind of historicism, to which we will return.

Ethnographic location; or, "true to their roots"

The feigned relationship to a history of practice that marks artworld fakery becomes even more complicated when we turn to African art. To paraphrase John Dewey, "African art" is one expression that signifies many things. For some, it most saliently refers to artists in or from Africa who circulate in networks of institutions that the western artworld has made familiar – museums, galleries, biennales, and the like. For others it denotes the familiar assortment of usually anonymous masks, carved figurines, and the like, recently produced in artisanal workshops, that one finds in import markets and tourist shops, as well as in some galleries. And for still others, to speak of African Art is to speak of the almost always anonymous historical artifacts that museums and galleries sometimes display as relics of a "pure," pre-modern African culture. Call these, respectively, *artworld, workshop, and traditional* African art.

The question of fakes and forgeries in African art usually has to do with traditional and workshop art – with, more precisely, trying to observe the boundary between them. Here we wonder whether this piece of Masai bead-work is actually *Masai* beadwork or a cheap knock-off; whether the Ghanaian *asafo* flag you want to sell me was made before independence in 1957, or whether it was made much later in the pre-independence style to dupe unwary collectors; or whether the ritual mask in your collection is actually a relic of pre-contact traditional society or whether it was made last year and artificially aged – again, to dupe unwary collectors. These appear to be relatively straightforward questions: as before, either the objects were made at the right times, in the right ways, and by the right people, or they weren't. But these questions make their claim on our attention because of much less straightforward considerations.

The Jackson Pollock example shows that the question of forgery is about feigning a relationship to the history of a practice, and to the agents of that history who have advanced the practice. When dealing with African art, this appeal to historical location implicates racialized ideologies of history, and of what we learned in Chapter 2 to call "Africanism." The easy way to make this point is to gesture at Hegel, who famously insisted that Africa had played no role in world history and therefore warranted no consideration in his philosophy of history. The harder way to make the point is to say that modern societies imagined themselves as modern in part by distinguishing themselves from the pre-modern, which they then located in societies with unfamiliar modes of social organization and different orientations to the work of technology. The clearest way to make the point is to return to Sidney Kasfir's German filmmakers. Yoruba identity and culture was for them an essentially historical phenomenon, which sounds like it runs counter to Hegel's point but actually affirms it. The filmmakers have re-evaluated this African contribution to world culture, but maintained the Hegelian picture of a culture that is not historically *progressive*. It is not a living tradition, capable of change and enmeshed in relationships with other traditions. It is static, fixed, and pre-modern: shorn of wristwatches and soda bottles, it is modernity's other.

So: an interest in history also drives concerns with African art fakes, and does so just as, and more clearly than, it drives worries about faked Pollocks. But the kind of history in question is different. Instead of acting as curators of a developing tradition of practice, we can, if we are not careful, become guardians of a static constellation of cultural essences. I say that this can happen *if we are not careful* because there are of course reasons to care about the differences between pre- and post-independence *asafo* flags, and one can do so without denying that Ghanaian culture can grow and change. But for most of the history of African art, this sort of concern was in fact anchored in the same complex of ideological commitments that spawned the field we now know as anthropology: it was about natives and savages, and derived its urgency and agendas from the need to figure out the savages in their natural habitat and condition.

The notion of authenticity that follows from this ethnographic impulse has complicated the work of contemporary African artists to no end. The artworld artists have long found the path to professional growth and recognition blocked by the artworld's insistence that their work would be interesting only if it clearly expressed their *own* (native) culture – and by the assumption that these artists could not plausibly think of themselves as belonging and contributing to the cultures of contemporary European art. This insistence and this assumption come coupled with the injunction that any resonances of western art in the work are to be treated as derivative,

rather than as evidence of the artist's attempt to orient himself or herself to a particular tradition. And so African artists who, one might say, come by their artworld attachments honestly, who learn about and work through North Atlantic artworld traditions like artists anywhere else might have, find themselves pushed toward "native" themes, away from the work they might have done, and away from the contexts in which they might have done it. The assumption that African art must be the artworld's Other has much less influence on the prospects of artworld artists than it ever has before, as we can see from – and thanks in part to – the work of people like Okwui Enwezor and Saleh Hasan. But visitors to African Art exhibits often still expect to find masks and carvings, and are still puzzled when confronted with video installations and photographs.

Just as the ethnographic appeal to authenticity undercuts the work of the artworld artist, it also complicates the activity of the workshop artist. There are many complexities here, but there is no way to achieve here the level of empirical detail that a full treatment of the subject would demand. Suffice it to say that (as Christopher Steiner and Sidney Kasfir point out) the "African" sculpture that I buy in an airport tourist store may have been made by people who pride themselves on their ability, on their ability *as artists*, to signify, as Skip Gates would put it, on so-called traditional styles. And this same sculpture may be marketed by a savvy trader to an unwary western collector or curator not as kitsch but as a "traditional" artifact.

There are questions about authenticity at either end, as it were, of the process that eventuates in the sculpture making its way to my study. At the near end is the question of fakery, of whether this thing is what the dealer told me it was (a traditional object). We've already assembled the reasons to see why this question matters the way it does, and why it is much less interesting than the question at the far end of the process: is this object a work of *art*, in the sense in which we're typically given to use that term?

One response to this question runs through the assertion that African cultures tend not to have a concept of art as such. There are different ways to get to this claim. The Afrocentrist or critic of European modernity will make the point by accepting that "art" refers to a wholly non-functional sphere of objects and practices that has been spirited away from its ties to everyday life and sequestered in museums and other special institutions. *If this is art*, the argument goes, *then no, Africans have in general not been interested in it, and so much the worse for art*. There is something to this view, but it does not quite hit the target at which it is typically aimed. Some African culture groups *do* have artworld traditions that westerners raised on the cult of genius would find familiar. Also, many peoples in many places outside Africa have similarly little attachment to the western artworld. And finally, there are many *western* critics of "the" western conception of art, like John Dewey.

The productive lesson to draw from the supposed tension between Africa and art is that the familiar notion of "western" art – what Dewey disparagingly called the "compartmental conception of art" – is deeply parochial, and conjunctural, and sociohistorically specific. One of the cultural shifts that brought European modernity into being, or that registered some of the many other shifts that defined its way of being, was its development of its distinctive artworld. European societies rather suddenly became deeply interested in things like museums and art markets and individual creative geniuses. These interests had a great deal to do with cultivating aesthetic experience, to be sure. But they also had a great deal to do with the emergence of modern empires and social classes; with the development not just of markets for art but of markets as such; with the emergence of the bourgeois who animated and populated the markets, and who used their activities there to signify their social standing; and with the consolidation of certain visions of the modern subject.

Approaching the European artworld as a conjunctural formation makes clear why that concept may not travel very well to other settings. If art just is what individual geniuses make and what ends up in galleries for wealthy individuals to buy and then perhaps donate to museums, then some places will not have art. And then when we try to take objects from these art-free places and insert them into the studio-gallery-parlor-museum matrix of institutions, we will encounter some friction or, to switch metaphors, some problems of translation.

The question of authenticity in the context of workshop art arises just where these questions of cross-cultural translation intersect with the ethnographic impulse. The workshop artifact seems not to count as authentic for two intertwined reasons. First, it seems not to aspire to the kind of originality and individual expressiveness that we associate with the western artworld, and so it cannot be an authentic instance of art-making in the western mode. (Of course, we know that the object does not properly aspire to originality – evidence to the contrary notwithstanding – because its creators inhabit a timeless history and ethnographic present.) This leads to the second failure of authenticity: the conditions that prevent the artifact from authentically aspiring to the condition of art might have made it ethnographically authentic. But its creators attempted to pass their work off as something it wasn't – an authentic traditional object. (Of course, this view is plausible only if we set aside the fact that the object's journey across contexts for production and exchange is the work of traders and merchants. We are encouraged to set this fact aside by the thought that African cultures are simple and do not involve complicated circuits of exchange.) Instead of properly representing a tradition that is unchanging and fully knowable, it is part of some new counterfeiting of that tradition, and so cannot even count as an authentic instance of whatever sort of object it purports to be (mask, drum, etc.).

Exegetical accuracy; or, reading history right

Teasing out the ethnographic impulse behind Africanist invocations of authenticity deepens the appeal to historical location that emerged from our discussion of Pollock. As we saw then, a forged Pollock is a problem because it feigns a relationship not just to the bare historical facts – who did what, when – but also to a tradition of human endeavor. Invoking history in this way points to a mode of authenticity that is in tension with things other than fakes and forgeries. It allows us, specifically, to talk about mistakes and failures, which we can identify only through interpretation.

Peter Kivy eloquently discusses the kind of interpretation I have in mind in his study of authentic musical performance in the European concert tradition. He argues there that while we might declare our determination to perform a Bach cantata in an historically authentic manner, it will take some philosophical work to get clear on what this requires. Are we concerned with Bach's intentions? With the sounds a performance of the piece would have involved in his day? With the practices that would have been used to make those sounds? Or with the performers' ability to strike the right balance between originality and score-compliance? These are not simple questions, but we needn't linger too long over them. The point is that taking account of history in something like this way will open the door to thinking of inauthenticity in terms of error rather than of fakery. If the early music movement folks are right, to perform a baroque piece without due regard for the details of the historical setting – whatever this regard turns out to mean – is not to engage in forgery, but it is still to get something importantly wrong.

5 From Exegesis to Ethics

Teasing out the varieties of authenticity discourse was meant to provide some resources for working through the kente case. It may pay us, then, to take stock of our progress. A worry about "fakery" should hang over the kente case – the indifferent merchants I mentioned did, at least some of the time, either assert or accept their suppliers' assertions that the fabric they were selling just was what Asante royalty would have worn. But the deeper worry by far has to do with error, of the sort that worries the early music enthusiast. Our concern back then was that we were doing violence to an historic tradition, that our sartorial performances were inappropriately unfaithful to the spirit of a venerable practice: that we were getting something wrong. And hanging in the background is the determination to refute aesthetic Africanism by providing, as a counterexample, a specifically aesthetic practice that is no

more bound up with putatively non-aesthetic considerations like status and commerce – and no less interested in individual expressiveness[11] – than the western artworld is.

Treating authenticity as a matter of properly relating oneself to an historical tradition opens onto another layer of considerations, one that we can make clear by distinguishing Kivy's cases from the kente question. The early music enthusiast is concerned with single pieces of music, composed by single individuals with in principle identifiable intentions, working during small windows in time. The kente case by contrast concerns a tradition that unfolded over several centuries, thanks to the creative efforts of many people, none of whom can claim control over the tradition the way an individual can claim control – however incomplete and susceptible to challenge – over a performance of his or her work. For this reason we might turn from Kivy's discussion of musical authenticity – grateful for the leverage it gave us for shifting from fakes to errors – to discussions of genre or idiom or, one might say, boundary policing.

Questions about the boundaries of creative traditions are a familiar part of our aesthetic lives. Is this up-and-coming architect still working in the style of Wright, or does his work resist the "mid-century modernist" label and require a new description? Does dancehall music count as reggae, say, for the purposes of giving out awards? (This was once a live question, until someone created the separate category of "roots reggae" to settle it.) Does *Knocked Up* belong to the film genre called "the comedy of remarriage," or is it some other kind of film?[12]

These questions about genre and tradition, like questions about historical fidelity in kente-related sartorial "performances," arise from a worry about piety – about how to properly inhabit and extend a tradition. As such, they connect the empirical, ethnographic, and exegetical grades of authenticity to something else, something related to volition and value. This connection marks a turn toward considerations of ethical and existential authenticity, a turn that we can complete only after considering some prior questions.

Who cares about boundaries?

The demand for fidelity to an expressive tradition presupposes a story about *why* one should be faithful. There are different answers for different practices, of course. For Kivy's early music advocates, there is (among other things) the thought that history is the best guide to optimal performance, for reasons that we needn't explore here and that Kivy effectively demolishes. Just assume they tell a good story and can motivate their arguments for deference to the conventions of "the tradition." Why accord kente-weaving this same deference and respect? Why not play fast and loose with

the tradition, especially if one is neither Asante nor Ewe? Why should I care about being (historically) authentic?

One reason follows from a general commitment to the integrity of culture. In the grip of this culturalist commitment, one might say that the kente tradition has underappreciated merits that culture lovers should insist on. Hand-woven fabric is *better* than mill-woven: it's harder to make, and the people that make it invest it with meanings that give the product even greater sophistication and richness.

Another approach eschews culturalism in favor of a commitment to cultural diversity. An adherent of this multiculturalist approach might argue that playing fast and loose with the constitutive practices of this tradition is disrespectful and will likely hasten the disappearance of the tradition in its proper form. If the weavers lose their customers, if they are driven out of the market by mass-produced knock-offs, then the world will be the poorer for the loss, just as our ecosystems would be the poorer for the loss of a species.

Whatever their merits, these culturalist and multiculturalist accounts of why historical fidelity matters depend on arguments that anyone could make, from any subject position. As such, they don't yet reach the version of the question that sits at the heart of the black aesthetic tradition. The question that faced Afro-US inhabitants of the post-civil rights moment as we considered buying kente neckties was a question specifically about *us*. People not of African descent might be constrained in some way by the kind of general arguments adduced above. But we felt some obligation above and beyond those constraints. We believed that the tradition had some claim specifically on us – that's why we wore kente instead of, say, Andean mountain shawls. And we believed that we had some duties to it. Teasing out this deeper sense of duty will require moving, finally, to a fifth grade of authenticity discourse.

Eigentlichkeit and virtue

This last grade of authenticity completes the transformation of the idea of genuineness from a notion suitable for things to a notion suitable for agents. It turns, in effect, from *authentikós* to *Eigentlichkeit* – the German word we translate as "authenticity," but that could bear the literal translation "one's-own-ness." This turn brings us to the brink of distinguishing the "in-itself" from the "for-itself," which means that mining this idea further will mean following out certain lines of thought that have been most thoroughly developed in the existentialist and phenomenological traditions.[13] In the spirit of these traditions, I'll say that the fifth grade of authenticity has four key features. It embraces contingency, insists on

context, counsels responsibility, and refuses moralism, all to give human agents the resources to make their projects their own.

(Putting the point in this way – by referring to contingency and such rather than to the *pour-soi* – should make clear that I deny any obligation to champion or follow any specific figure or approach in these traditions. I will instead find language in the traditions that have sustained me – principally the analytic and American naturalist traditions – to capture and explore the thoughts that figures like Sartre and Heidegger encourage me to have.)

To be authentic in this sense is to engage responsibly with, and to take responsibility for, the burden of choosing one's cultural path in a world of contingent options. Taking up this burden responsibly means remembering at least two things. Contingency and arbitrariness are not the same, and one person's choice needn't reveal or generate a universally valid imperative.

Concerning the distinction between contingency and arbitrariness: Particular cultural options are available to us because of historical accidents. Had we been born somewhere else, had an ancestor chosen a different occupation or faith tradition, or had any of an indefinite number of other things been different, the options would be different too. But those accidents *did* happen, and some of them condition our lives in ways that we cannot play fast and loose with. The acceptance of contingency does grant some degree of freedom, but it does not abolish all of the forces that constrain us. It does not, in short, mean that we can arbitrarily choose any path. Saying this much puts us quite near to a Sartrean discussion of the balance, if one can call it that, between facticity and transcendence; but I would rather talk, with Dewey, in terms of intelligent action. If one wants to navigate the world with reasonable success, forming reasonable estimates of the challenges one is likely to confront and of the resources one can bring to bear on these challenges, one simply *can't* pretend that all things are possible, that contingency opens the door to complete transcendence of any and all constraints on one's choices.

On this approach, then, one of the keys to experiential authenticity is the critical acceptance of contingency. One must accept that one's given cultural commitments – the practices one is born into or raised with – are contingent rather than necessary; and that moving beyond the given is a matter of creativity and choice rather than of discovery or of capitulation to an external authority. One must also accept, though, that these choices are still framed and conditioned – which is not to say "determined" – by factors beyond our control; and that taking these factors seriously is one of the preconditions of making a responsible choice.

After critical acceptance of contingency, a kind of heuristic particularism is the second key to experiential authenticity. As I'm thinking of it,

authenticity is a virtue, which is to say that the idea of authenticity is properly speaking the idea of an authentic agent, which serves as a resource for self-examination and self-care. Asking what an authentic agent would do helps us deliberate about the options available to us. But answering this question will not establish bright lines between right and wrong courses of action. One might perform either P *or* not-P authentically, depending on one's orientation to the sources of the self, one's account of the conditions behind the situation of choice, and one's estimate of the consequences of acting one way rather than another. Authenticity-talk is a heuristic device for action-guidance, not a decision procedure or bright-line standard for evaluation. I can't look at you and tell whether your cultural commitments are or are not authentic. I can't even make this judgment with certainty about myself. What I can do is use the question of authenticity to remind myself to weigh the right considerations, to explore the right kinds of evidence, and to seek the right balance between facticity and transcendence.

This has all been quite abstract, and has surely generated some questions. What does "rightness" amount to in heuristic deployment of authenticity-talk? Exactly what is one supposed to keep in mind? And what good is all this if it doesn't clearly tell us what to say about kente-wearing buppies? Answering these questions from the standpoint of black aesthetics will surely have something to do with cultivating a sense of the racial dimensions of the relevant cultural terrain. The injunction to remember facticity will, in racialized contexts, mean keeping track of specific social dynamics, like the racial ideologies that swirl around particular practices or the racialized resource asymmetries that condition the production of particular objects. And it will also mean keeping track of the way our choices and actions resonate and signify in a world of conjoint action and intersubjective meanings. The best way to make these thoughts still more concrete may be to explore some examples.

Repertory jazz

Not long ago, the great musician Wynton Marsalis, former trumpet prodigy and now, as of this writing, the Director of Jazz at Lincoln Center, put himself at the center of a mild controversy over repertory jazz performances. The repertory jazz movement insisted on note-for-note reproductions of old jazz recordings, with formerly improvised solos transcribed and treated as components of a through-composed piece. This approach generated controversy because some people took it as a repudiation of the essence of jazz music. Jazz, these people said, is ineliminably about improvisation; without that it just becomes an interesting academic exercise, or worse.

The repertory jazz idea might seem to suffer the same problems as Kivy's proponents of historical authenticity in European concert music. But there are important differences here, and these bear directly on the kind of considerations that have to frame the pursuit of experiential authenticity in racialized settings. For people like Marsalis, the point of note-for-note reproductions of old jazz recordings was to insist on the complexity and artistry of the music. And this insistence was grounded in social and political considerations, considerations we might say in the politics of culture, that provide the kind of hermeneutic grounding that Kivy's early music enthusiasts seemed to lack.

The repertory movement's aim was to block the once-common thought, often rooted in racism, that jazz music is lightweight fare tossed off by lightweight musicians. Jazz solos can be complex *compositions*, Marsalis wanted to insist and show. They are compositions worth laboring over and contemplating, works of art that reward the always-learning performer's scrutiny as well as the audience's rapt attention. Similarly, on this view the pieces that frame and motivate the solos are at their best on a par with the best works of European concert music. These pieces – often the handiwork of black musicians, and in any case of musicians working in a tradition that we might plausibly identify as black – these pieces represent the only indigenous *American* concert music. As a result, they should be treated with the same respect and deference that we show to Handel and Mozart. Which is to say, in a line of argument made most famous by the New Negro writers and artists: the achievements of black artists can compare to anyone else's achievements – but persistent racial biases force us to demonstrate this fact, repeatedly.

Repertory jazz did not spring from the sense that the original performances were somehow truer, or more faithful to some static tradition. (Better, yes, but just because Louis Armstrong was, on this view, a transcendent genius, which would of course give his work a greater claim on our time than the inferior efforts of some contemporary performer could ever manage. There are issues here, some related to the notion of the genius; but reliance on a metaphysic of piety isn't among them.) Perhaps better, the movement did not spring *entirely* from a desire for historical fidelity and veridicality. The thought, at least in part, was that the specific conditions of musical performance in the contemporary world make it important to *proselytize* for a particular vision of the tradition, and to commemorate the great achievements in the tradition. This is a self-consciously propagandistic enterprise, in something like Du Bois's sense. The repertory enthusiasts did not present falsehoods as truths for political ends; they consciously decided to craft and promote a particular vision, a tendentious but plausible vision, of the jazz tradition, as a way of responding to contemporary conditions.

Violet's song

In one of his autobiographical reflections, W. E. B. Du Bois discusses a song that his great-grandmother Violet used to sing. He recalls the "heathen melody" of the tune and he recalls the song's words, despite having never learned their meaning or the African language in which they conveyed this meaning. He reports all this near the end of a long discussion of the history and origins of the Du Bois family line, during which he insists not just on his African roots but on his Dutch ancestry and on the shaping influence of the integrated New England environment in which he was raised.

Having traced this complicated family history as well as he can manage, Du Bois writes, "As I face Africa I ask myself: what is it between us that constitutes a tie which I can feel better than I can explain?" He answers by dismissing appeals to "blood," and then by appealing instead to "a common history," "a common disaster, and to "one long memory." "[T]he social heritage of slavery," he says, links him to Africa, and not just to Africa but also to "yellow Asia and the South Seas."[14]

What seemed at the outset to be a search for roots turns out to be an explicit refusal of easy origins. Du Bois goes to the trouble of pointing out to the reader that he doesn't know where the song came from, or what its words mean, or even where his great-grandmother learned it. Instead of insisting on or speculating about the song's provenance in some particular part of Africa, he emphasizes that it came to him from a living ancestor in the United States, a woman who, like Du Bois himself, was "dwelling in displacement," an artifact of the restless movement of people and practices across national boundaries. A discussion like this could hardly be less effective as a way of excavating obvious roots, and it could hardly be more indicative of (the later) Du Bois's conviction that an African identity is something hard-won rather than something natural. This coda to the story of his multiply mixed heritage registers the *traces* of ancestry more than it testifies to the unambiguous bequest of an unsullied cultural heritage. It is less about digging up authentic roots than about self-consciously and creatively assembling resources for inhabiting the present and future. We might think he's wrong to assemble these resources in this way, but it is clear that he is engaged in an act of assembly rather than of discovery or recovery.[15]

The new black aesthetic

In 1989, novelist Trey Ellis published a manifesto – as much as an article in a literary journal can count as a manifesto – announcing the emergence of a "new black aesthetic." The entire point of the manifesto, and of the cultural movement it describes, was to resist crude appeals to racial authenticity. Black

culture workers born after the civil rights era, he argued, could admit to "liking both Jim and Toni Morrison," and had built their black aesthetic out of more than anti-racist polemics, "Africa and jazz."[16] One of the other members of the movement, filmmaker Reginald Hudlin, went on record for the article with a complaint about civil rights-era black film. Hudlin, Ellis reports, "has little tolerance for the Sounder-esque 'glory stories' of the Seventies where black 'films were more obsessed with being good PR for the race than with being culturally authentic. It's as if blacks have to be spoon fed'" (239).

Hudlin and Ellis here use the notion of authenticity to *resist* the crude vision of rootedness that marks the German filmmakers' encounter with the Yoruba festival. The idea here has less to do with an excavation of primordial, static roots than with fidelity to the contemporary exigencies of one's cultural situation. Cultural authenticity in this more complicated sense will mean, must mean, taking seriously whatever it is black people actually do, rather than insisting that what they actually do is less important than some allegedly essential commitment or attachment that may not have any actual bearing on their lives. This is something like what John Jackson means when he proposes that we talk less about racial authenticity and more about racial *sincerity*.[17]

6 The Kente Case, Revisited

Where does all this leave us? What can we say about the kente case that we could not say before? We have over the last several pages firmed up the motivation for reframing the question at the heart of the case. What seemed to be an empirical question – is that *real* kente cloth? – quickly became a question of interpretation: what counts as real kente, and why? This hermeneutic question then opened onto a deeper question, at once hermeneutic, ethical, and existential: why commit oneself to the boundaries of this tradition, wherever one puts or finds them? We saw that one way to answer this deeper question led to a metaphysic of piety, which in turn led to my existentialist- and pragmatist-inspired suggestions about experiential authenticity.

Reading the kente case through these various grades of authenticity-talk allows us to ask a question like this: what would a responsible engagement with these cultural conditions look like? The bad news is that no answer to that question will immediately impose itself on everyone as the obviously correct response. The good news is that asking the question in this way makes it more likely that we will deliberate, *together*, more productively and responsibly. Asking the question in this way prepares us to avoid the errors of invidious metaphysics and overhasty interpretation, and it helps us to take action in this situation of choice while knowing, more clearly than we otherwise would have, what we are about.

We should find ourselves asking questions like these: *Why* do you, why do *I*, want to wear this cloth? Is it because I see all things African as my birthright as an African-descended person? This is probably not a view I can sustain if I think at all about how complicated a place Africa is, and about how many different kinds of "things African" there are. What if, by contrast, I want to wear the cloth because I want to cultivate a kind of *Pan*-African sensibility, self-consciously crafted in and for the distinctive diasporic contexts of places like the United States? This seems more defensible, at least at first blush. But there are more questions to ask. Do I need empirically authentic kente to do this work? Or will knock-off "kente" actually function even better, as a marker of my distance from specifically *Asante* traditions? I can see one going either way from here, and wouldn't know how to insist on one path rather than the other. One line of thought will turn to empirical considerations, to projections about the likelihood that one's sartorial choices will be read one way rather than another, and about what that will mean for our fellows in the world. And here we are firmly launched on the sea of experimentation, hypothesis, and conjoint deliberation, with no bridge back to the consolations of metaphysics.

I'm encouraged to adopt the line I've developed here because it seems less at odds with the realities of cultural production, especially in the twenty-first century. Think here about the actual conditions under which fabrics and fashions get made for export markets. As Leslie Rabine points out, the fashions one thinks of as "authentically" West African may have been made by a Kenyan designer, who learned in a UN microenterprise program to make something called "African" clothing based on West African styles; she may have derived her interest in this work, and found her market for it, while living among black *estadounidenses* in Los Angeles; she may buy the African fabrics for her work from Iranian merchants; and these merchants may in turn buy the fabrics from a Senegalese factory that uses Indonesian production techniques.[18]

Similarly (as Christopher Steiner and Sidney Kasfir point out), my "African" sculpture may have been made in a workshop that supplies an airport tourist store. It may have been made by people who pride themselves on their ability, on their ability *as artists*, to signify, as Skip Gates would put it, on so-called traditional styles. And this same sculpture may be marketed by a savvy trader to an unwary western collector or curator not as kitsch but as a "traditional" artifact. This complicates the question of "fakery" quite considerably, in ways we'll return to in another chapter. For cases like these, authenticity-talk seems most useful not as a resource for distinguishing the really real from the faked, the mistaken, or the confused. It can be a way to take inventory on our own commitments, and to locate the selves that these commitments constitute in a world of ceaseless cultural exchange.

Notes

1 James C. McKinley, Jr., "Music, Activism and the Peruvian Cabinet," *New York Times*, August 20, 2011, C1, http://www.nytimes.com/2011/08/20/arts/music/susana-baca-peruvian-musician-and-culture-minister.html?_r=1&nl=todaysheadlines&emc=tha28 (accessed August 20, 2011).

2 *Freedom*, April 1953; quoted in Cheryl Higashida, "To Be(come) Young, Gay, and Black: Lorraine Hansberry's Existentialist Routes to Anticolonialism," *American Quarterly* 60:4 (2008), 899–923, 899.

3 Cited by Houston A. Baker, Jr. in *Blues, Ideology, and Afro-American Literature: A Vernacular Theory* (Chicago: University of Chicago Press, 1987), 24.

4 Sidney Kasfir, "African Art and Authenticity," in Olu Oguibe and Okwui Enwezor, eds., *Reading the Contemporary: African Art from Theory to the Marketplace* (Cambridge, MA: MIT Press, 1998), 87–113, 97.

5 Mieke Bal, "Lost in Space, Lost in the Library," in Sam Durrant and Catherine Lloyd, eds., *Essays in Migratory Aesthetics: Cultural Practices Between Migration and Art-Making* (Amsterdam: Rodopi), 2007, 23–36.

6 Doran Ross, "Kente," in Valerie Steele, ed., *Encyclopedia of Clothing and Fashion*, vol. 2 (Detroit: Charles Scribner's Sons, 2005), 299–300, 299.

7 Ross, "Kente" 300.

8 "Authentic," in Angus Stevenson, ed., *Oxford Dictionary of English* (Oxford: Oxford University Press, 2010), Oxford Reference Online, http://www.oxfordreference.com/views/ENTRY.html?subview=Main&entry=t140.e0049800 (accessed March 2, 2011).

9 Marie-Denise Shelton, "Fakes, Fakers, and Fakery: Authenticity in African Art," *African Arts* 9:3 (April 1976), 20–31, 48–74, 92.

10 Compare the case of a miner trying to pass off a piece of pyrite as gold. The miner wouldn't be committing an act of forgery, and his rock, strictly speaking, wouldn't be a fake. The rock just is what it is, and the miner would be fraudulently trying to pass it off as what it isn't. I don't think I would say that the problem with this transaction is that the rock is not authentic, except perhaps for the rhetorical effect noted above. The problem is that the miner has behaved badly.

11 Some students of black aesthetics would be tempted at this point to distinguish western individualism from African communalism, so I should say clearly that I am not headed in this direction. Individual weavers were highly esteemed for their individual achievements in the kente tradition, though most people outside the tradition have no access to this fact. What follows should make this clear, but why wait?

12 It's worth noting that the boundary question causes less trouble in the kente case than in some other cases. The kente tradition has as good a way of marking its boundaries as one is likely to get from anyone without the sticks and carrots of a state at their disposal. What we now recognize as the tradition achieved its recognizable form at a moment during which it was regulated by formal authorities. Those authorities still exist, and the form the practice took during

their heyday is still widely seen as the "true" form. There will be more to say about the question of boundaries later. But saying just this much should enable us to table the issue for a bit.

13 Steven Crowell, "Existentialism," in Edward N. Zalta, ed., *The Stanford Encyclopedia of Philosophy* (Winter 2010 edition), http://plato.stanford.edu/archives/win2010/entries/existentialism/ (accessed August 28, 2014).

14 W. E. B. Du Bois, *Dusk of Dawn: An Essay Toward an Autobiography of a Race Concept* (New Brunswick: Transaction, 1984), 114–117.

15 This reading of Du Bois may seem overly generous. Perhaps he doesn't handle the imperatives of migratory aesthetics as responsibly as I say. One might, for example, take his refusal or failure to translate Violet's song, along with other such moves, as a way of *refusing* the real complexity of the object, of, say, making it into a blank screen onto which he can then project his utopian anticolonial fantasies.

16 Trey Ellis, "The New Black Aesthetic," *Callaloo* 38 (1989), 233–243, 234.

17 John Jackson, *Real Black: Adventures in Racial Sincerity* (Chicago: University of Chicago Press, 2005).

18 Leslie Rabine, *The Global Circulation of African Fashion* (New York: Bloomsbury Publishing, 2002), 19.

6

Make It Funky; Or, Music's Cognitive Travels and the Despotism of Rhythm

Figure 6.1 Me'Shell NdegéOcello, "Leviticus: Faggot"[1]

> This ordering force that constitutes Negro style is rhythm.
>
> Léopold Senghor, "What the Black Man Contributes"[2]

BOBBY BYRD: What you gonna play now?
JAMES BROWN: Bobby, I don't know. But whatsoever I play, it's got to be *funky*.

> James Brown, "Make It Funky"[3]

Black is Beautiful: A Philosophy of Black Aesthetics, First Edition. Paul C. Taylor.

Rhythm is the key as we open up the door / Things a b-boy has never seen before / Polyrhythmatic with a big fat boom / You have an eargasm as you start to consume.

A Tribe Called Quest, *People's Instinctive Travels and the Paths of Rhythm*[4]

1 Introduction

Most of the chapters in this book represent steps toward a reconstructive survey of an already-thriving tradition of inquiry and expression. I have been trying to translate certain themes from the black aesthetic tradition into the vocabularies of largely English-language philosophy, in the spirit of "retroactive provisioning" – in order to provide the point of entry to the tradition that I wanted but did not have when I was in graduate school. This has involved giving an account of the tradition as a tradition, which has in turn meant identifying the recurring themes that enable me to think of black aesthetics as a unitary enterprise.

This chapter takes a slightly different approach. I will be less concerned here with a question or debate or line of thinking that I find in the tradition, though these will emerge, than with one of the issues that stimulates my interest in the tradition. To speak of this animating concern as an issue is somewhat misleading. I could for quite some time experience it only as a mute fascination, as a welter of thoughts that rattled around in my head when I listened to pieces like Me'Shell NdegéOcello's "Leviticus: Faggot," some bars of which I've reproduced above. I've long tried, and will try again here, to turn this fascination into a question, but it has most often simply demanded reverence for its object more than investigation.

With that said, the investigation will eventually come into focus, and three basic questions will emerge. The first question interrogates the common thought that there is such a thing as black music, and asks what this music is, and what constitutes its blackness. The second question asks what this blackness is supposed to mean for music, by interrogating the familiar thought that Senghor announces in the epigraph above: that blackness is somehow, perhaps essentially, bound up with rhythm. Senghor goes on, in a way that I'll distance myself from (while accepting that he means something more by this than a white supremacist would): "rhythm acts, despotically, on what is least intellectual in us, to make us enter into the spirituality of the object."[5] I want to consider what this juxtaposition of rhythm and intellect has typically meant, and what we should say about it. The third question has to do with the way music's rhythms move us. I mean this in a more literal sense of "move" than philosophers usually have in mind, but I will in addition

want to know what it means to listen to rhythmic music when literal movement is not on the agenda. I'll want to ask what Senghor's despotism of rhythm amounts to, and what anchors its rule over us, especially when, as in tunes like *Make It Funky*, very little of musical interest seems to be happening.

I'll take up these questions in the same bridge-building spirit that animates the rest of this book. I hope to point toward possible connections between one of the central preoccupations of the black aesthetic tradition – the focus on rhythm, and on rhythmic music in particular – with recent work not just in philosophy, but also in areas that intersect with or run adjacent to philosophy. These areas include phenomenological and enactive approaches to cognitive science, anti- or post-textualist approaches to performance studies, culturalist approaches to the musicology of popular music, and contemporary philosophical work at the intersection of dance studies and cognitive science.[6] I will say little squarely on these topics; I will instead try to translate my reverence for funk and similar idioms into terms that specify the common ground that these modes of inquiry share with black aesthetics and with each other. What do they share? A determination to understand – more than this, to come to grips with – the way rhythm and ideas of rhythm function in human experience and community. Linking this determination to the subjugated and embodied knowledges that animate racialized life-worlds can only deepen and enrich the inquiry.

2 Beyond the How-Possible: Kivy's Questions

Until recently, the closest I could get to turning my fascination with rhythm into a question was to draw an analogy to, of all things, the way people sometimes try to explain their interest in theories of content. Much as one might wonder how some bits of the universe can be about other bits, I found myself wondering how some bits of the universe can make other bits move, and do this not by pushing them or pulling them, or even by persuading them, but just by making sounds and having those sounds received in certain ways.

Remembering the grip of the how-possible question got me started toward the argument of this chapter, but it was not enough to capture the experience I had in mind. Let's say that this is the question: *how is it possible that certain sounds can, as one eminent authority puts it, move the crowd?*[7] This certainly raises issues of considerable interest, some of which I will return to in due course. But it is at bottom an empirical question, one to answer by appeal to cognitive science and evolutionary theory.

The first step in getting from the empirical question of how sounds can move crowds to the deeper fascination that I am trying to make articulate

is to note how easily how-possible inquiries can lead to peevishness. This peevishness can take different forms. There's the form that once led John Searle to answer questions about intentionality by saying simply, "that's how some bits of the universe work," and adding that brains secrete thought the way gall bladders secrete bile. There is in addition the form that inspired Barnett Newman to say that aesthetics is to art as ornithology is to birds,[8] which is to say that it utterly fails to illuminate the experience of its subject, no matter how clever it is. And then there's the form that hears how-possible questions as why-questions, and answers, testily, "why not?"

I am most interested in the second form of peevishness, the form that attempts to register the disconnect between how-possible questions and the phenomena that motivate them. This disconnect is partly phenomenological, driven by the realization that we can't know – more accurately, we can't have the experience of – what it's like to be a bird, no matter how advanced our ornithologists become. But it is also, in some sense, spiritual, or imaginative, driven by the sense that ornithology misses some significant portion of the *meaning* of birdness, and that aesthetics has the same problem with art. Put another way, drawing on slightly different, much older philosophic resources: one worry here is that scholarship originally rooted in wonder can too easily lose its way, and turn "how wondrous!" into, simply, "how?"

This shift from possibility to phenomenology allows us to redescribe the question of rhythm. The burden is not just to explain how such things as organized responses to recurring pulses are possible. It is also to credit the fact that these things are wonderful, and that one must say so, if one must say anything, in words that are adequate to this fact. One response to wonder, an incredibly important response, involves trying to figure out how it can be that this thing excites wonder in just this way. But another response involves crediting the wonder, or, one might say, giving it its due.

Acknowledging wonder is most clearly the province of creative expression: it is what we pay, more or less, our artists to do. Or, better, it is the province of experience. The virtue of the wondrous lies in experiencing it, in seeing the sunset or hearing the fugue or being moved by the beat. And the virtue of the artist lies in creating an experience that either participates in the wonder of its subject – a painting of a sunset, say – or that inspires reverence in its own right – the fugue, the dance. The virtue of the philosopher, by contrast, seems to lie in acting out "the rime of the ancient mariner,"[9] which is to say, in pinning things down and analyzing the life out of them.

So what is there for the philosopher to do in the space between phenomenology and poetry? The beginning of the answer that informs this chapter appears in the work of Peter Kivy, from whom I first learned to think about music philosophically. Kivy describes the argument of *Music Alone*, his

remarkable inquiry into "pure music," or music that has no aspiration to represent anything beyond itself, like this:

> Perhaps the question Why Music? is one of those senseless questions that people put without having any clear idea about what a satisfactory answer could possibly be. Why put it then? What I want to do, in putting it, is to convey some of my sense of wonder at the whole phenomenon of music alone; and that sense of wonder begins with what seems to me to be the genuine, if insoluble, mystery of why we have "pure" music at all…. But, of course, my "metaphysical" wonder does not end with the question of why there is musical something rather than nothing. For it also seems wonderful to me, and mysterious, that people sit for protracted periods of time doing nothing but listening to meaningless – yes, *meaningless* – strings of sounds. What is going on here? What *are* these people doing?[10]

Kivy perfectly captures the puzzled reverence that I've been trying to explain. What in the world *are* people doing when they wiggle their bodies in response to recurring periodic pulses? Even better, or worse: what are we doing when we *don't* wiggle but still listen? What is going on here?

One route to philosophy is to accept the thought that the familiar can be made strange, and few things strike me as stranger, once one manages to achieve the proper perspectival distance from them, as this business of wiggling. (Then again, there's this: I once told an acquaintance from West Africa that I don't believe in dancing. She looked at me the way one looks at moldy bread and said, "what about dance requires belief?") But the puzzlement, once one conjures it into being, goes beyond dancing and attaches to those of us who simply listen. Why do we sit for protracted periods of time and absorb, or whatever, James Brown's "The Payback," a tune that has virtually no thematic or harmonic development, and that can plausibly be described as doing the same thing, over and over, for just under eight minutes? At least dancers are doing something. What are we listeners doing?

Taking up Kivy's questions in relation to rhythmic music is doubly helpful. First, it helps close the gap between the how-possible and the how-wondrous, and in so doing helps locate the role for the philosopher. And second, it helps locate the point at which the preoccupations of analytical aesthetics overlap with the concerns of critical race aesthetics. The key to both moves lies in Kivy's argument against what he calls "the stimulus theory" of musical enjoyment.

3 Stimulus, Culture, Race

The stimulus model holds in essence that music moves the ear the way sweetness "moves" the tongue. Kivy argues vehemently against this view on the grounds that, "[i]f music stimulated pleasure the way drugs stimulate

euphoria," then we would be unable to make sense of the way we take pleasure in the specifically musical structure of otherwise meaningless sounds (40). We are not simply responding to sonic stimuli when we enjoy a piece of music; we are responding to *music*: to "an object of perception and cognition, which understanding opens up for ... appreciation" (41).

Put simply, perhaps too simply to do justice to the insightfulness of the argument: if listening to music were like eating candy or doing heroin, then we would be unable to account for the relationship between musical sophistication and musical appreciation. The more one knows about music theory, the more one can hear in the music, and the more opportunities one creates for critical discernment and, if all goes well, enjoyment. One does not just hear sounds, one hears progressions, and dissonance, and resolutions, and so on. Crucially for Kivy's argument, one hears these things if one knows *anything* about music, even if one knows only what one absorbs from being immersed in the right musical culture, and even if one lacks the capacity of the music theorist, composer, or critic to find just the right words for these musical elements.

This argument against the stimulus theory is, in a way, an analytical and aurality-oriented version of the argument for visuality that I rehearsed in Chapter 2. The basic claim in both cases is that perception is mediated by cognition, even, perhaps especially, when the cognitive dimension of the experience remains in the background. (Dewey, following Hegel before him, called this "mediated immediacy.") The more one knows, even if one doesn't know what one knows, the more one perceives. The arguments for visuality and aurality are of course both contemporary versions of much older arguments about what we once referred to as theory-laden perception.

Making clear that perception is theory-laden creates a space for the mode of philosophical engagement that the puzzle of rhythm seems to require. This space is bounded on one side by how-possible questions, and on the other by rapturous celebrations of the wondrousness of things. Between these poles one might find, among other things, *philosophical explorations of the cultural preconditions for the wondrous possibilities under investigation.*

Put differently: when we ask what in the world people are doing, this is not in the first instance a question about how something is possible. It is a question about how to understand, how to conceptualize, how to talk about and frame our inquiries into, the activity whose possibility we mean to investigate. Not "how is our response to rhythm possible?" but "what, exactly, is going on when we respond to rhythm?" What is it that we're doing? How should we talk about what it is that we're doing? And, sometimes: how should we talk about it not just to get it right but also to do justice to it – to give it its due?

These two questions – *how is it possible?* and *what sort of activity is this?* – are of course related. The second kind of question – call these "what the-" questions, as in "what the heck…?" – sets the stage for the first, how-possible question. It establishes the terms of the inquiry into possibilities, at least until that inquiry reveals that the initial terms are inadequate.

But the "what the-" question can also lead away from the how-possible and into the domain of *verstehen* and genealogy. Attempts to understand just what people are doing often begin profitably by asking what they *think* they're doing, not least because agents formulate the intentions that guide and define their actions in terms of their working concepts and vocabularies. We act under descriptions – descriptions of permissible and reasonable behavior, of virtuous or laudable character-types, and so on. And these descriptions have histories that define their internal structures and their relations to other elements in our semantic and symbolic environments. All of which is to say what one reader of Bernard Williams says on his behalf: that one of the principal burdens of philosophy involves "trying to think through what our concepts are by thinking hard about where they came from."[11]

These thoughts about exploring social action from the inside, as it were, in light of its histories and its self-understandings, provide the bridge from the how-possible to the wondrous. Kivy sustains his sense of wonder about pure music, I think, by insisting on the rich apparatus of social, intentional, and cultural practice – though he doesn't describe it this way – that intervenes between the physiological stimuli of sound and the cultural-cognitive provocations of music. To ask how pure music is possible is to presuppose, or demand, a story about what pure music is. And as Kivy shows, telling this story with any degree of care means attending to an intricate array of practices, with their constitutive intentions and conventions, and to the meanings and enjoyments that these practices make available. It means, in short, moving from the study of music to the study of what Christopher Small invites us to call "musicking."[12] Telling stories that capture this movement is not poetry, but done properly it is also not ornithology-as-seen-by-birds.

In addition to marking the space between how-possible and how-wondrous inquiries, distinguishing between physiological stimuli and objects of mediated perception helps explain why a study of black aesthetics should take an interest in rhythm. We are given to think that black music, whatever else it is, is quintessentially rhythmic. We are also given to characterizing the effects of rhythm on human experience in visceral terms – as something that just makes one move, and that in the process allows one to shut off the brain and revel in the primordial elements of human experience. But putting these thoughts together puts us uncomfortably close to an old racist canard: that black culture isn't really culture, that the enjoyments that constitute the aesthetic dimensions of black life are primitive, primal, unsophisticated.

It may be rewarding in various ways to indulge our animal sides, as the primitivists never tired of claiming. But it is worrisome, to say the least, that we can assume so readily that an entire race of people has some privileged access to animality.

4 Preliminaries: Rhythm, Brains, and Race Music

Refusing the stimulus model in relation to rhythmic music means taking culture seriously. And taking culture seriously in relation to rhythmic music means taking racial ideologies seriously. So to ask what we're doing when we respond to rhythmic music, or to ask this question after 1500 or so, in places like the United States, means mapping the meanings of black music. In particular, it means asking whether the idea of a distinctively black approach to rhythm makes sense, and whether this idea can be put to work for purposes other than racist ones.

The first of these questions – call it the "what the-" question, as in "what the heck are we doing when we listen to rhythmic music?" – is the most general, and the most distant from the distinctive burdens of a philosophy of black aesthetics. So I'll use it to motivate the narrower questions about specifically black music. For that purpose, it will be enough to approach the "what the-" question the way Kivy introduces his study of pure music: with a highly provisional and profoundly speculative gesture at the sorts of claims that seem to follow from some recent work in and near cognitive science and evolutionary psychology. Continuing the homage, I will say of my gestures what Kivy says of his: that my "arguments and philosophical positions ... in no way depend on these wild speculations being truth or even close to it."[13] The speculations serve to reinforce the sense of wonder that motivates the inquiry, since *something like* them must be true in order for us to have the capacities we manifestly have. One route to the requisite sense of wonder may run through the challenge of thinking about how creatures with these capacities could have evolved.

Once the broad motivation is in place and the sense of wonder is as secure as it can be, we can take up the questions about rhythm, race, and the meanings of black music.

Primordial rhythm: basic, fundamental, or primal?

One common thought about our response to rhythmic music is that we are turning off our brains and acting out some primordial, pre-human impulse. There is something importantly right about this thought, but it requires considerable tweaking in order to avoid also being importantly wrong or

radically incomplete. Rhythmic musicking – or, as I'll say, following Thelonius Monk, "rhythmaning" – is primordial, in at least one sense of the word. But it is in fact *distinctively* human, and woven into the most complex operations of our cognitive and perceptual systems.

The claim that rhythmaning is the expression of a primordial impulse is vague, with at least three different possible meanings. It might mean first of all that, as scientists often put it, we are "hard-wired" to enjoy rhythmic musicking.[14] We might say in this sense that musicking is a *basic* capacity of the human organism.

A second meaning follows close on the idea of basic hard-wiring, and involves the thought that we are "wired" for rhythm for reasons that are central to the emergence, persistence, and development of the human species. To say this is to refuse Steven Pinker's famous argument that music is a spandrel, a mere side-effect, however fortuitous, of the capacity for language use; and to insist that musical experience draws on a wide range of cognitive and physiological resources and contributes to the overall fitness of the organisms capable of it in ways that language does not. One might say in this spirit that the capacity for rhythmic musicking is *fundamental*: it is not just that we are wired in this way, but also that this wiring – its existence and its natural history – is vital to us being the kinds of creatures we are.

A third sense of the primordiality claim accepts that rhythmaning is fundamental to human experience, but denies it any interesting relationship to the aspects of the human that distinguish us most clearly from the lower orders of being. The claim here is that rhythmaning is *primal*: it is a primitive affair, a holdover from the early days of humankind, mobilizing capacities that may be central to human experience but that are peripheral to the distinctiveness of humanity as such.

Recent work on the mechanisms of musical perception and experience support only two of these senses of primordiality. Rhythmaning does appear to be basic, and it appears to have gotten that way via paths that bear on the fundamental nature of the human as such. But the distinction between more and less primitive fundamental capacities is hard to locate and maintain without a healthy dose of specious ideology, much of it drawn specifically from classical racialist sources.

We will return to the question of how and whether to move from the primordial to the primal in our reading of rhythmic musicking. It will be easier to take up the question once we bring the requisite sense of primordiality more clearly into focus. Doing this will require bracketing the thought of distinctively rhythmic music of the sort that inspired this chapter, and focusing on music as such as a manifestation of rhythmic experience. Rhythm is an essential feature of music, so tracking the natural history of human musical experience means tracking the history of rhythmic experience.

Once we have a story about that, then we can return to thinking about music that privileges rhythm in the manner of James Brown.

The thought that we are hard-wired for musicking follows from the recognition of at least two features of human experience. First, music is a human universal. As Daniel Levitin puts it, "Music is unusual among all human activities for both its ubiquity and its antiquity. No known human culture now or anytime in the recorded past lacked music."[15] Second, our brains are remarkably attuned to rhythmic pulses and, by extension, to rhythmic music. Even passive listening to rhythmic sound activates the motor system, in effect priming the body for movement. It also activates our reward and arousal centers, triggering the release of dopamine and, other things equal, exerting a positive effect on our moods and emotions.[16]

The ubiquity and depth of musical experience suggests that there is an interesting evolutionary story to tell about its origins and development. How could creatures like this evolve? What purpose might this capacity serve? The possible answers to this question grow more interesting as we learn more about the mechanisms of musical experience. A speculative but plausible thought is that the capacity for musicking might have evolved, been selected for, because of the advantages it conferred on social beings, or, perhaps better, because it helped actualize and promote the proto-human capacity for sociality.

Levitin offers three possible ways to cash out the idea of the fitness returns of the capacity for musicking. One approach holds that "collective music making may encourage social cohesions," either by serving as a training ground "for other social acts such as turn-taking" or by occasioning overt group behaviors that discouraged predators seeking solitary prey.[17] Another approach holds that the capacity for strategic entrainment provided a dimension along which organisms could demonstrate their fitness in the contest for mates. On this sexual selection account, the ability to sing and dance is evidence of overall fitness, not just at the level of performance but at the level of cognitive functioning. This thought is reinforced by evidence that rhythmic experience is related to the brain's mechanisms for internal timekeeping, to such a degree that music therapy can help "reset" the brains of patients with neurologic and cognitive impairments.[18] This fact leads in turn to a third possibility for the fitness returns of musicking: cultivating the capacity to make and perceive music promotes cognitive development, though perhaps not as directly as a generation of parents who invested in "Baby Mozart" recordings might have hoped.[19]

So for the reasons mentioned above or for reasons like them, humans evolved as musical, which is to say as rhythmic, animals. Unfortunately, thanks to the familiar temptations of sloppy evolutionism, especially in contexts shaped by race-thinking, many people have for a long time been

tempted by the related thought that specifically rhythmic musicking is an expression of animality. On this view, the capacity to perceive, create, and respond to rhythms in the way that makes musical experience possible may be distinctive and essential to humans; but this capacity marks, in its way, humanity's beginnings. On this approach, rhythmic musicking hearkens back to the point at which humanity set off on the long road from primitivism to civilization. This may be good news or bad news for the rhythm enthusiast, depending on whether one thinks of the primitive as barbarous or as untainted, and of civilization as a matter of refinement or of debasement. But the approach I have in mind commits itself to using civilizationist categories, and to treating rhythmic musicking as, for good or ill, a remnant of an earlier stage in the journey toward contemporary humankind.

What is black music? Empiricism against essentialism

The point of the previous section was to motivate my interest in two thoughts. One, the one I want to endorse, is that rhythmic musicking is *fundamental*: it is a vital and profound aspect of human experience. The other, which I want to undermine, is that rhythmaning is *primitive*, where "primitive" connotes a low civilizational status or lack of cognitive or cultural sophistication.

The link between rhythm and the ideology of civilizationism was forged in the cauldron of modern racialization, and the key to this link lay in the easy and reflexive devaluation of blackness. The psycho-cultural operation here is straightforward, and should be familiar. The African and African-descended cultures that have shaped western conceptions of black people tend to foreground rhythm in ways that European art music and its most prominent sources do not. European modernity's racial projects tended to equate Africanness with backwardness. The obvious inference from this starting point is that distinctively rhythmic music, of the sort that Africans produce, is backward.

Dropping the assumption of black backwardness undermines this whitely ideology of musical civilizationism, and opens the door to a revaluation of the idea that black music is distinctively rhythmic. An anti-racist or post-racist critical race aesthetics can unpack the value of black rhythmicking by building on but going beyond the aforementioned virtues, substantial as they are, that the cognitive science of musical perception reveals to us. This aspiration requires access to a responsible account of black music, one that eschews the occult metaphysics of classical racialism. Luckily, the model for this account is near at hand, in my earlier attempts to frame the argument of this book.

Like an account of black aesthetics, an account of a distinctively black music privileges history over metaphysics, and replaces static racial essences with dynamic racializing processes. This means refusing a priori claims about the way certain practices necessarily attach to certain kinds of people, and embracing empirically evaluable claims about the contingencies of cultural retention, transmission, and development over time. And it means locating this historicist impulse in the context of racial formation, which is to say that we think of some cultural objects as racially black because of their relationship to the processes by which African ancestry and the physiognomic markers of that ancestry became resources for the demarcation of human populations and groups. Once one takes these steps, it becomes possible to speak responsibly about certain musics being integrally bound up with racial projects involving the definition and redefinition of blackness. This in turn makes it possible to speak meaningfully about the stylistic features of black music.

There is no shortage of empirically responsible accounts of black style that exemplify this model, and they are not limited to music. Brenda Dixon-Gottschild, for example, has developed an account of "Africanist aesthetics," a pan-diasporic alternative to "Europeanist" aesthetics that manifests itself across a variety of forms of expressive activity.[20] On her view, what distinguishes Afro-diasporic approaches to expressive practice from their European counterparts is a commitment to the following principles:

1. "Embracing the conflict," or the privileging of "friction and dynamic tension" over smoothness and harmony. Think here of the way "big-band brass and reed players intentionally made their instruments squawk and screech," thereby valorizing "sounds that would be characterized as ugly according to Europeanist aesthetics."[21]
2. "High-affect juxtaposition," or the willingness to combine contrasting elements with relative abandon, pushing "beyond the acceptable range of contrast to that place of danger" where a more conservative approach might fear for the integrity of the work.[22] Think here of Bill T. Jones, and his willingness to combine elements of vernacular and modern dance in his performances.
3. "Ephebism," or a determination to express "a combined sensual, spiritual, and metaphorical intensity and energy."[23] This has to do with giving vigorous expression to the affective dimensions of human experience, including the rougher, rawer emotions that classical European art-performance traditions tended to smooth over. Think here of the rougher vocal timbres that R&B, gospel, and blues singers introduced to American popular music, or of the aggressive abandon with which Lindy-Hoppers, or the tap-dancing Nicholas Brothers, inhabited, or invaded, the previously genteel cultures of American popular dance.

4. "Polyrhythm," which is what it sounds like, and "is translated in the African American experience as counterrhythms and cross-rhythms."[24] Think here of West African drum choirs, or, as we'll soon see, of The Godfather of Soul.

5. "The aesthetic of the cool," or "the dynamic tension" between "visibility and masking," that manifests as "an attitude ... of carelessness combined with a calculated sense of aesthetic clarity." Think here of "the musician or dancer whose body and energy may be working ephebically hard, fast, and hot, but whose face remains as calm and detached as an ancestral mask."[25] Or think of Miles Davis.

Vindicating this kind of broad framework requires a great deal of attention to detail, and gets more difficult the wider one casts the net. Dixon-Gottschild's account is broadly plausible, and something like it must be right, I think. Still, I have no desire to defend that specific story here. I'm more interested in using it to set the stage for attempts to adduce the narrower principles that inform "Africanist" approaches to music.

Art historian Robert Farris Thompson points us in the right direction. He begins his germinal study of Black Atlantic visual culture with a thumbnail account of the "ancient African organizing principles" that continue to inform black practices in the Americas. He writes:

> Among those principles are the dominance of a percussive performance style (attack and vital aliveness in sound and motion); a propensity for multiple meter (competing meters sounding all at once); overlapping call and response ... inner pulse control (a "metronome sense," keeping a beat indelibly in mind ... in a welter of different meters); suspended accentuation patterning (offbeat phrasing of melodic and choreographic accents); and ... songs and dances of social allusion.[26]

Farris Thompson's approach clearly overlaps with Dixon-Gottschild's, once we look past the different names they give to similar ideas. Farris Thompson uses his approach as a launching pad for an ambitious attempt to find organizing principles for visual culture, but claims that these broader principles "parallel ... the massive musical and choreographic modalities that connect black persons of the western hemisphere." This is his way of putting a common claim about the centrality of black music to black culture, a claim that makes musical metaphors and ideas central to the study of black style in general. Take this as an additional reason to study black music with care: it enriches the experience of the music, while also introducing the vocabularies that routinely inform the study of black culture more broadly.

The indispensable starting point for an inquiry into the elements of black musical style as such is the work of Eileen Southern and Samuel Floyd.[27] Drawing on the kind of historical detail that Southern masterfully synthesizes in *The Music of Black Americans*, Floyd argues in *The Power of Black Music* that black musicking has a handful of clear "characterizing and foundational elements."[28] His account of these is worth quoting at length.

> Calls, cries, and hollers; call-and-response devices; additive rhythms and polyrhythms, heterophony, pendular thirds, blue notes, bent notes, and elisions; hums, moans, grunts, vocables, and other rhythmic-oral declamations, interjections, and punctuations; off-beat melodic phrasings and parallel intervals and chords; constant repetition of rhythmic and melodic figures and phrases (from which riffs and vamps would be derived); timbral distortions of various kinds; musical individuality within collectivity; game rivalry; handclapping, footpatting, and approximations thereof; apart-playing; and the metronomic pulse that underlies all African-American music.[29]

Taken by the way Henry Louis Gates uses the idea of signifying as a broad organizing principle for thinking about black literature, Floyd gathers all of his musical elements under the single rubric of "call and response." He then follows Gates in treating these elements of black vernacular musicking as a key to the development of an appropriate critical practice.

I want to set aside Floyd's critical aspirations and focus on a preoccupation that runs consistently through these various accounts, and that gets more detailed the more we zero in on music as such: the focus on rhythm. All of the accounts summarized above give pride of place to polyrhythms and to ideas like "pulse control," percussiveness, and off-beat phrasing. I take the existence and consistency of these accounts of black music as evidence for two propositions. First, there is an empirically responsible way to give an account of black music. The details and language will vary with the author and the context, but the broad outlines coincide, and allow for drilling down into the underlying anthropological and musicological detail. And second, a central element in these accounts, perhaps *the* central element from the perspective of pure music, is the focus on rhythm.

5 The Flaw in the Funk

Now that we have an account of black music, and of the blackness of black music, in hand, we can take up the question that I opened with the epigraphs to this chapter. What about the blackest black music, the music of, among others, the mature James Brown and of the 1990s incarnation of Me'Shell NdegéOcello? To put the question in the way I did a few pages back: What

are we doing when we listen to tunes that, like James Brown's "The Payback," have virtually no thematic or harmonic development, but that nevertheless deign to repeat themselves for minutes on end?

The worry I mean to be raising – call it "the flaw in the funk" if you can hear George Clinton saying it, and "funk's flaw" if you can't – is a familiar one for students of black music. The most familiar version of the worry comes from Adorno, for whom the sort of repetition one finds in jazz is an expression of, as one commentator puts it, "industrial standardization, loss of individuality ... and hence fascism."[30] Adorno's reasons for this view, if this is his view, have more to do with his prior theoretical commitments than with the music, and will require more space and patience than I have available to me here to render them responsibly, much less to engage them productively. Luckily, less loaded versions of the worry are ready at hand.

An easier path to funk's flaw begins with the science we've just surveyed. Neuroscientist Daniel Levitin closes a discussion of the role of expectations in the psychology of musical perception by pointing out that "the organization [of musical elements] has to involve some element of the unexpected or it is emotionally flat and robotic."[31] This could be the beginning of a brief against repetition, backed by a robust scientific story about how the managed violation of our expectations – the careful production of surprise – holds our attention and gives us pleasure. I say that it could be the beginning of such a brief because this is not at all the use to which Levitin puts it, as we'll see.

In an interesting twist, the next steps in a philosophically noncommittal path to funk's flaw might take us to the work of documented advocates for certain forms of black music. The great musician-composer-educator-critic Gunther Schuller is well known for his insistence on the aesthetic merits of jazz. But he worries that the "harmonic stasis and lack of melodic interest" in the work of masters like Count Basie complicate their claims to true musical greatness. André Hodeir echoes this complaint, putting it in terms of a worry about "extreme melodic monotony" in Basie's music.[32] Both criticisms focus on Count Basie, but can in principle be generalized to all expressly rhythmic black music. The question is whether the piece, performance, or tradition in question fits the description that these critics give of Basie's music. And whatever else "The Payback" is, it is melodically monotonous, nearly to the point of refusing melody altogether. And in this respect it stands in for the entire funk idiom, which *The New Rolling Stone Encyclopedia of Rock* defines as a "bass-driven, percussive, polyrhythmic black dance music, *with minimal melody* and maximum syncopation."[33]

The Schuller–Hodeir path to funk's flaw appeals to me because ethnomusicologist Ingrid Monson invokes it on the way to providing a comprehensive and intuitively plausible response. Building on the work of John Chernoff

and others, Monson argues that the approach to rhythm that organizes Basie's work is, one might say, *dynamically repetitive*. That is:

> Repeating parts of various periodicities are layered together to generate an interlocking texture ... which then serves as a stage over which various kinds of interplay ... and improvisational inspiration take place. If the layered combination generates a good flow (hits a groove) a compelling processual whole emerges that sustains the combination.[34]

Monson's point is that Basie's music appears monotonous only to those who – perhaps in the grip of uncritical assumptions about the overlap between western art music and music as such – overemphasize the melodic and harmonic aspects of the music and underemphasize, or utterly fail to notice, its rhythmic sophistication. Through musicological analysis, Monson shows that Basie layers *different* repeating figures to create an "interlocking texture" that then underwrites various kinds of improvised soloing and riffing. Then, donning her ethnomusicologist's hat, she shows that this dynamic repetition tracks an approach to rhythm that appears across a wide range of Afro-diasporic musical practices, with roots that are easily traceable to West and Central Africa. These practices are the clearest musical exemplar of Baraka's "changing same" – an experience or practice in which the overall structure persists over time, but the elements that make up the structure are always changing, reflecting the culture workers' determination to inhabit and revise the overarching structure creatively.

I cannot manage and will not attempt to give "The Payback" the sort of close reading that Monson gives Basie's "Sent For You Yesterday." But musicologist Guthrie Ramsey makes clear how this sort of reading would go. On his way to analyzing another of Brown's tunes, he explains that funk, the idiom that "Payback" exemplifies and that Brown is usually taken to have substantially created, involves "spontaneity-within-the-pocket."[35] This is an approach to rhythm that creates competing and alternative groove patterns, distributes them to different instruments and performers, and with this "division of sonic labor" creates "sonic variety within the mix" of a single, persistent musical structure.[36] This sonic variety maps onto the ideas we've seen from the other authorities invoked above. It constitutes Monson's "layered combinations," revels in Farris Thompson's "multiple meter" and "suspended accentuation patterning," and embodies what all of these authorities join *Rolling Stone*, Floyd, and Dixon-Gottschild in calling, simply, "polyrhythms." And the way these combinations continue to mesh despite their variety, despite being continually recreated through structured improvisation, helps maintain our interest in them.

The overall point here will be evident to anyone who has ever heard "Payback," or any of Brown's mature work, or, for that matter, any good funk music. But it will pay us to have the language to state it clearly. We continue to listen to the repeating riffs of funk (or jazz, or zouk, or reggae, or rumba, or West African drum choirs, or, or) because the repetitive macro-structure is built from constantly shifting rhythmic micro-elements, and because we take pleasure in the way these micro-innovations surprise us while still sustaining the overall pattern of musical organization. The musical structure persists, which is to say that the groove goes on. But the guitarist, bass player, horns, and so on continually reinvent the resources for this persistence, with the improvisational choices they make about just how to keep the groove going.

This account of rhythmaning's changing same allows us to block the easy path to funk's flaw right at its neural-cognitive starting point. As we saw above, humans are hard-wired for rhythm, and this hard-wiring does many things for us. It helps us to reset our neural-cognitive timing. It promotes what a Kantian might want us to think of as the free play of, among other things, our motor centers. And it reinforces pro-social practices and attitudes, if the evolutionary psychologists are right. But, as Levitin points out, we are not hard-wired for *monotony*.

> As ... music unfolds, the brain constantly updates its estimates of when new beats will occur, and takes satisfaction in matching a mental beat with a real-in-the-world one, and takes delight when a skillful musician violates that expectation in an interesting way.... Music breathes, speeds up, and slows down just as the real world does, and our cerebellum finds pleasure in adjusting itself to stay synchronized.[37]

Dynamic repetition, the musico-rhythmic changing same that in large part constitutes Afro-diasporic musical culture, works precisely to weave the unexpected, the routine generation of surprise, into our persistent sonic expectations.

Levitin makes the point himself in a reading of Paula Abdul's "Straight Up." Focusing on this tune is an odd choice, since it is no match even for Brown's lesser efforts. But Levitin's musical tastes notwithstanding, his comment is worth attending to, not least because the piece he discusses sits squarely in a tradition that would have been impossible without James Brown. To his credit, he notes this in a passing reference to the funk tradition.

> There is so much going on in "Straight Up" that it is difficult to describe in words. The drums play a complex, irregular pattern with beats as fast as sixteenth notes, but not continuously – the "air" between drum hits imparts a sound typical of funk and hip-hop music. The bass plays a similarly complex

and syncopated melodic line that sometimes coincides with and sometimes fills in the holes of the drum part.... While all this is going on, synthesizers, guitar, and special percussion effects fly in and out of the song dramatically, emphasizing certain beats now and again to add excitement. Because it is hard to predict or memorize where many of these are, the song holds a certain appeal over many, many listenings.[38]

Everything Levitin writes here about "Straight Up" applies, in spades, to nearly every up-tempo tune James Brown recorded after 1964. "Payback" is repetitive, but in the dynamically repetitive manner that characterizes many Afro-diasporic music traditions. In these musics, the listener experiences the groove, but "cannot predict or memorize" the precise events that will make it possible for this experience to continue. The continual discovery of the next iteration of the groove is what reconciles funk's repetition with our bias against monotony.

6　(Soul) Power to the People

In the time-honored manner of philosophical reflection, I fear I've just spent a great deal of time finding words for the obvious. This is not necessarily a problem, for reasons I tried to explain in the opening sections of this chapter. One way to credit certain marvelous aspects of human experience is to find words that both explain and do justice to states of affairs that are manifestly the case. And one reason to take up the burden of giving credit and finding these words is to dispel the fog of ideological myth that obscures our view of the obvious, and makes it needlessly mysterious.

So what words have I found? Words like these:

We listen to tunes like "The Payback" over and over, despite what one might think of as monotony, because they are dynamically repetitive. They are superficially unchanging, at the level of macro-structure; but the persistence of this structure depends on the unpredictable choices that musicians make in the moment, in each moment, about just how they will inhabit the structure. This story about dynamic repetition is less obvious than it otherwise might be because the dynamism in these musical structures appears principally in the domain of rhythm, which modern racial ideologies have conditioned us to think of as inherently unsophisticated. Fortunately, the evidence of contemporary cognitive science gives the lie to this ideology. Rhythm is fundamental to human experience, but it is not primitive in the sense used by civilizationists. That is: it is not the case that rhythm *was* fundamental to humankind at some distant historical remove, only to have been superseded by more sophisticated approaches to the organization of

sound for enjoyment. Rhythm *is* fundamental: the capacity for rhythmic experience and the exploitation of this capacity are conditions of possibility for beings like us, and for the kinds of experiences, lives, and cultures that we have even now.

Introducing the idea of culture brings us to a final question, and to an obvious feature of funk that I've somehow kept out of the discussion until now. There is of course more to being moved by funk than the abstract triggering of pleasure centers by dynamically repeating figures. Music also carries cultural meanings, and this obviously contributes to the way it moves us. In the discussion above I cited Monson for the proposition that a compelling layering of rhythmic elements sustains musical structures. She goes on to add, in a passage that I did not reproduce above, that a properly layered combination of dynamically repeating elements sustains not just the groove but also "the people [who are] interrelated through playing it, dancing to it, or listening to it."[39] What can this mean?

Monson's point about sustaining a groove and a people at the same time, with the same activities, has at least two important meanings. On the one hand, it leads into a portion of her argument that I've so far given short shrift. I've insisted on the musicological insights that she uses Count Basie to articulate, but I've sped past one of her deeper, squarely *ethno*musicological claims.

Monson's key ethnomusicological claim begins by working out the idea developed above: that the widespread Afro-diasporic commitment to dynamic repetition with a special emphasis on rhythm allows us to cash out popular ideas about Black Atlantic cultures in ways that are both empirically supportable and music-theoretically responsible. She shows that attending with care to the details of the music bears out the thought that there is such a thing as a transnational black culture, with continuities linking peoples and practices at the very least on all sides of the Atlantic Ocean. The unity of this culture is provisional, and episodic, and highly contingent, but it is united nonetheless, in a living, transnational cultural formation.

For Monson, this proof and elaboration of the Black Atlantic thesis is not just a matter of retentions, survivals, and creolizations, but also of ongoing borrowing and exchange. The open-ended musical structures that she explores under the heading of "riffs" are supple enough to incorporate grooves from a wide variety of sources. This is why James Brown's famous tour of West Africa in 1970 was a celebration of mutual recognition and reciprocal influence. Brown's music was importantly intelligible to African audiences, and was an important influence on musicians like the great Fela Kuti. And when Brown heard what musicians in the motherland had done under the influence of his music, he borrowed from them in his subsequent work. Musicians and artists always borrow from each other, even across cultural boundaries. But this exchange was particularly fertile and

spontaneous, Monson argues, because the musical elements fit together like missing pieces of the same rhythm-centered puzzle. As Kuti's biographer puts it, Brown's tour showed that the "cross-cultural influence between West African and African-American musicians had come full circle."[40]

One sense, then, in which a proper layering of musico-rhythmic elements can sustain a people has to do with the ongoing exchanges that constitute a living Black Atlantic culture. But another sense of the claim grows directly out of this. Immersion in this musical culture is a crucial element in the formation of black subjects, in ways that bear directly on the phenomenology and content of black identity. Or: if the first claim vindicates the thought that there is such a thing as a Black Atlantic culture, then the second claim burrows into this thought, and begins to work out what it means to inhabit that culture from the inside. This points us to the other way to sustain a people with music: not just by knitting together geographically dispersed cultures that have diverged from shared roots, but also by giving the individuals in those cultures the resources to think of themselves as particular kinds of persons, as, in this case, black persons.

In a 1980 piece in the *Village Voice*, writer Thulani Davis makes clear just how closely black identity was once intertwined with Brown's music. Recalling her encounter with Brown's music as a college student, she writes:

> By 1971 my friend Jim had us all calling him James, just James, like we knew him, cause we did.... JB was proof that black people were different. Rhythmically and tonally blacks had to be from somewhere else.... [I]t was the polyrhythms that snared us. The horns on a half time from the drums, rhythm guitar alternating riffs that slapped the bass line once or twice, horns popping little accents and James in the middle. His left leg would be on the fastest time going while his voice got the long notes, holding a scream and everything in-between.... Brown gave us a sound that led us to many other musical places but that we cherished for not being diluted, not influenced by things outside ... of our black American world. We called him James cause ... he made a stomp and holler analysis of ourselves.[41]

7 Funky White Boys and Honorary Soul Sisters

This shift from black culture to black subjects opens onto one of the riddles inherent in theorizing black music. I've spent much of this chapter motivating and responding to what may be the most obvious of these riddles: can there be such a thing as black music without invidious racial essentialism? Monson's discussion of peoplehood points us to a second riddle. If the blackness of black music is not a matter of essential racial traits, then how do we make

sense of the thought – call this "racial exclusivism" or, following Gilroy, "cultural insiderism"[42] – that black people have special access to this music? Or, why bother making sense of this thought, if, as it appears, it is simply a form of compensatory pro-black racism?

I've argued elsewhere that some forms of exclusivism are worth taking seriously, and are therefore worth making sense of, because they are expressions of an astute ethical and social-critical sensibility.[43] The claim that people other than blacks can't play blues or funk, or dance like Michael Jackson (who can?), or rap, *really* rap, might be, I suggested, a way of registering the short-circuiting of an aesthetic experience by ethical considerations. In short: black auditors are more likely to know the histories of appropriation and exploitation that attend the uses of their cultures by out-group members. As a result, they find their experiences of performances by out-group members irremediably tainted. Elvis, or Vanilla Ice, or Paul Desmond, or Eminem, or Ke$ha, or Iggy Azalea, or whomever, just doesn't sound as good when you know about the racial maldistribution of profit and opportunity in the music industry, in just the way, some argue, that *Birth of a Nation* feels, or should feel, or feels like it should feel, less like a towering cinematic achievement once one factors in its overt embrace of a white supremacist point of view. I called this short-circuiting of the aesthetic experience "the Elvis effect."

This appeal to the Elvis effect was meant to provide only a provisional defense of racial exclusivism in aesthetics. The idea was that exclusivist judgments are in at least some instances not simple expressions of pro-black racism but of an awareness of anti-black racial injustice. If this awareness stunts the auditor's unfolding aesthetic experience, causing it to suffer by comparison to the less ethico-politically burdened experience of in-group member performances, then the conversation-stopping accusation of "reverse" racism is not yet warranted. The accusation may turn out to be right, but it will take more work, and more phenomenological or psychological data, to show that it is.

Instead of continuing down that methodologically and conceptually complicated path, which would involve, among other things, returning to the question of how ethical and aesthetic judgments are related, I want to turn back in the direction of the empirical resources mobilized above. Instead of using the phenomenology of aesthetic experience to reinterpret the factual claim at issue in exclusivism – *those people just can't perform this music as well as we can* – I want to take exclusivism at face value, and evaluate it in light of what we know about how brains work.

I should say that I want to evaluate exclusivism's claims in light of what we know about how brains *and* about how human societies of certain kinds work. This addition is important because socialization has a great deal to

do with what each brain ends up being, and with what it ends up being empowered and prepared to do and perceive. Here is neuroscientist Levitin on the point:

> Our ability to make sense of music depends on experience, and on neural structures that can learn and modify themselves with each new song we hear, and with each new listening to an old song. Our brains learn a kind of musical grammar that is specific to the music of our culture, just as we learn to speak the language of our culture.[44]

This deep musical socialization shapes how and how much we hear of the music we hear. In the extreme cases, it shapes whether we can hear a sonic event as music at all. And what we can hear shapes the music that we can imagine making, and that we can plausibly aspire to make. If this deep socialization takes place in a single society that is deeply internally divided – along racial lines, say – then the capacity for musicking will be to some degree race-specific, to the extent that the potential producers and consumers of the music have their habits of perception and attention indexed to specific communities of practice.

The capacity for musicking will not be completely race-specific because, as Du Bois put it, the walls of race were never clear and straight. There has been frequent borrowing across racial lines, first in the context of the "monstrous intimacies" of slavery and colonialism, and then in the various modes of collaboration, cultural diffusion, and outright theft that marked the racial orders that came after. Some places, like Brazil, refused the idea of racial separation, though not as completely as they've pretended to, with the result that they distribute the inheritance of Afro-diasporic musical practices rather evenly across a mixed and multiracial population. But some places, like the United States and South Africa, committed to regimes of racial separation until quite recently. This had the result of minimizing opportunities for fully interracial musicking, or of shunting these opportunities into the domain of appropriation and theft; which in turn did make it harder for people outside of black communities to immerse themselves fully in the formative contexts for black musical practice.

All of this to say that there are reasons, reasons straightforwardly rooted in neuropsychology and in the sociology of racial segregation, to think that white people are less likely to perform black music "properly." Those reasons have to do with the high barriers to entry that long kept aspiring white musicians out of the training grounds for black musicking. The barriers didn't keep all of them out, as Eminem, Red Rodney, Marian McPartland, and many others make clear. But the barriers were forbidding enough to make people like this more an exception than a rule. This is why a *Vibe* magazine

article on singer Teena Marie called her an "honorary soul sister": because she was unusual enough to require some marker of her status.

8 Conclusion

Much of the last section relies on past-tense assertions like these: "the barriers to entry *were* forbidding," and "Teena Marie *was* unusual."This way of putting things is necessary because the cultural consolidation of the United States' second reconstruction has had the effect of bringing interracial borrowing back above ground. People outside of black communities have always used blackness, in various ways, as a resource for understanding their own identities. But for a stretch of years in the United States, after the heyday of minstrelsy and before the rise of, say, Eminem, this process was in many places oddly indirect and sublimated, and never fully able to work itself through. So every few years would produce some new version of Mailer's "White Negro," with its explicit invitation to a peculiar and exoticized form of wiggerism, and the same questions and tensions would arise.

Now, though, it is perfectly clear that, as Ellison and Baraka argued in rather different ways, US culture would be unthinkable without black people, and without black music in particular. It is clear that the arts of jazz and blues and hip-hop are culture-wide inheritances, and training in at least the first of these is more readily accessible to white aspirants, through its full incorporation into higher education, than to blacks. Similarly, it is clear that the world culture industries would be unrecognizable without black music, from reggae to rap. Something like this has been true since at least the age of the Lindy Hop. But the unprecedented reach of culture work in a fully networked world, and the fact that the culture industries as we now know them have only recently come into their own, gives this truth a more profound claim on our attention than ever before.

Now we have generations of people of all races who have been raised, out in the open, as it were, on black music. Where white musicians once had to work to find black music and cultivated their attachment to it in underground subcultures, and where the condition of escaping obscurity and entering the "mainstream" was usually having the music fully whitened and stripped of all attachment to black people as anything other than symbols and vehicles for the work of white identity formation, now the mainstream is itself racially coded as black, and popular entertainers become popular in part because of their mastery of the conventions that once set black musical contexts apart – contexts that they have been eavesdropping on and participating in, in earnest, since at least the ascendance of Michael Jackson and Prince. Or: Mick Jagger became an icon to white people by unashamedly

borrowing from and building on black musics, but this earned him little credibility with black musical audiences. Robin Thicke, by contrast, borrows and becomes, in the peculiar twenty-first-century way that puts some people in mind of post-racialism, a favorite of white *and* black audiences.

I mean to be describing a world in which white performers Justin Timberlake and Jimmy Fallon can perform a credible version of "Rapper's Delight" on Fallon's talk show, with the black hip-hop group The Roots playing backup. This is a world in which a white Australian teenager – Iggy Azalea – can rocket to the top of the charts by rapping in a simulated "Dirty South" style. Or: a world in which a white rapper from Seattle can win a Grammy and then tweet an apology to a black peer and competitor, Kendrick Lamar, on the grounds that he stole the award from Lamar.

Macklemore's semi-apology to Lamar – "semi" because he didn't return the award – is an instructive opening onto a discussion of the legacy of cross-racial cultural appropriation. That discussion can productively begin in the domain of racial styles in music, because of the centrality of black music to black culture and to the globalizing culture industries. But it takes us away from questions about the possibility of authentic cross-racial borrowings – they surely are possible, and are not as rare as they once were – and away from questions about the meanings of rhythm – if rhythm is primitive then, as Picasso and Senghor apparently said to each other, we're all savages now – to the question of whether these borrowings are impermissible or otherwise blameworthy.

Notes

1 Me'Shell NdegéOcello, "Leviticus: Faggot," *Peace Beyond Passion*, © 1996 Maverick Recording Company, Beverly Hills, CA; discography information at http://www.discogs.com/MeShell-Ndeg%C3%A9Ocello-Peace-Beyond-Passion/release/392871 (accessed August 14, 2014). Transcription by Mark Taylor.

2 Léopold Senghor, *Liberté I, Négritude et humanisme* (Paris: Seuil, 1964), 296; cited in Souleymane Bachir Diagne, "Négritude," in Edward N. Zalta, ed., *The Stanford Encyclopedia of Philosophy* (Spring 2014 edition), http://plato.stanford.edu/archives/spr2014/entries/negritude/ (accessed August 14, 2014).

3 James Brown, "Make It Funky," © 1971 Polydor Records, London, UK; discography information at http://www.discogs.com/James-Brown-Make-It-Funky-Part-1–Part-2/release/552530 (accessed August 15, 2014).

4 A Tribe Called Quest, *People's Instinctive Travels and the Paths of Rhythm*, © 1990 Zomba Recording Corp. Manufactured and Distributed by RCA Records, A label of BMG Music, New York, NY; lyrics found at http://www.metrolyrics.com/rhythm-devoted-to-the-art-of-moving-butts-lyrics-a-tribe-called-quest.html; discography information at http://www.discogs.com/A-Tribe-Called-Quest-Peoples-Instinctive-Travels-And-The-Paths-Of-Rhythm/release/87304 (both accessed August 15, 2014).

5 Senghor 296, cited in Diagne.

6 See Tom Froese and Thomas Fuchs, "The Extended Body: A Case Study in
 the Neurophenomenology of Social Interaction," *Phenomenology and the
 Cognitive Sciences* 11 (March 2012), 205–235; Lorne Conquergood,
 "Performance Studies: Interventions and Radical Research," *TDR: The
 Drama Review* 46:2 (Summer 2002), 145–156; Anne Danielsen, *Presence
 and Pleasure: The Funk Grooves of James Brown and Parliament* (Middleton,
 CT: Wesleyan University Press, 2006); Renee Conroy, "Responding
 Bodily," *Journal of Aesthetics and Art Criticism* 71:2 (Spring 2013),
 203–210.

7 Eric B. and Rakim, "Move The Crowd," *Move The Crowd/Paid In Full*, ℗ 1987
 Island Records, Inc., Los Angeles, CA; discography information at http://www.
 discogs.com/Eric-B-Rakim-Move-The-Crowd-Paid-In-Full/release/1314966
 (accessed August 15, 2014).

8 Barnett Newman, *Selected Writings and Interviews*, ed. J. P. O'Neill (New York:
 Knopf, 1990), 304, 242–243; cited in Paul Mattick, Jr., "Aesthetics and Anti-
 Aesthetics in the Visual Arts," *Journal of Aesthetics and Art Criticism* 51:2,
 "Aesthetics: Past and Present. A Commemorative Issue Celebrating 50 Years of
 The Journal of Aesthetics and Art Criticism and the American Society for
 Aesthetics" (Spring 1993), 253–259, 253.

9 On at least one reading of it, anyway. See Patrick Keane, *Coleridge's Submerged
 Politics: The Ancient Mariner and Robinson Crusoe* (Columbia: University of
 Missouri Press, 1994).

10 Peter Kivy, *Music Alone: Philosophical Reflections on the Purely Musical Experience*
 (Ithaca: Cornell University Press, 1990), 12.

11 Timothy Chappell, "*Philosophy as a Humanistic Discipline* – by Bernard Williams,
 The Sense of the Past – by Bernard Williams" (review), *Philosophical Investigations*
 32 (2009), 360–371, 362.

12 Christopher Small, *Musicking: The Meanings of Performing and Listening*
 (Middletown, CT: Wesleyan University Press, 1998).

13 Kivy 12.

14 Andrea Rinaldi, "Speak To Me, Melody," *EMBO (European Molecular Biology
 Organization) Reports* 10:12 (2009), 1294–1297, 1294, http://www.ncbi.nlm.
 nih.gov/pmc/articles/PMC2799200/.

15 Daniel J. Levitin, *This Is Your Brain on Music: The Science of a Human Obsession*
 (New York: Dutton, 2006), Kindle edition, Kindle location 131.

16 Levitin, Kindle location 3100.

17 Levitin, Kindle location 4189.

18 See Michael Thaut, *Rhythm, Music, and the Brain: Scientific Foundations and Clinical
 Applications* (New York: Routledge, 2005), esp. Ch. 4, "Biomedical Research in
 Music," 61–84.

19 Levitin, Kindle location 4223.

20 Brenda Dixon-Gottschild, *Waltzing in the Dark: African American Vaudeville and
 Race Politics in the Swing Era* (New York: Palgrave, 2002), 11.

21 Dixon-Gottschild 12.

22 Dixon-Gottschild 13.

23 Dixon-Gottschild 14.

24 Dixon-Gottschild 15.

25 Dixon-Gottschild 15.

26 Robert Farris Thompson, *Flash of the Spirit* (New York: Random House, 1983), xiii.

27 Eileen Southern, *The Music of Black Americans: A History* (New York: Norton, 1971); Samuel A. Floyd, *The Power of Black Music: Interpreting Its History from Africa to the United States* (New York: Oxford University Press, 1995).

28 Floyd 6.

29 Floyd 6.

30 Ingrid Monson, "Riffs, Repetition, and Theories of Globalization," *Ethnomusicology* 43:1 (Winter 1999), 31–65, 31.

31 Levitin, Kindle location 1799.

32 Gunther Schuller, *The Swing Era: The Development of Jazz 1930–1945* (New York: Oxford University Press, 1989), 253; André Hodeir, *Toward Jazz*, trans. Noël Burch (New York: Grove Press, 1962), 97; both cited at Monson 31.

33 Patricia Romanowski, Holly George-Warren, and Jon Pareles, eds., *The New Rolling Stone Encyclopedia of Rock* (New York: Fireside-Rolling Stone Press, 1995), 362, emphasis added.

34 Monson 36, 44.

35 Guthrie Ramsey, *Race Music: Black Cultures From Bebop to Hip-Hop* (Berkeley: University of California Press, 2004), 154.

36 Ramsey 154.

37 Levitin, Kindle locations 3112–3115.

38 Levitin, Kindle locations 973–975, 978–980.

39 Monson 44.

40 Michael E. Veal, *Fela: The Life and Times of a Cultural Icon* (Philadelphia: Temple University Press, 2000), 88–89; cited in Penny von Eschen, *Satchmo Blows Up the World* (Cambridge, MA: Harvard University Press, 2004), 234.

41 Thulani Davis, "J-a-a-a-ames Brown!," in Nelson George and Alan Leeds, eds., *The James Brown Reader: Fifty Years of Writing About the Godfather of Soul* (New York: Plume-Penguin, 2008), 148–154, 148, 154; originally published June 9, 1980, in the *Village Voice*.

42 Paul Gilroy, *The Black Atlantic: Modernity and Double Consciousness* (New York: Verso, 1993), 3.

43 See Paul C. Taylor, "Funky White Boys and Honorary Soul Sisters," *Michigan Quarterly Review* 36:2 (1997), 320–335; reprinted in Sonia Maasik and Jack Solomon, eds., *Signs of Life in the U.S.A.: Readings on Popular Culture for Writers*, 3rd ed. (New York: Bedford-St. Martin's, 2000); and Paul C. Taylor, "… So Black and Blue: Response to Rudinow," *Journal of Aesthetics and Art Criticism* 53:3 (1995), 313–316.

44 Levitin, Kindle location 1771; see also Jay Seitz, "Dalcroze, the Body, Movement, and Musicality," *Psychology of Music* 33 (2005), 419–435, 420: "composers [of European concert music] most likely internalize rhythmic patterns of language very early in life or incorporate rhythms of folk and popular (sung) songs acquired in childhood in their mature compositions." The same thought applies, *mutatis mutandis*, to the shaping of musical sensibility for musicians in other idioms, and for their audiences.

7

Conclusion: "It Sucks That I Robbed You"; Or, Ambivalence, Appropriation, Joy, Pain

In New York, some years ago, Mr. P. T. Barnum had a clever boy who brought him lots of money as a dancer of negro break-downs; made up, of course, as a negro minstrel, with his face well blackened, and a woolly wig. One day [the boy], thinking he might better himself, danced away into the infinite distance. Barnum, full of expedients, explored the dance-houses of the Five Points and found [another] boy.... It was easy to hire him; but he was a genuine negro; and there was not an audience in America that would not have resented, in a very energetic fashion, the insult of being asked to look at the dancing of a real negro....

Barnum was equal to the occasion.... He greased the little "nigger's" face and rubbed it over with a new blacking of burnt cork, painted his thick lips with vermillion, put on a woolly wig over his tight curled locks, and brought him out as the "champion nigger-dancer of the world." Had it been suspected that the seeming counterfeit was the genuine article, the New York Vauxhall would have blazed with indignation.

<div style="text-align: right">

Thomas Low Nichols, writing in 1864, cited in Lott,
"The Seeming Counterfeit"[1]

</div>

You got robbed. I wanted you to win. You should have. It's weird and it sucks that I robbed you.

<div style="text-align: right">

Macklemore tweet to Kendrick Lamar[2]

</div>

Black is Beautiful: A Philosophy of Black Aesthetics, First Edition. Paul C. Taylor.
© 2016 Paul C. Taylor. Published 2016 by John Wiley & Sons, Ltd.

In the foregoing pages, I have repeatedly put off questions related to the ethics of appropriation. Those questions have come in many forms, inspired by many different cases. We've considered African Americans wearing kente cloth; white musicians playing black music; whitely narratives using – *invisibilizing* – black bodies to work out issues internal to the idea and experience of whiteness; and white-dominated artworlds incorporating African objects while leaving aside the individuals responsible for creating the objects. In these and other cases, the worry keeps arising: isn't there something *wrong* with this? Shouldn't those people leave those other people alone?

These ethical questions are knotty enough in their own right, as I hope to have shown even in the short gestures I've made to this point. But they are confused even further by the layers of psycho-emotional complexity that attend the problems of appropriation. What does it mean that Macklemore, in the events that I mentioned at the end of the previous chapter and signaled once more in the epigraph above, apologizes for having "robbed" Kendrick Lamar? What does it mean that the context for Thomas Low Nichols's "seeming counterfeit" – the black boy made up like a white boy pretending to be a black boy – centrally involves the practice of minstrelsy, which in its original forms bears interpretation as both "a transparently racist curiosity"[3] and a celebration of the wellsprings of an authentically homegrown US culture? (I say "in its original forms" because there are additional questions about the contemporary reappropriation of minstrelsy's meanings by black artists like Spike Lee.)[4]

The idea that minstrelsy might be more than an expression of racism, or of simple racism, is easier to countenance now than it once was thanks to the work of people like Eric Lott, whose germinal book *Love and Theft* helped revive scholarly interest in the tradition. Interest in this practice needed reviving because it had long since been written off as an embarrassing relic of benighted times. White men pretending to be black men by blackening their faces and performing, on stage, the peculiar antics that constituted their vision of blackness – what else could that be but a particularly shameful bit of white supremacist culture? For our purposes right now, the key consideration is what makes this practice shameful. It was theft thrice-over. It reinforced an image of blackness that actual black people lacked the resources to contest with any consistent success; this image, informed by problematic racial ideologies, was false; and this false image effectively stole black images from blacks themselves, who, one might think, have some right to define their own image in the public mind.[5]

Lott's point goes beyond shaming and repudiation, though, to suggest that minstrelsy is more, and more interesting, than a garden variety expression of racism. The men who donned blackface did so in an attempt to work out their own identities as Americans, and some chose blackness as a vehicle for this

because of a genuine, if paternalistic and complicated, respect for black culture. This is why Lott speaks of *love* and theft, and why it is important to talk about appropriation *and ambivalence*. The borrowing, exchange, and theft of cultural objects and practices across racial lines is, when it comes to black folk, typically fraught with ambivalence. The hegemonic meaning of blackness in modernity assigns it a negative value; but this negative value is entwined with traits or properties that nevertheless find some way to remain widely, if sometimes surreptitiously, regarded as repositories of value or objects of desire.

Examples of this ambivalence are easy enough to come by. Minstrelsy may be the clearest one – a white settler society adopts as its most widely loved form of popular entertainment a performance practice that celebrates, in its way, the folk culture of one of the peoples it is at the same time grinding underfoot. But there are, of course, many other cases, with more coming into view every day as the barriers against interracial cultural exchange continue to fall.

The cases come and go so frequently now, as the pace of renewal – or of competition by innovation – in the popular culture industries continually quickens, that I hesitate to use contemporary examples. (Were it not for this hesitation I would say more about Iggy Azalea, the white Australian teenager who sounds for all the world like a Dirty South rapper.) But Macklemore's peculiar stab at an apology stands in some ways as the perfect emblem for this odd phenomenon, and for much else in our allegedly post-racial world. It sucks, he says, *that I robbed you*. Which is to say: Yes, I did it, and I know there's something shady about it, and I'm sorry. But I'm not sorry enough, or whatever else enough, to undo it.

These questions of appropriation and ambivalence – of, as Lott rightly puts it, *love and theft* – are a vital area of scrutiny for anyone interested in black aesthetics. But they are such rich and weighty topics that they deserve more scrutiny than I can give them in the space I have left here. Cultural appropriation has become a going concern in and near the field of philosophical aesthetics, thanks in no small part to the pioneering work of James Young.[6] The next step in the work begun here will be to bring the arguments of this book into conversation with this work on appropriation. But the work had to begin in order for that next step to make sense.

The point of the work so far has been to assemble black aesthetics as an object of philosophical study, using the resources, broadly speaking, of analysis, pragmatism, and genealogical cultural criticism and social theory. This has meant, among other things, identifying the themes that have long knitted together the registers of inquiry and argument that persistently shape discussions of the aesthetic dimensions of black life. These themes register for us in questions like the ones I've taken up in this book: What is blackness in cultural production? How does it involve habitual modes of perception?

Does it mean different things in different places? Do racial identities come with racial obligations, either for people in general or, more specifically, for artists? Do these duties bar us from crossing racial lines in our practices and preferences? Does it even make sense to draw racial boundaries around our practices? How does blackness relate to musicality and rhythm? And: How are black bodies related to beauty?

There are of course other questions to ask. In addition to the questions of appropriation and ambivalence, of love and theft, there is this question: How do people sustain themselves under conditions of racial terror, exclusion, and oppression? How, in particular, can black people stay sane – and find *joy* – in societies that demonize, brutalize, and objectify black bodies? What does it mean, what is it like, to have an experience, to have a world that produces the experience, that leads to words like these: "My Black Aesthetic is Bobby Seale, bound and gagged and straining at his leash in a Chicago courtroom"?[7] What does it mean to accept the limits of that world while still hoping for more, and finding ways to laugh, love, and dance?

I can't take up these questions here, but propose to do so in the next installment of this project.

Notes

1 Eric Lott, "'The Seeming Counterfeit': Racial Politics and Early Blackface Minstrelsy," *American Quarterly* 43:2 (June 1991), 223–254, 228.

2 Mike Ayers, "Macklemore to Kendrick Lamar After Grammys: 'You Got Robbed,'" *Rolling Stone*, January 27, 2014, http://www.rollingstone.com/music/news/macklemore-to-kendrick-lamar-after-grammys-you-got-robbed-20140127 (accessed January 30, 2014).

3 Lott 223.

4 See Spike Lee, dir., *Bamboozled* (New Line Cinema, 2000). For a discussion of this phenomenon see Leonard Harris, "Against Minstrelsy," *Black Diaspora Review* 3:2 (Winter 2012/2013).

5 Lott puts the point this way: "blackface minstrelsy's century-long commercial regulation of black cultural practices stalled the development of Negro public arts and generated an enduring narrative of racist ideology – a historical process by which an entire people has been made the bearer of another people's 'folk' culture." Lott 225.

6 See James O. Young, *Cultural Appropriation and the Arts* (Malden, MA: Blackwell, 2008); James O. Young and Conrad G. Brunk, *The Ethics of Cultural Appropriation* (Malden, MA: Wiley-Blackwell, 2009).

7 Julian Mayfield, "You Touch My Black Aesthetic and I'll Touch Yours," in Addison Gayle, ed., *The Black Aesthetic* (New York: Anchor-Doubleday, 1971), 27.

Index

Black is Beautiful: A Philosophy of Black Aesthetics, First Edition. Paul C. Taylor.
© 2016 Paul C. Taylor. Published 2016 by John Wiley & Sons, Ltd.